Cinematic Projections:
The Analytical Psychology of C G Jung and Film Theory

Cinematic Projections
The Analytical Psychology of C G Jung and Film Theory

UNIVERSITY
OF LUTON

press

British Library Cataloguing in Publication Data
A catalogue record for this book is available from the British Library

ISBN: 1 86020 569 0

Published by
University of Luton Press
University of Luton
75 Castle Street
Luton
Bedfordshire LU1 3AJ
United Kingdom

Tel: +44 (0)1582 743297; Fax: +44 (0)1582 743298
e-mail: ulp@luton.ac.uk
www.ulp.org.uk

Cover Design by Gary Gravatt
Typeset in Van Dijck and GillSans Bold
Printed in Great Britain by Thanet Press, Margate, Kent

Contents

Acknowledgements		vii
Introduction		1
PART ONE	Circumstantial Evidence: An Introduction to Analytical Psychology and its Relevance to Film Analysis	11
Chapter 1	An Introduction to C G Jung	13
Chapter 2	The Objective Psyche and Archetypal Patterns	29
Chapter 3	A Film Analysis: *Tightrope*	47
PART TWO	The Case for the Defence: Archetypes and Symbols	57
Chapter 4	Archetypes: The Hypothesis	59
Chapter 5	Re-reading *Blade Runner*	77
Chapter 6	The Symbolic Search	89
Chapter 7	Individuation and the Detective	103
PART THREE	Guilty as Charged: An Analysis of *Trancers*	123
Chapter 8	*Trancers*: Movie as Psychological Myth	125
Chapter 9	Archetype: Image and Mythologem	139
Chapter 10	Symbolism: Mythology and Mythologem	149
Chapter 11	Mythological Amplification	159
Chapter 12	The Individuation of Jack Deth	169
Glossary		177
Bibliography		181
Filmography		199
Index		209

Acknowledgements

I would like to thank my academic colleagues, past and present, for their tolerance and support during the preparation of this book. *Cinematic Projections* had a previous life as a PhD thesis at the University of Stirling, where it benefited from the adroit supervision of John Izod and Richard Kilborn, and the refining fire of Gareth Palmer. A special thank you is given to Manuel Alvarado, for his leap of faith in allowing this interjection into film studies. To Mark Anderson, *Cinematic Projection*'s midwife and nursemaid, a deeply given thanks for keeping me afloat in some choppy grammatical waters; your skill and patience, in taking arms against a sea of troubles, is as valued as your friendship. A fond thank you is given to Dr David Toms who generously nurtured my fledgling interest in analytical psychology. To Andrew Campbell OSB, thank you for giving me shelter when it was needed. Finally, a debt of gratitude is owed to my family and to everyone who has given their personal support, during what have been some troubled times.

... image alone is the immediate object of knowledge.

C G Jung

Medicine and Psychotherapy Collected Works Volume 16: 201

Introduction

Fundamentally, Jungian psychology is a psychology of images. Without invoking the full weight of the Jungian position, this single point means that the relevance of Jungian based psychology is greater today than ever before. It also suggests why it deserves to be taken seriously by scholars of the mass media, for the following reasons.

It hardly needs to be said that we live in an age that surrounds us with images. The roots of this explosion in image-making and production lie in the 19th century, where the means with which to make images in an affordable and repeatable manner gave birth to the technologies of photography and film-making. Together, they gave the opportunity for people to communicate with each other, by using symbolic and iconic systems. It is true that this was nothing new for the wealthy, who had always been able to take up the services of painters, sculptors, and other creative artists. As a result of patronage and commission, they could create and own personal, and unique, works of art. But image-making technologies effected two changes. Firstly, they brought the means of production (to borrow a phrase) into a realm where they could be afforded by the middle classes. Secondly, the 'new-technologies' meant that images could be reproduced perfectly, an unlimited number of times. Photography quickly established itself as a popular medium, and the development of light-weight cameras in the early to mid-part of the 20th century, and commercial low-cost film processing and printing, ensured its continued appeal. The emergence of television as a mass medium, brought electronic images into the public domain. The 1970s saw the arrival of affordable and portable home-video equipment. The dominance and appeal of television remained unchallenged until the 1990s, when anyone who owned a desktop computer could create and manipulate digital images.

I mention these developments not as fresh news, but rather to remind ourselves that across the 19th and 20th centuries, and into the new millennium, images have become more, not less, important. Curiously, there is almost a sense in which we can see a contemporary battle between images and the typographic word, where we are witnessing a return to a mediaeval outlook on life. Like a painting on a cathedral wall, images are coming not just to represent their subjects, but also to embody a world-view. But it is not my intention here to

enter into the intricacies of post-modernism, or to dwell on the complex history of the technological developments of audio-visual media. (In any case, they have already been dealt with extensively, and thoughtfully, by other authors.) Instead, I want to suggest that if we are to understand the attraction of images, then it is not enough to just see them in terms of the economic conditions of capitalist society: it is also important to reflect on their psychological appeal. Watching films is a case in point.

In the midst of this technological change we have cinema. There is something compelling about the cinematic experience that has ensured the longevity of this strangely appealing medium. Cinema stands out as a curious anomaly in the audio-visual landscape of the 21st century, where the trend has been towards miniaturisation, affordability, portability, ownership and repeatability. By contrast, cinema isn't portable and it is expensive. It is large and difficult to access – you have to buy tickets, go at a certain time, and, if the film is a popular one, you also have to queue. The experience of watching films in the cinema, obstinate as ever, revels in bigger screens, surround sound and eludes any attempt at personal ownership. Despite the best attempts of advertisers to persuade us otherwise, watching a video, or a DVD, isn't a cinematic experience. But it remains significant that the latest developments in television and video technologies attempt, with wide-screen television and Dolby surround sound, to recreate the 'big screen' experience. Cinema is important enough for us to want to spend substantial amounts of money to recreate it in our homes. This isn't rational.

One of the reasons behind the appeal of cinema can be found in the apparent dichotomy that exists between the need to make images of ourselves, as paintings and latterly as photographs, and the desire to watch films. In fact, while the intention may be different, the psychological process, and its outcome, is the same. In a photographic portrait, or even just a holiday snap, we record who we are, what we are doing and who we are with. It documents a set of personal relationships and identities, through which we can define our sense of self, what we have done, and perhaps even the problems we have. In this sense, the cinema is the psychological medium *par excellence*. The large screen, the relative immobility of the audience, the dark, warm environment and immersive sound: all focus our attention on the screen. And, in so doing, these conditions enable the psychological process of projection. Put another way, photography and video offer us the opportunity to create representational images of ourselves, but what we see in the cinema is our *psychological* portrait. As Phyllis Kenevan puts it:

> It seems that, while we are outwardly mere spectators of the film or silent readers of the novel, an inner observer is relating itself to the characters, situation, action and reacting to the work in highly personal ways...When we recognise ourselves in the characters and situations of the novel or film, we become receptive to what we otherwise fail to see as belonging to us.[1]

Images encourage this type of psychological reflection; they initiate a personal and emotional response. Jung knew this, and that is one of the reasons why he encouraged his clients to paint and to be creative – in essence, Jung was one of the first pioneers of art therapy. He also devised the analytical technique of 'active imagination', in which analysands are encouraged to enter into the fantasy world of their paintings, with the intention of gaining a better psychological understanding of their life and personal circumstances. For Jung, images encapsulate the totality of a psychological situation, both the aspects that are conscious, and the elements that are unconscious. As he notes, 'The image is a *condensed expression of the psychic situation as a whole*, and not merely, nor even predominately, of unconscious contents pure and simple' (italics as original).[2] At different periods in his thinking, Jung wrote about images and symbols, and their differences and similarities, from different perspectives. But throughout his latter work he continually asserts the centrality of images, because they carry a psychological significance: 'The psyche consists essentially of images',[3] and later, 'The symbolic process is an experience *in images, and of images*' (italics as original).[4]

Given the centrality of images in analytical psychology, it is all the more puzzling that film theorists haven't made more use of Jungian and post-Jungian psychology.[5] There are literally a handful of books on the subject, while there are hundreds, if not thousands, of volumes whose psychological approach to film has been dominated by Freudian psychoanalysis, often with a Lacanian inflection. The reasons for this are difficult to unravel, but here are a few possible explanations. Jung is not a clear writer, and the arrangement of the *Collected Works* of Jung do not help matters. If you want to understand how Jung's thinking on a topic changes over time, then you have quite a project on your hands. Jung uses terms interchangeably, for example, image and symbol, and then suddenly insists on a distinction. The *Collected Works* are quasi-thematic, but not historical, and so the problem of pinning down what Jung means is made worse, as his thinking seems to change from page to page. In psychoanalysis there are several very clear concepts that are easy to grasp and which fit neatly with contemporary interests in sex and sexuality. Which isn't to say that psychoanalysis isn't sophisticated and as complex as analytical psychology – it is. By contrast, Jungian ideas are polyvalent and intrinsically subtle in their distinctions between form, content, metaphor, and fantasy – this is particularly the case in the work of post-Jungians such as James Hillman. Traditionally, the professional Jungian societies have not welcomed 'lay academics' – although, to be fair, in recent years the situation has improved slightly. Jung's personal life raises all sorts of problems: political, sexual and racial. Rather than confront and deal with these issues, Jungians have tended to be secretive. Such institutionalised repression does little to further the cause of analytical psychology. But this situation is changing, and the perspective offered by analytical psychology is gaining more wide-spread acceptance. As Andrew Samuels notes:

> Also on the credit side, I think we can discern a certain acceptance that has hitherto been denied to 'Jungians' in clinical, cultural and academic

circles. It is not an open-armed welcome, but there is an open-mindedness, stimulated not only by the cogent arguments and improved behaviour of the Jungians but also by shifts in cultural process, and in how we understand both clinical work and the nature of knowledge itself in contemporary culture.[6]

Finally, when film theory uses psychoanalysis, it often does so with something other than psychoanalytic intentions. This may seem odd, but a clear articulation of this can be found in Mulvey's classic article *Visual Pleasure in Narrative Cinema*, where in the opening paragraph she notes, 'Psychoanalytic theory is thus appropriated here as a political weapon, demonstrating the way the unconscious of patriarchal society has structured film form'.[7] Of course, psychoanalysis and politics don't have to be enemies. Indeed some Jungians, such as Andrew Samuels, in his book *The Political Psyche*, argue that it is a failing of analytical psychology that it is not more engaged with the realities of the political world. But there is a significant difference between this position, and using psychoanalysis as a 'political weapon'. The writers and editors of *Screen* saw how psychoanalysis could be deployed in support of their broadly deconstructive project. Psychoanalysis, along with structural linguistics, and economics (of a Marxist persuasion) were used to expose the social relations of individuals, institutions, and whole societies. The importance of this legacy should not be underestimated. Essentially, *Screen* engaged with screen-studies through the challenge offered by the Marxist problematic. However, they came to the realisation that this position did not adequately address the problems of the subject, and of spectatorship – hence *Screen*'s interest in a Lacanian elaboration of Freudian theory. Even when recent writing on film does mention Jung, it tends to follow this trajectory, and ends up deprecating the Jungian position. For example, a recent collection of film theory contains the following comment, 'Lastly, I turn to myth criticism, derived from the legacy of Carl Jung, which adopts a semi-spiritual stance on the text. Such an approach cannot understand feminist concerns...'.[8] Of course, on both accounts, the writer is mistaken.

However, it is clear that the Jungian position is not as well suited to use in deconstructing images as psychoanalysis. Further, at a time when *Screen* was leading the field in exposing cultural myths, it was hardly likely to be drawn to a school of psychological endeavour that placed mythological and symbolic material centre-stage. A psychoanalytic perspective constructs the psyche primarily in terms of repressed material. While this is an oversimplification, it is still clear why the essential elements of this point of view would be of interest to those engaged in a politically motivated deconstruction of cultural value; it provided them with a means by which patriarchy could be reconstituted in psychoanalytic terms, and the tools of psychoanalysis could be appropriated to explore what had been repressed by the capitalist patriarchal unconscious. Jung's model of the psyche takes the opposite approach. Rather than seeing the psyche as composed of essentially repressed material, he suggested that the psyche is developmental. Both psychoanalysis and analytical psychology want to understand the unconscious. But the Jungian view sees the

role of the unconsciousness in primarily positive terms. The role of consciousness, and the aim of life, is to be more aware of how the unconscious can influence our everyday behaviour and attitudes.

Ultimately, both schools of thought have similar aims, but they get to their end points via quite different routes. The Freudian approach is essentially reductionistic and dialectical. At its most extreme, it constructs a model in which the psyche is essentially engaged in the task of attempting to deal with the impossibility of the oedipal situation. The id drives the psyche forward, the superego constrains it, and the ego survives in the middle ground. By contrast, the Jungian view suggests that the relationship between consciousness and the unconscious might be better understood as a discussion. The unconscious communicates to consciousness the reality of the psychological situation as it is, and suggests the way forward. As such, Jung's view of the unconscious is a teleological one. This means that images, which carry a psychological significance, cannot be understood by using a reductionistic method. This led Jung to state, 'The view that dreams are merely the imaginary fulfilments of repressed wishes is hopelessly out of date...The dream is specifically the utterance of the unconscious'.[9] Freud memorably remarked that dreams were, 'the royal road to the unconscious'. A Jungian reformulation might be that dreams are the royal road *from* the unconscious, *to* the future.

This makes us look at films in a very different light. Verena Kast has reflected on the relationship between fictional narratives and the psyche, and comments:

> I like to see all the stories we human beings (and our culture in general) have collected as a transitional space, as the reservoir of the collected creativity of all human beings in the past and in the present. The more the symbols that are used are reformulations of archetypal structures and dynamics, the more they seem to trigger the personal fantasy and the fantasy of survival, and the more they help one to work on actual and repressed problems.[10]

Here, Kast uses the term 'transitional space' in a technical sense, to describe the use of an object to define what is me, and what is other, or not-me. Her suggestion is that this process of self-definition is actually central to all story-telling. By extension, perhaps this is also one of the ways that we use films. At the heart of Jungian psychology lies a generosity of spirit: it believes that the psyche has the ability to heal itself, that the psyche aims to find out what is wrong with itself, and to put it right. As part of a natural and biological system, the natural inclination of the psyche is towards health. Even without working at understanding the unconscious, elements of stories and images will still confer some benefit; there is merit in just listening and looking.

> Maybe the power of fantasy can be revived. Through the funnel of the inner image, the fairy-tale can have a huge impact on the chemistry of our emotional transformation. Thus, listening to a fairy-tale already has a therapeutic effect.[11]

This makes us wonder if it is too much to pursue the claim that cinema might be good for you. Perhaps just the act of watching a film *might* have a therapeutic effect.[12]

Organisation of the Book

The ideas in *Cinematic Projections* have been ordered so that one chapter develops logically into the next. However, it is not necessary to read the book in such a linear manner – indeed if you are familiar with analytical psychology and film theory, you would be well advised to proceed along different lines.

Part One: Circumstantial Evidence carries out some initial connecting up between analytical psychology and film theory. The first chapter introduces the basic elements of analytical psychology and identifies what makes Jung's approach distinctive. It explores Jung's theory of consciousness and personality type, before moving on to consider his views on the structure of the unconscious. Throughout, reference is made to a range of films and this indicates the general applicability of Jung's psychology as a tool for understanding the behaviour and motivations of on-screen characters. The aim is to show that, from the very start, it is possible to adopt a psychological approach to films and their characters.

The second chapter focuses on the idea of the objective psyche and archetypes. A central concern is the relationship between the pattern, or form, of the archetype and its associated images. As the chapter progresses, it links-up the interest that film theory has with structure and image to archetype theory, which has similar concerns. This develops into a consideration of the role that symbols have in the psyche, and presents Jung's comments on the function of dreams. Many of the themes in this chapter are developed in part two of the book.

The final chapter in part one takes the theory of the previous chapters and uses it to interpret the film *Tightrope* (Richard Tuggle: 1984). It focuses on the relationship that exists between the detective and criminal, and sees these two figures in archetypal terms, as persona and shadow. It also explores the mythological and archetypal theses that lie beneath the film's surface. Using the process of mythological amplification, it relates these themes to the narrative of the film, and the psychology of its central characters.

Part Two: The Case for the Defence is a good place to start if you already have some familiarity with analytical psychology and film theory. It picks up themes of the previous chapters and offers a more detailed consideration of them. Chapter four examines the archetypal hypothesis. It locates the idea of archetype, or fundamental structure, as part of a series of cultural discourses, and examines the determining characteristic of an archetype – how do we know one when we see one, or do they elude classification and definition? It goes on to examine how the metaphor provided by the idea of fundamental pattern is useful not only in terms of a consideration of a personal psychology, but also with regard to how

it can be used to reflect on our collective psychology. This establishes the basis on which it is legitimate to examine the collective psychological appeal of cinema films. The chapter concludes by offering a model that enables analytical psychology to be applied to the analysis of films.

Chapter five applies the model that was presented in the previous chapter as a means by which to reflect on the film *Blade Runner* (Ridley Scott: 1982). There are various reasons for choosing this particular film. First, it is a well-known film that has achieved an almost cult status. This suggests that there is something particularly appealing about the film, at least for a certain section of society. It's also a film that film theorists, of numerous persuasions, have been drawn towards. From a psychological perspective, *Blade Runner* has been left relatively unexplored and virtually nothing has been written about the mythological themes and imagery of the film. This analysis attempts to rectify this oversight. It takes the character of the detective Deckard, and examines the other characters in the film in terms of his psychological projections. Taking this is a starting point, the mythological themes in the film are tied into Deckard's individuation, in which his search for some escaped Replicants (androids) is seen to mirror his inner-search for self-understanding.

Chapter six provides a detailed examination of what analytical psychology means by the term 'symbol'. This is important as it helps to differentiate between the use that Freudian psychoanalysis makes of symbols and their function in analytical psychology. Having established the psychological context, the chapter examines the opening sequences of two films: *Sleuth* (Joseph Mankiewicz: 1972) and *The Woman in the Window* (Fritz Lang: 1944). In much the same way that dreams which occur at the start of an analysis are seen to anticipate its future developments, so too the symbols at the start of these films suggest how their narratives will develop. The opening of these films acts as a sort of symbolic overture, which cues the audience about the narrative's psychological direction. Two particular concerns of the chapter are the image of the labyrinth and the function that dream sequences have in films.

Chapter seven is the last of the theoretical chapters and has two sections. First, there is a general overview of the process of individuation. This is followed by a more detailed examination in which the various stages of the process are related to detective films. The general approach is to see individuation as a natural and developmental process, but also one that is an ideational or archetypal fantasy. Applying the psychological theory to films, it promotes a non-literal reading in which, instead of seeing films in straightforwardly representational terms, it locates their images and characters as part of a complex process of psychological projection. This gives what is essentially a post-Jungian perspective on archetypes and their role in films. This offers a markedly different perspective to a Freudian psychoanalytic reading of cinema, in which films are seen as giving voice to elements of the psyche that have been repressed. Instead, a post-Jungian view regards films as offering a metaphorical

and symbolic perspective on our psychological life.

Part Three: Guilty as Charged offers an in-depth analysis of the low-budget, science fiction, B-movie *Trancers* (Charles Band: 1984). In many ways this is an odd film to choose to spend so much time analysing. Being a B-movie, it isn't particularly well-made, the acting isn't great and the plot stretches the bounds of belief. But visually the film is inventive and stylish and it's tongue-in-cheek humour, and genre references, make it great fun. In short, it is unpretentious and entertaining. But underneath its surface the film also touches on some deeper psychological themes and, once these are recognised, they raise our interest in the film.

Chapter eight opens the analysis of *Trancers* with an examination of the archetypes that populate the narrative of this film. It explores the mythological and psychological role of the hero and introduces his relationship to the persona, shadow, and contrasexual archetypes.

Chapter nine focuses on an exploration of the main mythological motif in *Trancers*. It shows how the theme of the quest can be related to the secondary, or auxiliary, myth themes of life and death, height and depth, and body and spirit. In doing this, it reveals that the film rests on an intricate mythological framework, which gives it a psychological structure and mythological coherence.

Chapter ten examines a number of the key symbols in *Trancers*. Firstly, it explores how the film depicts time. It locates this within a consideration of Newton's versus Einstein's views of time, and proceeds to introduce a mythological perspective. Secondly, it examines the role of water symbolism, and concludes with some brief reflections on the role of food and colour in the film.

Chapter eleven uncovers the mythological parallels to the central, and auxiliary, myth themes of *Trancers*. Deploying a process of mythological amplification, it examines the myth of Atlantis and then examines some of the myths that surround labyrinths. The intention is to show that what may appear on the surface as a series of separate mythological motifs are actually related.

Chapter twelve examines the general images of individuation in *Trancers* and looks at those images that are particularly associated with the individuation of the central character, the detective Jack Deth. Of particular interest is the function of what appear to be opposites in the film. Here the notions of *enantiodromia, conjunction* and *conincidentia oppositorum* are used to provide a basis on which to consider individuation.

By bringing together Jung and film theory, my intention is to make it possible to take a more positive, and less literal, view of cinema than is often the case. The hope is that, in repositioning films as part of cultural and psychological discourse, we will get a different perspective on the problems of representation, and that this can be combined with a fresh understanding of the role that

cinema films have for us, as individuals and cultures. If nothing else, it provides an alternative way of thinking about films: one which suggests that there is merit in reflecting on our cultural values, and in considering our personal, as well as collective, relationships with the people around us, and the films we watch.

Notes

1 Kenevan, P. B. *Paths of Individuation in Literature and Film: A Jungian Approach* (New York, 1999) p7.

2 CW6: 745.

3 CW8: 618.

4 CW91:82.

5 These early references should not be taken to imply a Jungian fundamentalism. Actually much of the strength in current Jungian thinking comes from post-Jungian developments. These take some of the basic concepts that lie behind Jung's original ideas and jettison what's outdated or unhelpful.

6 Samuels, A. *Will the post-Jungians Survive?* in, *Post-Jungians Today: Key Papers in Contemporary Analytical Psychology* , Casement, A. (ed), (London: 1998). p16.

7 *Screen*, Vol 16, no3 Autumn 1975.

8 Miller, T. 'The *Sensual Obsessions* of Film Theory', in Miller, T. and Stam, R. (eds) *Companion to Film Theory*, (Oxford, 1999). p331.

9 CW 16: 317.

10 Kast, V. 'Can you change your fate? The clinical use of a specific fairy-tale as the turning point in analysis', in *Post-Jungians Today: Key Papers in Contemporary Analytical Psychology,* Ann Casement, A. (London: 1998) p134.

11 *ibid* p119-120.

12 The possible effects of films, and other mass media, is probably the most researched area in the field of media studies. Interestingly when it comes to proof, it is also the most inconclusive. The reasons for this are two fold. Firstly the amount of money spent by the major players in the media industry, shows that they take their effect 'seriously'. Secondly research academics have developed this area of investigation precisely because it appears to be impossible to prove. For an excellent account see Gauntlet, D. *Moving Experiences: Understanding Television's Influences and Effects* (London, 1995).

Part One

Circumstantial Evidence:
An Introduction to Analytical Psychology and its Relevance to Film Analysis

I

An Introduction to C G Jung

Harry Lime (Orson Welles): *In Italy, for 30 years under the Borgias they had warfare, terror, murder and bloodshed, but they produced Michelangelo, Leonardo da Vinci and the Renaissance. In Switzerland, they had brotherly love, they had 500 years of peace — and what did they produce? The cuckoo clock.*

The Third Man (Carol Reed: 1949)

Introduction

The first part of this book introduces the psychological theories and hypotheses that were formulated by the Swiss psychologist C G Jung. To differentiate these from Freud's already established 'Psychoanalysis', Jung termed his method of understanding the psyche 'Analytical Psychology'.[1]

There are two main sections in this chapter. The first provides a psychological context for Jung's theories, and seeks to set his ideas against three major schools of psychology, namely: behaviourism; psychodynamic theories; and humanism. The second section presents Jung's theory of consciousness, and relates this to what is probably his best-known work on personality types. It is an indication of the significance of this work that some of the terminology he devised has now passed into everyday usage. For example, as far back as 1921 Jung used the terms 'introvert' and 'extravert' as ways of describing what he identified as two different psychological orientations to the world.[2] This introduces to us a problem that will reoccur throughout this work, namely the way in which a technical, psychological vocabulary has subsequently become popularised. In this transition, the terms acquire new meanings, and become inflected with attitudes derived from current popularist psychology, with which we are all too familiar. These new definitions are then read back into the original Jungian sources, thereby providing a wonderful opportunity for misreading, obfuscation, misappropriation of terms and general confusion. One of the intentions of this book is to reclaim some of this language and apply it to help develop a psychological approach to understanding movies.

Throughout, reference will be made to a variety of films, with the intention of indicating their general psychological attributes and, in so doing, establishing some association between analytical psychology and film theory. The next chapter will develop these ideas and explore Jungian theories about the

unconscious; this will enable a firmer link between analytical psychology and film theory to be forged.

Core Concepts in Psychological Thought

To map the development of psychological thinking during the nineteenth and twentieth centuries is, of course, a project in its own right. Nonetheless when identifying the similarities, in some cases, and the distinctive nature in other examples, of Jung's observations, it is helpful to have sense of these general discourses. Such a guide is particularly useful as Jung himself was sometimes vague and curiously contradictory in what he claimed for analytical psychology. Others, on his behalf, have often not been much clearer. For example, Jung was at pains to stress that he regarded himself as an empiricist – which he was not. However, recent criticism labelling him a mystic and accusing him of starting a religious cult is also misplaced.[3] At best, this puts a particular, and somewhat bizarre, spin on his writings and at worst it misrepresents the main tenets of analytical psychology. Given what amounts to an extreme characterisation of Jung's work, where can we place the model of the psyche that he hypothecated? Was he an empiricist or a mystic? Was he a scientist or philosopher? It is against these questions that we set our initial exploration of Jung's ideas.

While accepting the only too apparent danger of oversimplification, it is possible to identify three broad approaches that have characterised psychological thought in the twentieth century. Perhaps the simplest, and most commonplace, of these is behaviourism. This school is concerned directly with what it thinks can be unambiguously observed, and additionally it aims to measure such observed behaviour. The example that most people are familiar with is Ivan Pavlov's work on conditioned reflexes. However, in America it was J B Watson who launched the behaviouristic movement in 1913, his ideas being subsequently developed by Clark Hull and B F Skinner. Underpinning their approach is the idea that all human behaviour can ultimately be reduced to the relationship between stimulus and response. As Skinner comments:

> The important fact is that such contingencies, social or non-social, involve nothing more than stimuli or responses; THEY DO NOT INVOLVE MEDIATING PROCESSES. We cannot fill the gap between behaviour and the environment of which it is a function through introspection because, to put the matter in crude physiological terms, we do not have nerves going to the right places.[4]

A weakness of the theory is that it does not incorporate the human need for both introspection and consciousness.[5] To be more accurate, it regards human consciousness as the result of external stimuli. Although behaviourists do not like referring to consciousness, they are nonetheless attempting to understand why people behave in the way they do to events. The intention is to create a 'science of behaviour' in which humans are essentially seen as higher animals. This places the emphasis placed firmly on what is observable, and excludes all else. However, such an approach cannot accommodate the existence of

consciousness, in the sense that it is used by depth psychologies, and the existence of the unconscious is a notion that is regarded with some hostility. This has led to the work of the behaviourist movement being criticised as, 'an elegant but superficial pursuit of trivial problems couched in arid language and too artificial to have relevance for 'real life' problems of either animals or people'.[6] Nonetheless, behaviourism, with its scientific claims, has been influential.

What this view of the world shares with the Jungian approach is the desire to understand how humans function. In fact, some of Jung's early work was concerned with the development of word association tests.[7] In these experiments he tried to measure the delay between the stimulus of a word and the subsequent response by a subject; Jung suggested that longer than typical delays indicated the existence of an unconscious complex, or that something had been repressed. In making these suggestions, he parted company with any form of behaviourist thinking. Moreover, Jung quickly left these early experiments behind and instead concentrated on trying to understand the interplay between the unconscious and conscious parts of the psyche. This led him to suggest that there is a life-long struggle to understand and accept the totality of ourselves. (In short, the psyche wants to know itself.) The idea that psychological maturity – like biological maturation – is a gradual, life-long process is one of Jung's most developed and enduring concepts, and is a founding principle of Analytical Psychology.

Despite initial appearances, in some ways psychodynamic theories are curiously analogous to those of behaviourism. The term 'psychodynamic' has a variety of meanings, but in this context it is being used to describe and encompass all, 'theories which represent symptomatic behaviour as determined by an interplay of forces within the mind of an individual subject without involving awareness. This is exemplified by Freudian psychoanalytic theory...'.[8] However, as the earliest of the psychodynamic theories pre-dates behaviourism's formal birth, it is misleading to think of psychodynamic theories as encompassing behaviourism. Further, the major refinements to the behaviourist model were not presented until 1926, some 25 years after Freud's *The Psychopathology of Everyday Life*, and the general approach in which the unconscious has such a central role is clearly the antithesis of the world view promoted by behaviourists. It was Freud who first noted that some patients exhibited clinical symptoms that had no apparent medical origin, and he called these 'psychoneuroses proper'. In doing so, he was going against the prevailing psychological and medical opinion of his day. He eventually distanced himself even further from the medical establishment by claiming that these psychoneuroses proper, were the consequence of the now well known Oedipal Complex. In essence, the complex is the result of the child's inevitable sexual attraction to the parent of the opposite sex. The inability to deal with this impossible situation leads to life long consequences and may even result in neuroses in later adult life.

As part of his model, Freud suggested that there were two levels to the psyche, and he termed these the 'conscious' and the 'unconscious'. Within his framework, the agencies of the id, ego and superego provided additional theoretical constructs, and together created a dynamic and interactive model within which he was able to explore human psychology. For Freud, the ego is the controlling centre of the personality and is concerned with facing up to the demands of the real world, dealing with both impulses from the id and the censoring behaviour of the superego. The id acts to curtail pain and amplify pleasure (the so-called 'pleasure principle') by giving free rein to primitive impulses. As such, it conflicts with the 'reality principle' of the ego and the demands of social integration of the superego. The superego is the moral part of the personality that strives for perfection, rather than pleasure, and represents the assimilation of cultural moral values.

Within this approach there are two central concepts, both of which are somewhat behaviourist in the way in which they regard human behaviour. First, the pleasure principle is like the 'law of affect' in that it states that if an action is pleasurable, it is likely to be repeated. Secondly, the theory is somewhat deterministic in suggesting that all behaviours are learnt reactions to the environment.

> (1) Man is essentially hedonistic, motivated by the 'pleasure principle'; even his most noble works may be no more than the sublimated release of sexual energy in a socially acceptable activity; and (2) man's behaviour is determined by his instinctive drives and the ways in which these are directed and apportioned in early childhood.[9]

What separates psychodynamic theory from behaviourism is the acceptance of an unconscious dimension to the psyche. It aims to explore and understand the interplay between stimuli that, as in the Oedipal situation, may have been unconscious or repressed and the effect that these have on our everyday behaviour.

The film *The Terminator* (James Cameron: 1984) provides a good, if somewhat extreme and simplistic, example of on-screen behaviourism. To some extent all robot and cyborg films can be regarded as explicit, if exaggerated, examples of the behaviourist paradigm, but *The Terminator* is a particularly good example as it displays the android's decision making and responding processes in a strongly visual manner. The film's narrative is simple. A cybernetic organism, or Terminator, (Arnold Schwarzenegger) is sent from the future back to 1984. His mission is quite simply to kill Sarah Conner. Naturally enough, his first problem is to find her. To do this he goes to the telephone book in which (unfortunately for him – though luckily for the plot of the film) he discovers there is more than one Sarah Conner. His ruthlessly logical response to the stimulus name is to work through the list, killing the first Sarah Conner, then the second and so on. The Terminator makes no attempt to question any of his victims; he has no capacity for consciousness, no creativity and no sense or need for introspection; he is, after all, little more than a machine. Later in the

film, there is even clearer evidence of his programmed behaviour. The Terminator is repairing itself in a hotel bedroom when it hears a knock on the door. This stimulus causes a table of possible responses to flash up on-screen as a representation of the workings of the computer brain.

Yes / No

Or what

Go away

Please come back later

Fuck you arse hole

To the delight of adolescents, the Terminator selects the last of these options as the most suitable response.

While there are undoubtedly ways in which behaviourism could help us examine the behaviour of on screen characters, it is also limited. The intention is not to suggest that just because the film is simplistic so too the model must also be simplistic. Rather the film represents a *Reductio ad absurdum* of the approach, and in so doing acts as an illustration of the tendency within this theoretical position to over-emphasise the mechanical and rationalistic aspects of human psychology.

The third and final of the three psychological theories is the humanistic theory, which recently seems to have gained popularity. Perhaps a reason for this is that the Freudian and Behaviouristic views of human nature seem somewhat pessimistic and deterministic. One of the founders of humanistic psychology, Abraham Maslow, intended that his approach to psychology should be directly applicable to the everyday lives of ordinary people. Consequently, this approach is highly critical of any branch of psychology which, because of its interest in measurement and statistics, may seem dehumanising. It is also interesting to note that two of humanism's central tenets are in direct contradiction to Freudian and Behaviouristic schools and theories:

> (1) Motivation, we are not only solely the result of reinforcement of innate drives – we are being pulled upward to a final goal not just pushed rudely by our past. (2) Since not all behaviour is directed by reinforcement or early toilet training or whatever, then the concept of free will can exist. We are to some extent the captains of our own souls.[10]

The concept of 'motivation' could be more generally described as one of self fulfilment, and is termed 'self-actualisation' by Maslow and Rogers. It describes the human need, and ability, to achieve a psychological balance in life. Self-actualised people are able to accept their own peculiarities and accept other people without prejudice or irrational judgementalism; they are less likely to twist 'life experiences' just to flatter their own egos. However, precisely because they are aware of their own independence, and are therefore self-

reliant, they are not 'perfect' people. Many people never achieve the desired state of self-actualisation, being drawn, or pulled away, from its path. The degree to which one is distanced from this path to self-actualisation is termed 'incongruence' or alienation. To a certain extent, there is a parallel between incongruence and Jung's concept of the 'complex', for, as already noted, Jung regarded the complex as the result of trying to stop the life-long process of psychological maturation.

Jung's Theory of Consciousness and the Theory of Types

The personality theory of C G Jung, the so called 'theory of types' or 'typology', is important as Jung's theories about the psyche connect, in some way, to the concepts of personality, growth and development. The level of integration within Jung's thought will become clear as each aspect of analytical psychology is introduced. As the theory unfolds, it will provide a framework with which to explore how we relate to film characters, and how the characters function within the autonomous and closed world of the film narrative. To conduct this analysis effectively, it is important to have a psychological model for both the evaluation of characters in the film, and the psychological characteristics of the societies that produce the films. Thus the specific applicability of this personality theory, and the wider theoretical constructs of analytical psychology, are at their clearest and most obvious during the practical analysis of detective films. These occur in the following chapters, after more Jungian theory has been presented; nevertheless, during this chapter some reference to film theory will be made when relevant and helpful.

In his writings on the psychology of types, Jung deals mainly with the conscious, and not the psychology of the unconscious. The bulk of this work can be found in Volume 6 of the Collected Works *Psychological Types*.[11] The core of Jung's theory lies in what he identified as two distinct approaches that people adopt to the world. According to Jung, they represent quite opposite ways of reacting to, and of making sense of, everyday life. They are fundamentally different ways of relating to the world.

> ...there is a whole class of men who at the moment of reaction to a given situation at first draw back a little as if with an unvoiced 'No', and only after that are able to react; and there is another class who, in the same situation, come forward with an immediate reaction, apparently confident that their behaviour is obviously right. The former class would therefore be characterized by a certain negative relation to the object, and the latter by a positive one...the former class corresponds to the introverted and the second to the extraverted attitude.[12]

The result of this is that extraverts direct their attention away from the inner world towards the outside world of events, people and whatever is happening around them. While both introverts and extraverts are affected and orientated

by the outside world, the extravert relies heavily upon this information, and needs this type of stimulation to function effectively. Thus the extraverted type is characterised by an outward flow of psychological energy.

As in real life, it is possible in the movies to find both introverted and extraverted personalities. A particularly clear example of an extraverted type is Jake la Motta (Robert De Niro) in *Raging Bull* (Martin Scorsese: 1980). Jake is an extreme extravert who is almost pathological in his incapacity for introspection and in his alienation from the world of feelings. To use the technical language of analytical psychology, he is 'disassociated' from the unconscious. Consequently, his relationships fail as, unwittingly, he redirects his energies away from himself. Instead, they find a physical and aggressive outlet in his career as a professional boxer. Proving that he can cope with pain in the boxing-ring, he permits himself to be struck, to let himself feel pain, before he finally destroys his opponent. His home life is no less combative; here, with only the slightest of provocation, he beats his wife and flares into the most appalling tempers. The film represents a cycle of impulsive and aggressive behaviour in which Jake shows an inability to care about anyone – even himself.

The film ends with Jake as a sad and broken club owner, rehearsing the lines of his pathetic act. His face is distraught, he is overweight and still appears to lack any understanding of himself, his situation, or how to cope with his life. Scorsese ends the film with a quote from the gospel of Saint John: 'The Man replied, "Whether or not he is a sinner, I do not know, all I know is this: once I was blind and now I can see"'. (John 9). The irony is that Jake still has no sight, either into the outer world, or into the inner world of his unconscious. [13]

The introvert represents the antithesis of this extraverted position, and is characterised by a withdrawal into the psyche, together with an inward flow of psychic energy. Typically, the introvert lacks confidence in people and objects, and also has difficulty with relationships, preferring instead to withdraw inwards – with the possible result of appearing antisocial. In contrast to the activity and dominance of the extravert, the introvert is quiet and passive, preferring reflection to activity. It is when either introversion or extraversion become habitual that Jung feels it is justifiable to characterise the person as either an introvert or an extravert type. It is worth pointing out that everyone has the capacity to be introverted and extraverted, although Jung suggests that one will be the more normal or natural way of behaving; just as most people can write with either their left or right hand, they prefer one over the other; the same is true of extraversion and introversion. Further complicating the picture, work on typology notes that at different periods in life the degree of introversion and extraversion can change and that our environment can also pull us away from our underlying preferences. [14]

The film *Equus* (Sidney Lumet: 1976) depicts an individual who has become introverted to such an extent that he has lost his grip on external reality and has been overwhelmed by his unconscious fantasies. The central character of the film, Alan Strang (Peter Firth), believes a god spirit named Equus lives

inside all horses (Equus is the Latin for horse). Alan creates a complicated ritual of nocturnal horse riding in which a wooden stick, called the 'man bit', is placed between the naked rider's teeth. Alan also talks to Equus, using a quasi Christian phraseology, for example, 'gentle Equus meek and mild' and 'Two shall be one' (meaning horse and rider). In his fantasy world, Alan not only sees himself as a horse (at one point he makes a rope bridle which he wears as he beats himself) but also identifies the horse with Christ. One of the key moments in the film occurs when Alan enacts a corrupted version of the Christian Eucharist, using sugar cubes which both he and the horse eat.

Alan's psychic energy is funnelled towards the development of his own inner fantasy world; consequently he is psychologically unable to cope with the real world. When he attempts to have sex with Jill Mason (Jenny Agutter) in the horse stables, a place he refers to as the 'Temple of Equus', he finds himself impotent. His devotion has emasculated him; it is only with Equus that Alan desires intimacy. Unable to cope with the mixture of reality and fantasy, he calls on Equus as the 'all seeing God' to blind and kill him. Still naked, and in a blood frenzy, Alan hacks out the eyes of six horses.

Clearly few people in the real world behave either like Jake La Motta or Alan Strang. The examples are certainly not meant to suggest that all strong personality types have a tenuous grip on reality. Rather, they show two very different ways of attempting to cope with the harsh realities of life. Neither is successful because, in both cases, the root cause of the situation remains unconscious. Neither of the characters manages to come to terms with, or understand, why they have been forced into their compulsive patterns of behaviour. What the terms introvert and extravert do provide is a framework within which to describe and analyse the behaviour of on-screen characters.

The Relationship of Introvert and Extravert

Suggesting that different cultures value extraverts and introverts differently, Frieda Fordham has noted:

> In the West we prefer the extraverted attitude, describing it in such favourable terms as outgoing, well-adjusted…in the East, at least until recent times, the introverted attitude has been the prevailing one. On this basis one may explain the material and technical development of the Western Hemisphere as contrasted with the material poverty but greater spiritual development of the East.[15]

One of Jung's major contributions to psychology has been to show that the introverted position is not pathological (that is, detrimental to psychological well-being) but is instead an integral part of everyone's psychological makeup.[16] But, as Fordham also notes, there is a tendency for introverts and extraverts to communicate badly with each other:

Unfortunately the two types misunderstand one another and tend to see only the other's weakness, so that to the extravert the introvert is

egotistical and dull, while the introvert thinks the extravert superficial and insincere.[17]

In personal relationships the situation is further complicated, because it is not unusual for opposite types to be attracted to each other, as unconsciously they seek to psychologically balance themselves. This calls to mind one of Jung's observations about the psyche: namely, that there is a curiously contradictory sense in which opposition(s) are needed because they bring with them balance and stability.

Jung developed this typological system by additionally identifying four attitudes: sensation; thinking; feeling and intuition. He thought that as well as being predominately extraverted or introverted, individual personalities relate and make sense of the world using these four functions. This approach has been subsequently developed in the work of Myers and Briggs, who have located thinking and feeling on a continuum with the one flowing into the other. Similarly, they have paired sensation with intuition and extraversion with introversion.[18]

As with many of the terms in analytical psychology, what are now everyday words have a specialist, distinctive meaning. For example, Jung notes that, 'Thinking in its simplest form tells you *what* a thing is. It gives a name to the thing. It adds a concept because thinking is perception and judgement.'[19] Thus thinking is not a neutral activity, and the preference of 'thinking-types' is to understand the world in terms of what *appears* logical or rational. They have a matter of fact approach to solving problems and, while valuing emotions, can find that they hurt other people's feelings without even being aware of their apparent lack of sensitivity. One of the best known 'thinking-type' characters is Chief Science Officer Spock (Leonard Nimoy) in the television and film series *Star Trek*. His catch phrase, 'that is illogical', parodies his Vulcan over-reliance on rationality. But Spock is half-human and needless to say these human origins give him endless problems – otherwise known as feelings. In the first of the *Star Trek* films (*Star Trek: The Motion Picture*, Robert Wise: 1979) Spock participates in a Vulcan ceremony the purpose of which is to initiate him into the realm of total logic, and to finally shed the human world of emotions.

High Priestess: Our ancestors cast out their animal passions here on these sands. Our race was saved by the attainment of Kolinahr.

Acolyte: Kolinahr: through which all emotion is finally shed.

High Priestess: You have laboured long Spock...Now receive from us this symbol of total logic.

Of course Spock is frustrated in his aspirations to enter the realm of total logic, as his Vulcan ancestry is polluted with human feelings and emotions. The film seems to suggest a very Jungian message; namely, that while thinking is a vital human function it must always be balanced with feeling. Later in the film Spock achieves this realisation for himself. His moment of insight occurs when he

comes into contact with a 'living' machine called Vger. He comments, 'Yet with all its pure logic Vger is barren, cold, no mystery, no beauty; I should have known this simple feeling is beyond its comprehension.'

If thinking is to do with the rational world, then you might be forgiven for thinking that feeling deals with the irrational. But Jung was insistent that this is not the case, and that feeling is as rational as thinking. Moreover feeling, just like thinking, is a way of evaluating an experience or object's worth or value.[20]

> Feeling informs you through its feeling-tones of the *value* of things. Feeling tells you for instance whether a thing is acceptable or agreeable or not. It tells you what a thing is worth to you...Now the "dreadful" thing about feeling is that it is, like thinking a rational function.[21]

The pairing of sensing with intuition, accommodates part of the non-rational dimension in the personality. Typically, sensing types are characterised by a strong interest in the outside world, by smells, touch and taste. They also tend to be rather orderly in the way that they organise their lives, valuing regular patterns of behaviour and routines.

> By sensation I understand what the French psychologists call *la fonction du réel*, which is the sum-total of my awareness of external facts given to me through the function of my senses... Sensation tells me that something *is*: it does not tell me *what* it is and it does not tell me other things about that something; it only tells me that something is.[22]

The 1933 version of the film *King Kong* (Merien C. Cooper and Ernst B. Shoodsack: 1933) gives us, in the character of the giant ape Kong, a caricature of one aspect of the sensing type, with an overriding focus on the outer world of sensation. In the film, Kong is taken to New York where he searches for Anne, his bride-to-be. At one point, Kong reaches inside a bedroom and finds a woman, but as soon as he recognises that it is not Anne he lets her fall to her death. Eventually, Kong finds Anne and climbs with her to the top of the Empire State Building. Here – attacked by airplanes and with death imminent – in a moment of sensual awareness, Kong puts down Anne before falling to his death. Standing beside Kong's corpse, Denham remarks, 'It was not the aircraft which killed Kong, it was beauty that killed the beast'. Perhaps, in Jung's terms, it was sensation that overwhelmed the beast, or rather it was the final understanding that he could not get beyond sensation.

The last of the attitudes, intuition, is altogether more difficult to describe as it is concerned with an area of the psyche that is largely unknown. As Jung's critics have been quick to point out, at this point his theory seems to get somewhat 'mystical' – although if we are dealing with the unknown, perhaps this is not surprising. It would appear that when Jung talks of intuition,[23] he is claiming that it is a form of perception, although it is perception not via the senses but through the unconscious.

> That is what is called *intuition*, a sort of divination, a sort of miraculous faculty...you 'get an idea', you 'have a certain feeling', as we say,

because ordinary language is not yet developed enough for one to have suitably defined terms. The word intuition becomes more and more a part of the English language, and you are very fortunate because in other languages that word does not exist.[24]

Put another way, intuitive types use subtle facts and observations about the world, and the people in it, to arrive at conclusions. They are interested in patterns, and because of this they can find order in seemingly chaotic structures. To give a simple example, a sensing type might arrange their books by author or subject, while an intuitive type has piles of books all over the house but still seems to know where everything is. The central character in *2010* (Peter Hyams: 1984), Dr Heywood Floyd (Roy Scheider), is an intuitive type. Floyd is on a mission to rescue the abandoned space ship Discovery, and to activate the shutdown of the HAL 9000 computer. His speech is full of references to things that his intuition 'feels' or 'thinks' are true. He remarks, 'I tell you, there's some kind of life...I also think it knows we're here' and, 'We have so much to ask. I've a feeling that the answers are bigger than the questions'. In both these examples, which are typical of his speech, Floyd has no rational evidence for his assertions, he just 'knows'. This leads one of his crew, Tanya Kirbuk, to remark, 'Dr Floyd, you're not a very practical man'.

As if to prove just how unpractical (for which read non-rational) he is, Floyd has a vision in which one of the dead members of the Discovery, David Bowman, appears to him. Bowman asks for the spaceship to leave the orbit of the planet Jupiter within two days because, 'something is going to happen, something very wonderful...Please believe me'. Understandably Floyd is somewhat shaken by this communication, but chooses to take it at face value. In so doing, he adopts a Jungian approach to his dreams; rather than seeing the dream in a Freudian manner, as a disguised fantasy, he takes the dream literally. The narrative of the film validates this response, for on the second day Jupiter explodes, forming a new sun – and on a nearby planet a whole new process of life begins.

Approaching the Unconscious

So far this chapter has been mainly concerned with the theory that surrounds typology and personality type. Jung fashioned these ideas into a useable system while working at the Berghölzli hospital. Here he was able to study the fantasy material produced by patients suffering from various forms of schizophrenia, and during this period he also studied his own dreams and attempted an in-depth analysis of his personality. From these observations he formulated a more complex theoretical framework and devised a series of terms for speaking about the psyche. (By 'psyche' Jung means the totality of the self, in other words all that makes us human, whether this is conscious or unconscious.)

This distinction between what is conscious and what is unconscious is basic and fundamental to his ideas, and to analytical psychology:

> Whatever we have to say about the unconscious is what the conscious mind says about it. Always the unconscious psyche, which is entirely of an unknown nature, is expressed by consciousness and in terms of consciousness, and that is the only thing we can do.[25]

Significantly, Jung claims that the only clues we have about the unconscious come from the conscious expression of unconscious contents. Thus, the unconscious is the primary experience; it subsequently finds expression in the secondary experience of consciousness. This is in direct contrast to the behaviourist position, which finds its intellectual roots in seventeenth and eighteenth century French and English psychology. At that time, the move was to form concepts about consciousness that were based solely on information gathered by the senses. This idea finds expression in the dictum, '*Nihil est in intellectu quod non antea fuerit in sensu*'.[26] In many ways, Freud adopted this position. For example, he assumed that dreams were not a matter of chance but rather associated with conscious thoughts and problems. By contrast, Jung asserts the primacy of the unconscious. However, consciousness remains significant as it is only through the conscious understanding of images in dreams, myths and symbols that anything of the elusive character of the unconscious can be discerned. This is why analytical psychology is well suited to film analysis: it is, above all else, a psychology of images.

Jung departs even further from this approach in suggesting that from birth we have a set of conditioning psychological structures that are located in the unconscious mind, but which find expression through consciousness.

> Thus man is born with a complicated psychic disposition that is anything but a *tabula rasa*. Even the boldest fantasies have their limits determined by our psychic inheritance, and through the veil of even the wildest fantasy we can still glimpse the dominants that were inherent in the human mind from the very beginning.[27]

However, as we try to understand the exact structure of the unconscious, matters become increasingly difficult; for the deeper one delves into the unconscious, the harder it becomes to understand. Jung charted a series of functions that map the route down into this concealed core of the psyche. The first, and outermost, of the four functions is 'memory'. For Jung, this memory connected with things that may at one time have been conscious, but have now faded away: with material that once belonged to personal consciousness, but has now been 'forgotten'. Thus this type of memory is principally a collection of repressed – hence unconscious – personal events:

> What we call memory is this faculty to reproduce unconscious contents, and it is the first function we can clearly distinguish in its relationship between our consciousness and the contents that are actually not in view.[28]

The second function is more difficult to describe and is termed 'The subjective components of conscious functioning':

Every application of a conscious function, whatever the object might be, is always accompanied by subjective reactions which are more or less inadmissible or unjust or inaccurate. You are painfully aware that these things happen to you, but nobody likes to admit that he is subject to such phenomena.'[29]

These subjective components may be disregarded or pushed, into the dark, shadow-side of the psyche. Such repression represents a type of coping mechanism for the 'undesirable thoughts' and dark aspects of the psyche. The shadow is the negative side of the personality, described by Jung as, 'The sum of all the unpleasant qualities one wants to hide, the inferior, worthless and primitive side of man's nature, the "other person" in one, one's own dark side'.[30] The shadow side is difficult to accept and so much an "other person" that when we deny it is part of ourselves, it may appear as a character all of its own; in this situation, the shadow has been projected onto someone, or something, else — a type of projection which can be clearly observed in mythological material. For example, the hero's fight against an evil monster, or the detective's combat with a criminal may both be regarded as narratives depicting the projected personifications of the hero's unconscious shadow.

The film *Tightrope* (Richard Tuggle: 1984) gives a particularly clear example of this process (it will be examined in greater detail in the following chapter). Police detective Wes Bloch (Clint Eastwood) is engaged in an attempt to catch a killer who has been murdering prostitutes. Each time the murderer strikes, he handcuffs his victims, ties them with red ribbon, and finally rapes and then kills them. In an effort to conceal his identity, he wears a black mask (incidentally the first time the viewer sees the killer, his face is concealed in shadow). Throughout the film, there is the strong suggestion that the detective and the criminal have similar personality traits. While such tendencies are clearly an unacceptable part of the persona of a policeman, they nevertheless help Bloch to understand the motivation behind the murders. This is made explicit when one of the characters in the film remarks to Bloch of the killer, 'He said you were just like him'. On another occasion, Wes goes to visit a criminal psychiatrist who comments, 'Once you started going after him, you became closer to him than anyone else'. She adds, 'There's darkness inside all of us Wes; you, me and the man down the street. Some have it under control, some act it out, the rest of us try to walk a tightrope between the two'. Until the end of the film, when he is able to capture and destroy the criminal (and in so doing metaphorically acknowledge his shadow), Bloch's shadow is outside his control. Even then, the shadow threatens to overwhelm him when, in the final sequence, Wes pushes the murderer under the train, thus severing the killer's arm as it grips Bloch by the throat.

The third function, concerns the 'affects' and 'emotions', and here the psyche is really losing control over conscious action. Everyone knows how easy it is to 'deliberately forget' events, and this represents a moment when the unconscious asserts itself and there is a temporary loss of control over its

functions. This leads Jung to claim that it is no longer reasonable to think about conscious functions: rather we should look at behaviour in terms of events.

> The primitive does not say he got angry beyond measure: he says a spirit got into him and changed him completely. Something like that happens with emotions; you are simply possessed, you are no longer yourself, and your control is decreased practically to zero. That is a condition in which the inner side of a man takes hold of him, he cannot prevent it.[31]

Good examples of this state are when an individual is obsessed with an idea or cause, when someone is unaccountably moody, or perhaps when someone first falls in love. In all these cases, the emotions well up and, like a rising river, spill over the banks of the unconscious and into consciousness; and the psyche is swept along, caught in this sudden flood of emotions and affects.

The power of the unconscious is shown in Bloch who, on first encounter, seems to be a good, clean, upstanding family man. However, as the film progresses we discover that after his wife left him he became a 'vice cop' and that professionally and personally he become involved with the sexual underworld of prostitution and perverted sex. As the film progresses, Bloch's shadow gradually takes control of his consciousness, and he becomes increasingly intertwined with the murder investigation. Each prostitute he has sex with is subsequently murdered. *Tightrope* depicts his growing loss of self-control and, as the film unfolds, his shadow assumes a dominance which causes his sexual exploits to become both more aggressive and perverted. This point is illustrated by the following conversation which takes place between Wes and his girlfriend.

Beryl:	Do you investigate many sexual crimes?
Bloch:	Why?
Beryl:	Just wondered if they'd affected you.
Bloch:	They did want me to treat my wife a little more tenderly.
Beryl:	How did she respond?
Bloch:	She said she wasn't interested in tenderness…

The film's constant reference to perverted sexual practices indicates the move Wes has made away from the world of compassion to one of bondage and prostitution. It is only after he has realised how he has been affected by this realm, that he is able to 'cast out' the spirit that has possessed him, and embrace his shadow.

The final function is termed by Jung 'invasion'. Here consciousness is not just partly out of control, but is totally powerless because it has been invaded with the full strength of the unconscious psyche, as in the case of Alan in *Equus*. This condition, which is characterised by extreme emotions and loss of control, is

not necessarily pathological – that is, detrimental to psychological well being; it is just a forceful assertion of the unconscious, as Jung comments:

> These phenomena are not in themselves pathological; they belong to the ordinary phenomenology of man, but if they become habitual we rightly speak of a neurosis. These are the things that lead to neurosis; but they are also exceptional conditions among normal people.[32]

Conclusion

This brief introduction to Jungian personality theory has attempted to show that if the motivation of a character is to be understood, then some awareness of his/her psychological character is, at the very least, helpful. To place characters within their psychological context requires some knowledge of personality theory. As subsequent chapters will demonstrate, terms such as sensation, intuition and shadow will prove central concepts in discussing the characters found in films, and in placing them in their psychological contexts.

This chapter has sought to examine Jung's psychology of consciousness and to see this in relation to his typological theory. In summary, the Jungian model of the psyche has the following elements:

- Personality – The most conscious levels of the psyche.

- Sensation – information that world objects exist, that things are.

- Thinking – naming and organising the sense data.

- Feeling – as rational as thinking, an evaluation of an event's worth to us.

- Intuition – perception, not via the conscious, but the unconscious.

- Approaching the Unconscious – The deeper and more unconscious levels of the psyche:

- Memory – the recall of repressed 'forgotten' personal events.

- Subjective components – the shadow, the negative aspects of an individual's personality, often personified as a separate individual.

- Emotions and affects – partial loss of the conscious self as the unconscious takes over or possesses the psyche.

- Invasion – total loss of control over the psyche as it is overwhelmed by the unconscious. This state is often highly emotional although it is not necessarily pathological.

Notes

1 In modern terminology both can be categorised as Depth Psychologies and both are also Psychodynamic theories.

2 Jung, C. G., Collected Works of C. G. Jung vol 6 *Psychological Types*, (New York, 1921).

3 c.f. Noll, R., *The Aryan Christ: The Secret Life of Carl Gustav Jung*, (London, 1997).

4 Skinner, B. F., *Reflections on Behaviourism and Society*, (New Jersey, 1978): p50-51.
5 Behaviourists have been anxious to defend themselves on this charge and for an example of this c.f. Skinner, B. F., *About Behaviourism*, (New York, 1974).
6 *Fontana Dictionary of Modern Thought*, (London, 1983): p57.
7 Jung, C. G., Collected Works of C. G. Jung vol 2 *Experimental Researches*, (New York, 1973). *The Reaction-time Ratio in the Association Experiment*, first published in German in 1906.
8 *Fontana Dictionary of Modern Thought*: p507.
9 O'Neil: p11.
10 O'Neil: p12.
11 Jung, C. G., Collected Works of C. G. Jung vol 6 *Psychological Types*, (New York, 1921).
12 Jung, C. G., *Modern Man in Search of a Soul*, (London, 1933). This edition (London, 1985): p98.
13 It is interesting and poignant to note that the real Jake la Motta served as an advisor to Scorsese.
14 c.f Myers, I., and Myers, P., *Gifts Differing: Understanding Personality Type*, (Palo Alto, 1980).
15 Fordham, F., *An Introduction to Jung's Psychology*, (London, 1953): p30.
16 For much of his work on this area Jung drew on Eastern sources. c.f. C. W. 11 *passim*.
17 Fordham: p33.
18 They also identify a fourth pairing, namely judging to perception. If each person embodies one element from each of the four pairs, then this gives a possible 16 basic personality types.
19 C. W. 18:22.
20 c.f. C. W. 6: def 44.
21 C. W. 18:23.
22 C. W. 18:21.
23 c.f. C. W. 6: def 35.
24 C. W. 18:24.
25 C. W. 18: 8.
26 Leibniz, C., *Nouveaux Essais sur l'Entendement Humain*, Bk. 11, Ch. 1, Sec. 2 (trans., 'There is nothing in the mind that was not in the sense'.).
27 C. W. 8: 719.
28 C. W. 18:39.
29 C. W. 18:40.
30 Samuels, A., Shorter, B., Plan, A., *A Critical Dictionary of Jungian Analysis*, (London, 1986): p138.
31 C. W. 18:42.
32 C. W. 18:43.

2

The Objective Psyche and Archetypal Patterns

Joe (James Kodl): *What you don't know won't hurt you.*
Detective Stevens (Lawrence Tierney): *That's what you think.*

The Female Jungle (Bruno VeSota: 1944)

So far we have not considered what is the most important element in analytical psychology: namely, the postulated existence of the 'collective unconscious'. (Jung later withdrew this term and renamed it the 'objective psyche',[1] and it is this revised term that we will retain). At the centre of the psyche, Jung thought there was a central, unconscious collective core. He suggests that this unconscious core is the repository for the psychological experience of mankind, and that it also contains the plan or pattern for psychological development. To borrow a metaphor from biology, the objective psyche is not unlike psychological DNA in that it contains both the collective genetic material for the human species and the imprint for our own individual characteristics. In so doing, Jung suggested the existence of a personal unconscious that is made up of individual material that was once conscious but has subsequently been repressed. Broadly, this equates with the Freudian notion of the unconscious, although in Jung's view it is not composed solely of repressed sexual material. While in theory the personal and the collective are separate, in practice they interrelate and interact, as the personal unconscious rests upon the wider objective psyche.

Jung's hypothesis of the objective psyche was the result of research and experience in a variety of areas. He observed his own dreams and those of his patients at the Berghölzli hospital; he analysed fantasies and delusions, and he became interested in comparative religion and mythology. Out of this welter of material, Jung eventually noticed that in all these areas there seemed to be certain recurring myth themes or patterns. To a certain extent, there is a relationship between Jung's interest in mythological material and anthropology, as both treat myths as expressions of structures and desires within a given culture; the one identifies social, economic and political structures, the other psychological. As a sociologist, with an anthropological inflection, Jarvie has

recognised in films the expression of these latent needs. He notes, 'Apart from anthropological field work, I know of nothing comparable from the point of view of getting inside the skin of another society as viewing films made for the home market'.[2] The assumption behind his observation is that films possess something of the nature of myths in that they reflect, or at least embody, concealed hidden societal structures. Allied to this is the view that films are not individual 'authored' products but are better thought of as cultural expressions of 'fundamental motifs'. It is self-evident that the broad themes of Hollywood's narratives – love, death, alienation, fear, hope, and so on – are not just individual concerns. As Monaco has commented, 'The "auteur theory" as applied to cinema is thus not only historically inaccurate but also fundamentally misleading. Movies are not "authored" but are rather reflections of shared thoughts and structures'.[3]

When analysing recurring myth themes, Jung made a distinction between form and image. For example, the form 'hero' is a pattern, but its content, that is its image, will vary from culture to culture and age to age. At one moment it may be a medieval knight, the next a detective, and then a warrior. While the pattern 'hero' remains constant, its associated image is renewed. It is important to realise that in analytical psychology the objective psyche is composed of patterns and not images, and therefore it is the pattern that is inherited and passed from generation to generation. Contrary to the commonly held misconception, the objective psyche is not a giant psychological warehouse of images:

> The autonomous contents of the unconscious, or, as I have called them, dominants, are not inherited ideas but inherited possibilities, not to say compelling necessities, for reproducing the images and ideas by which these dominants have always been expressed. It matters little if the mythological hero conquers now a dragon, now a fish or some other monster; the fundamental motif remains the same, and that is the common property of mankind, not the ephemeral formulations of different regions and epochs.[4]

For Jung, myths, symbols and religious experiences (experiences that are spiritual, magical, transcendent, awe-inspiring) are all connected to the objective psyche, for it is through these images and experiences that the objective psyche makes itself conscious. In other words, when looked at psychologically some images can be seen to give expression to collective themes and cultural concerns. For Jung, these themes are also part of the objective psyche. Put another way, rather than regard the objective psyche as an expression of collective cultural concerns, he inverted this and thought that these concerns were invested with shared psychological material. Thus myths, and for our purposes at least some films, can be a manifestation of the objective psyche.

The objective psyche itself is composed of archetypes. This gives us another example of a term that was once used in a technical, psychological manner that has now acquired another meaning. In current usage, more often than not, the

words 'archetype' and 'stereotype' are treated as interchangeable, but in analytical psychology the term 'archetype' refers to the structuring potentials that are latent within the unconscious objective psyche. These patterns govern the psychological life of an individual, regulating the development and balance of the psyche to ensure that it remains healthy and adjusted to life in the world. By contrast, 'stereotype' implies a conformity or caricature of an original 'type'.

The role of the archetype is to regulate the life-long process of psychological growth that analytical psychology terms the individuation processes. Much as the body at puberty automatically starts hormonal changes, so too the psychic system may at certain times produce archetypal guidance. The archetype therefore links together body and psyche and as such is a psychosomatic concept.[5] This idea is touched on by Basil Wright in his book on the history of cinema, *The Long View*, where he comments on the psychosomatic and dreamlike nature of films and in so doing regards films as expressions of the objective psyche. For Wright, films indicate a link between body or 'outer world' and psyche or 'inner world', and he comments that films seems to be one way in which the objective psyche expresses its archetypal guiding images:

> I wish Jung had paid more attention to cinema, especially in terms of those filmic illogicalities which are often ... only acceptable in terms of (a) dream ... but can, perhaps, be accepted as signals reaching us from inner rather than outer space.[6]

Archetypes are recognisable in our outward and everyday behaviour, especially when connected with what Jung calls 'universal events' such as birth or marriage. It is at these moments that the archetypes of the objective psyche are at their most active, and may therefore be most clearly observed. Typically, they assume such figures as the hero or shadow, but Jung is always at pains to indicate that these images, the visualisations of one archetypal pattern or another, do not reveal the whole nature of an archetype. They merely represent one of the pattern's many facets; the essential nature of an archetype remains ultimately unknowable:

> We must, however, constantly bear in mind that what we mean by 'archetype' is in itself irrepresentable, but has effects which make visualisations of it possible, namely, the archetypal images and ideas. We meet with a similar situation in physics: there the smallest particles are themselves irrepresentable but have effects from the nature of which we can build up a model. The archetypal image, motif or mythologem, is a construction of this kind.[7]

These archetypal patterns wait to be released in the psyche. One of the ways they can be released is as a result of creative activities such as storytelling, dreaming, painting and film-making. It is also a consequence of this argument that while archetypal analysis may tell us something about films, film will tell us little about archetypes. Nonetheless, much as individual's own life experience causes a variation in the contents of archetypal expression, so too

cultural changes cause filmic contents, as archetypal expressions, to vary. Thus analysis of these filmic contents may reveal their underlying psychological nature. As Monaco has observed:

> Latent collective meanings of films reveal themselves through analysis of surface film contents ... In some instances, however, the repetition or stylization of certain such devices and techniques in the popular films of a nation may reveal important psychological tendencies.[8]

Archetypal Theory

The claim made by analytical psychology is that archetypal patterns reside in everyone's psyche. It is this assertion that has given rise to much of the confusion over what is popularly referred to as the 'collective unconscious'. This is mistakenly often taken to mean that somehow mankind has some sort of mystical shared psychological experience. In fact Jung only argues that archetypes, as structuring potentials, reside unconsciously within us, lying dormant, waiting until they are needed.

> Archetypes are like river-beds which dry up when the water deserts them, but which it can find again at any time. An archetype is like an old water-course along which the water of life has flowed for centuries, digging a deep channel for itself. The longer it has flowed in this channel the more likely it is that sooner or later the water will return to its old bed.[9]

As already hinted at in the previous chapter, for Jung the unconscious is composed almost entirely of oppositions, eg conscious/unconscious, thinking/intuition, light/dark, individual/collective, and the index of the *Collected Works* contains a special index of such oppositions.[10] To give archetypal expression to something is to interact with both collective and historical images in such a way that the oppositions contained within the unconscious find expression. It is not the function of the archetypes to directly unite these opposites but rather to acknowledge that opposition does exist, and in so doing to bring them to a fresh state of creative tension with the rest of the psyche. Thus opposites are united but not integrated, as in the Buddhist symbol of Yin and Yang that symbolises the male and female principles – while they form one image, the principal oppositions remain separate.

As all psychic imagery is to some extent archetypal, so dreams, films, myths and other psychic events may exhibit a certain numinosity. This is the 'power' that is felt as the objective psyche expresses itself through the archetype and its associated imagery. More literally, numinosity is a spiritual or transcendent experience. Jung postulated that somehow it is possible to get a 'religious' experience by being in contact with the unconscious, or as Jung would more cautiously postulate, the experience would be one of the image of God, the *imago dei:*

> It would be a regrettable mistake if anybody should take my
> observations as a kind of proof of the existence of God. They only
> prove the existence of an archetypal God image, which to my mind is
> the most we can assert about God psychologically.[11]

This may seem a long way from film theory but some theorists have touched on
the quasi-religious dimensions of the cinema. In his book, *The Magic and Myth
of the Movies*, Parker Tyler observes that it is vital:

> ...to conceive the supernatural fables of Hollywood as *bona fide* creative
> offerings, destined to be accepted as true or untrue representations of
> the orders of reality – part of such orders being of course the spiritual
> orders.[12]

Parker Tyler proceeds to argue that for any manifestation of spirit to be
accepted in a film, there must also be a common audience presupposition
concerning the validity of such spiritual events. Which is to say that there is an
unconscious psychological need for spiritual or numinous experiences that, to
some extent, films both express and gratify: 'In other words, some basic and
common spirituality must exist to support belief in any manifestation of spirit,
no matter how outrageous or symbolic in form'.[13]

However, for Jung the psyche and its constituent parts, including the objective
psyche, are not just symbolic but are real, and they form part of a categorised
and analysable system whose effects can be repeatedly seen. Therefore, on the
subject of God, he is able to write:

> The idea of God is an absolutely necessary psychological function of an
> irrational nature, which has nothing whatever to do with the question
> of God's existence. The human intellect can never answer this
> question, still less give any proof of God. Moreover such proof is
> superfluous, for the idea of an all-powerful divine Being is present
> everywhere, unconsciously if not consciously, because it is an
> archetype.[14]

So the question as to whether God exists or not is for Jung irrelevant. For him,
it is sufficient to say that an archetypal experience of the *imago dei* exists and
characterises archetypal expression. As an important psychological event it
should not be surprising to find that expressions of the objective psyche are
characterised by a religious nature. In fact, it is possible to say that any analysis
of the archetypal which fails to take into account the numinous may be flawed,
and flawed in quite a fundamental way.[15]

However, Jung took this concept of the archetype even further. He felt that, in
the final analysis, archetypes serve as the models or patterns for *everything*
within the human realm. Thus all enduring ideas – be they creative, scientific,
political or mathematical – give expression to the deep structures of the
psyche, namely the archetypal forces and patterns. From this premise, it would
be expected to find the collective archetypal patterns of the unconscious clearly

stamped onto the conscious world. To restate once more: the unconscious expresses itself only through conscious images and forms:

> All the most powerful ideas in history go back to archetypes. This is particularly true of religious ideas, but the central concepts of science, philosophy, and ethics are no exception to this rule... For it is the function of consciousness not only to recognize and assimilate the external world through the gateway of the sense, but to translate into visible reality the world within us.[16]

The Contrasexual Archetype

This is an appropriate stage to introduce two of the most important archetypes in analytical psychology. These are the so-called contrasexual archetypes of the anima and animus, and potentially this is another of those areas that can easily be misunderstood. One of the Post-Jungian views on these archetypes is that they indicate the tension between biology and culture.[17] Jung defines the anima as the inner figure of woman in man and the animus as the inner figure of man in woman. In so doing, analytical psychology suggests that both sexes have the capacity for the full range of human experience but that culturally certain types of behaviour have been ascribed to men and women. The inevitable result of this is that the anima exists in a state of tension with conscious masculine sexuality, as does the animus for women. Both sexes are drawn towards their contrasexual archetype and at the same time worried by the attraction that appears to transgress culturally acceptable gender divisions. Potentially, Jungian psychology offers the opportunity for a theory of sexuality in which female and male qualities are valued equally. It is important to note that the anima or the animus tells us nothing about the psychology of the other sex – what it does shed light on is how men view women, and men's sense of the feminine, and vice-versa.

The images in which these archetypes clothe themselves are termed 'psychopompi'. They are figures who guide the psyche, or inner self, especially at times of initiation or personal crises, and at rites of passage.[18] Because of their archetypal qualities, the forms of anima and animus have found expression in many collective images. For example, the anima is released in quasi-mythological figures such as Aphrodite and Helen of Troy, while aspects of the animus can be recognised in Hercules and Romeo. However, these figures often assume a more symbolic form, and can have a dark side. They show that the contrasexual archetype is attractive and threatening in the way that it challenges our assumptions about gender. Consequently the anima has a dark and potentially destructive aspect, as typified by the image of the Gorgon and the Siren, while conversely the animus may appear as a murderer such as Bluebeard. It is precisely because the archetype adopts so many guises that it is difficult to understand and comprehend. When dealing with the collective expressions of the objective psyche it is only sensible to look for other expressions of these archetypes, in the hope that they will help us to

understand. This can be achieved by referring to a variety of myths with similar themes because, as Jung notes, the cores of all myths and religions are archetypal:

> In spite or perhaps because of its affinity with instinct, the archetype represents the authentic element of spirit, but a spirit which is not to be identified with the human intellect since it is the latter's *spiritus rector*. The essential content of all mythologies and all religions ... is archetypal.[19]

This position can be summarised as follows. Firstly, in the objective psyche are archetypes. These are the structuring potential for the psyche, and may evolve over a period of time; they are liberated at times of personal crisis and transition and operate in a compensatory fashion. Secondly, when the archetypal patterns are freed they assume the form of images and symbols; they are concerned with the uniting of opposites within the psyche. Thirdly, all conscious events are, in the final analysis, archetypal and thus are expressions of the collective.

The Symbolic Function

One area identified by Jung for special study was the symbolic – although he uses the term in completely different manner to modern day commentators such as Lacan. Jung was interested in the way in which symbols could be regarded as unconscious communications, and this stress on the value of symbols was one of the many factors that led to his break with Freud. As Jung states in the quotation below, he differed with Freud over both the definition of symbols and their function within the psyche:

> Those conscious contents which give us a clue to the unconscious background are incorrectly called symbols by Freud. They are not symbols, however, since according to his theory they have merely the role of signs or symptoms of the subliminal processes. The true symbol differs essentially from this, and should be understood as an intuitive idea that cannot yet be formulated in any better way.[20]

Thus the symbol comes from the unconscious and is a means of expressing a concept or truth that has been grasped by the intuitive part of the psyche but that has yet to find conscious expression. Parker Tyler has noted that films, as a collective product, may express symbolic truths and that as such they illustrate insights which cultures may have comprehended intuitively and which find a concrete expression in films. 'Many modern movies illustrate the latter-day vestiges of very remote but serious beliefs of mankind that now have the appearance of mere symbolic fantasy.'[21] Jung also regarded symbols and symbolic products as part of the objective psyche's self-balancing system.

It may be that films, as collective psychological expressions of symbols, have a role in this regulating process. Archetypes balance the psyche by making

consciousness aware of opposites, and part of this regulation process can involve the creation of symbols. These symbols are released in dreams, as part of a structured personal analysis, or via virtually any creative act, including film-making. They function in what Jung has termed a 'compensatory fashion'. The idea is that the psyche tries to maintain a state of homeostasis so that when its natural balance is upset, the unconscious compensates, much as the immune system compensates when the body is under attack. As he comments:

> From the activity of the unconscious there now emerges a new content, constellated by thesis and antithesis in equal measure and standing in a compensatory relation to both. It thus forms the middle ground on which opposites can be united.[22]

Jung regarded the whole process of symbolic compensatory regulation as so vital that he remained concerned for individuals, or cultures, that are no longer in contact with the symbolic dimensions of their lives. To ignore symbols is to ignore the collective aspects of the unconscious, and to ignore the unconscious is, according to Jung, to live in isolation.

> Anyone who has lost the historical symbols and cannot be satisfied with substitutes is certainly in a very difficult position today: before him there yawns the void, and he turns away from it in horror. What is worse, the vacuum gets filled with absurd political and social ideas, which one and all are distinguished by their spiritual bleakness.[23]

The content of a symbol — that is, what it means — is often far from clear, and it is precisely because it is a communication from the unconscious that its meaning remains shrouded in mystery. At the same time, symbols possess a universal imagery and thus address themselves to the needs of specific individuals or cultures, but in a mythological and psychological language. If sufficiently analysed and reflected upon, symbols can be seen as aspects of images that control and which give order to human life, and their source can be traced to the archetypes, from which symbols derive their meaning.

Again, it may seem that we have drifted a long way from films, but in fact this theory is beginning to provide a framework for an analysis of how symbols function in films. Further, it may be that in one sense movies are themselves of symbolic value. Monaco has suggested that films are, in effect, a symbolic communication from the unconscious and as such their collective appeal is due to a shared psychological and symbolic base. He claims that in films it is possible to recognise the expression of shared cultural and psychological needs. To translate this into the language of analytical psychology, he is suggesting that films represent a compensatory communication from the objective psyche that functions as part of an unconscious, psychological regulatory process.

> Film communicates by the elaboration of precise, symbolic visual material that creates both a mood and a story. The result is a medium whose primary appeal is psychological. And the psychology of the most popular movies must be collective...

> The symbolism of popular movies must be such as to create the basis of a shared, collective psychological appeal to at least a portion of the mass audience.[24]

While Monaco may be right to claim that the 'psychology of the most popular movies must be collective', the situation is more complicated than this statement implies. For example, the function of symbols in film is not to create 'both a mood and a story'; rather they transcend the limitations and oppositions of the narrative, thereby helping to imbue the story with a mythological dimension. Also, the symbol is emphatically not a precise formulation but instead it is associated with the archetypes, and possesses an imprecise, numinous quality the ambiguity of which is essential to both its psychological and narrative function. Once robbed of this mystery (ie once it has been understood) the symbol has lost its symbolic power. The suggestion is that the symbols operate in an intuitive mode that is distinct from rational analysis.

> A symbol loses its magical or, if you prefer, its redeeming power as soon as its liability to dissolve is recognized. To be effective, a symbol must be by its very nature unassailable. It must be the best possible expression of the prevailing world view, an unsurpassed container of meaning; it must be sufficiently remote from comprehension to resist all attempts of the critical intellect to break it down; and finally, its aesthetic form must appeal so convincingly to our feelings that no arguments can be raised against it on that score.[25]

So, while the ultimate nature of a symbol must remain a mystery, there are generalisations that can be made concerning its role. For example, the symbol is an intervention of the objective psyche to solve a problem of consciousness. So it is possible to speak of unifying symbols – which bring together apparently disparate elements and become 'living symbols' – which are intimately connected with our conscious situation (when Jung writes about 'living symbols' he is of course being metaphorical). It is a consequence of this activity that symbols are not sterile, but very much alive and active parts of the psyche. As Jung comments, 'The symbol is thus a living body, *corpus et anima*; hence the "child" is such an apt formula for the symbol'.[26]

In attempting to discover the meaning of a symbol, it should be firmly placed in its archetypal context as a corrective or compensatory regulation from the objective psyche. Specific reference must also be made to the environment, that is the dream, myth or film narrative, in which the symbol occurs, and there should be an attempt to view the symbol as part of a unified symbolic structure that operates within that environment. It should be possible, with reference to historical, mythic and symbolic parallels, to create a model within which a given symbol and symbolic structure can at least be partly understood. However, it should always be remembered that the meaning of a symbol is liable to change and ultimately understanding of a symbol will remain incomplete. Despite this, with recourse to mythological processes, the relatively fixed meaning of many recurring archetypal symbols can be deduced.

The Function of Dreams

One of the distinctive elements of analytical psychology concerns the function and importance of dream imagery. Both Freud and Jung thought that dreams contained unconscious material. Freud suggested that this material came from conscious experiences that, as a child, we were unable to cope with, and from day residues. This largely sexual material is derived from the impossibility of the Oedipal situation and is used as a coping mechanism for the psyche which attempts to repress any memory of the event. However, this strategy is only partially successful, and subsequently the memories represent themselves in a disguised form in dreams and other fantasies of which the day residues may be a part. Jung adopts a different position and suggests that dreams may contain archetypal material that has never been conscious. While allowing for the Freudian view of dreams in which the dream images represent repressed sexual material, Jung did not think that this painted the full picture. Instead of dreams springing from repressed unconscious material, Jung suggests that they should be thought of as a helpful communication:

> As against Freud's view that the dream is essentially a wish-fulfilment, I hold... that the dream is a *spontaneous self-portrayal, in symbolic form, of the actual situation in the unconscious.*[27]

As his theory evolved, Jung came to see dreams as active elements in the psyche. Rather than just indicating the situation in the unconscious, analytical psychology suggests that the dream provides necessary corrective or compensatory images. In so doing, there is an attempt by the objective psyche to redress imbalances in the psyche: 'The dream rectifies the situation. It contributes the material that was lacking and thereby improves the patient's attitude. That is the reason we need dream-analysis in our therapy.'[28]

In terms of film theory, Basil Wright has suggested a parallel between this Jungian view of dreams and the cultural role of films. Wright's emphasis is on the way in which films can be an expression of latent or unconscious needs, and as such he endows films with a compensatory function.

> If, as he (Jung) suggests, dreams are capable of arousing in individuals 'not only the contents of personal conflicts but also manifestations of the collective unconscious', might not films, if only to a degree, have something of the same ability?[29]

While compensation maybe the principle way in which the objective psyche operates, Jung was also anxious to note that what is being compensated at any given time is not always obvious. Therefore, great patience is required if dream images are to be understood. This is further complicated as dreams not only indicate the present situation of the unconscious, but also show the way in which the psyche ought to develop; as such they have an anticipatory nature that presents itself in symbolic form. For example:

> The snake in the first mandala dream was anticipatory, as is often the case when a figure personifying a certain aspect of the unconscious does or experiences something that the subject himself will experience later. The snake anticipates a circular movement in which the subject is going to be involved; ie, something is taking place in the unconscious which is perceived as a circular movement... .[30]

While acknowledging this anticipatory quality in dreams, Jung also stresses that dreams do not provide clear prophetic statements, rather they indicate, in a very general way, a path for the development of the psyche. Dreams can be thought of as anticipatory in much the same way that an architects blueprint anticipates the final building.

While most dreams appear to have a constructive compensatory nature, there are certain types of dreams that are destructive in their compensatory effects and these accomplish their role in a most unpleasant, albeit necessary, fashion. Such dreams can assume the quality of what Jung terms 'Big Dreams', which come to represent either major changes in an individual's life, or the close of a stage in psychological development.

> The 'big' or 'meaningful' dreams come from this deeper level (the unconscious). They reveal their significance – quite apart from the subjective impression they make – by their plastic form, which often has a poetic force and beauty. Such dreams occur mostly during the critical phases of life... .[31]

Whatever the specific nature of dreams, their images are perhaps more aptly seen as the best possible expression of psychological facts or truths which are latent in the unconscious.

> Dreams contain images and thought associations which we do not create with conscious intent. They arise spontaneously without our assistance... Therefore the dream is, properly speaking, a highly objective, natural product of the psyche, from which we might expect indications, or at least hints, about certain basic trends in the psychic process.[32]

To a certain extent, here is another point of contact between film and Jungian theory. Just as dreams give an impression of reality, and contain many symbolic-mythic and coded compensatory signals, so too films may have something of this quality. As already noted, films contain symbols and myths and so, like dreams, they also operate as carriers of psychological information. In one sense, films present a picture of conscious 'reality', in another, they present a symbolic and mythic picture of an unconscious reality. As Wright comments:

> The magico-mythological element of the motion picture, as opposed to the scientific-technological aspect, involves a double aspect of reality. A film can give an impression of actuality – a reality which we accept as being in line with our daily experience of the world. But a film can also give

an impression of super-reality – the reality of one of those dreams whose circumstance we do not accept as part of our daily experience, but whose intensity seems to produce a conviction of reality superior to actuality itself. (Such indeed must, in part, be the experience of the visionary.)[33]

Jung admits that the interpretation of dreams is a difficult task. His suggestion is that the analyst should approach dreams without any preconceived ideas about what they might mean. From this basis, the patient should be encouraged to make free associations with the dream images in an attempt to discover their personal meaning. However, understanding the dream process is a multifaceted procedure, for the dream is not concerned with the intellect alone but with the totality of the psyche. As such, and as manifestations of the objective psyche, dreams have a collective, symbolic and archetypal quality that can only be understood with reference to the appropriate historical and mythological parallels, and this is especially true for the so-called big dreams.

> Such reflections are unavoidable if one wants to understand the meaning of 'big' dreams. They employ numerous mythological motifs that characterize the life of the hero, of that greater man who is semi-divine by nature. Here we find the dangerous adventures and ordeals such as occur in initiations. We meet dragons, helpful animals, and demons; also the Wise Old Man, the animal-man...they have to do with the realization of a part of the personality that has not yet come into existence but is still in the process of becoming.[34]

Perhaps the same method of mythological amplification could profitably be used in film analysis? If dreams and films are closely related, then the method used by analytical psychology of finding mythological parallels to help understand the meaning of symbols would seem a valid approach. Monaco, like Wright, suggests that myth and film resemble each other. Both commentators regard films almost as culturally shared dreams that transcend reality to super-reality, in an expression of unrecognised unconscious needs.

> Myth represents the reflection of a certain kind of thinking that creates a particular mode of being. This may be true of the cinema as well. It is not so much that the cinema creates a 'reality lived', but rather that it transcends reality (quasi-magically) while maintaining a close connection to the pictorial accuracy often associated with reality.[35]

Thus in attempting to understand archetypal forms and images, in either films or dreams, the analyst should refer to that great store house of the archetypal – the myth – and in so doing intuitively recognise the collective nature of these images. Finding expression in these dreams are not only an individual's present psychological needs and future development, but also broader collective emotions. As Jung notes:

> ...we have to go back to mythology, where the combination of snake or dragon with treasure and cave represents an ordeal in the life of the hero. Then it becomes clear that we are dealing with a collective

emotion, a typical situation full of affect, which is not primarily a personal experience but becomes one only secondarily. Primarily it is a universally human problem which, because it has been overlooked subjectively, forces itself objectively upon the dreamer's consciousness.[36]

To summarise the situation so far, symbols and dreams are communications from the objective psyche and are part of its regulating system. Jung notes that they are vital for a healthy psychic life, both individually and culturally, and that symbols can never be fully understood; to do so would destroy their 'magical' or redeeming qualities. Any attempt to comprehend a symbol or a dream must involve placing it in its archetypal and mythic context. Dreams and symbols function in a compensatory fashion. Dreams may have an additional anticipatory nature and deal with collective emotions that also have a personal relevance.

The Individuation Process

So far this overview of analytical psychology has taken account of the following: personality theory; symbols; dreams and archetypes. These have been shown to be parts of a cohesive psychological system. However, there is one important concept that has not been examined, and it is particularly significant because it can be thought of as the concept that unifies analytical psychology; it is termed by Jung the 'individuation process'. The *Critical Dictionary of Jungian Analysis* opens its definition of individuation by describing it as, 'A person's becoming himself, whole, indivisible and distinct from other people or collective psychology (though also in relation to these).'[37] This is a good basic definition, for the individuation process is about becoming a whole person who is aware of their own psychological make-up, and how they relate to other people and society in general.

The individuation process is controlled (governed or structured) by the archetypal core at the centre of the objective psyche. Jung claims that if mankind becomes consciously aware of the archetypes and listens to their messages, then the human psyche, and hence all human life, would be relatively free from problems. The problem is that this is not as straightforward as it might at first appear. As he notes:

> We must be able to let things happen in the psyche. For us, this is an art of which most people know nothing. Consciousness is forever interfering, helping, correcting and negating, never leaving the psychic processes to grow in peace. It would be simple enough, if only simplicity were not the most difficult of things.[38]

As Jung developed his psychological theories over the course of his life, he grew increasingly interested in the ways that consciousness expresses the unconscious, which is to say with the ways in which the unconscious makes itself known through myths, dreams, creativity, meditation, Eastern and Western religions, symbols, etcetera. He developed a therapeutic technique in

which the analysand was encouraged to draw, paint, or write poetry in an effort to represent and release the unconscious process of individuation. The aim was to side-step the defences of consciousness and to help release the natural mechanisms of repression.[39]

Even though the individuation process is an integral and normal part of human life, there is a possibility that individuation may be misinterpreted as an elitist process only for a few gifted, creative individuals. Indeed, Jung's study of Christ's individuation may have unwittingly contributed to this point of view.[40] In fact, individuation is available for everyone, although not all undertake to travel its path. As a natural process, individuation potentially *has* to be part of everyone's life, as it is the way in which the psyche realises its full human and collective potential. As Jung puts it:

> In so far as this process, as a rule, runs its course unconsciously as it has from time immemorial, and means no more than that the acorn becomes an oak, the calf a cow, and the child an adult. But if the individuation process is made conscious, consciousness must confront the unconscious and a balance between opposites must be found. As this is not possible through logic, one is dependent on symbols which make the irrational union of opposites possible. They are produced spontaneously by the unconscious and are amplified by the conscious mind.[41]

The mediation of these oppositions is termed by Jung 'the transcendent function' and this finds expression in symbolic images. As this process develops, the psyche liberates symbols of wholeness and of completion and balance. These images can manifest themselves in dreams, or in paintings or in any media that seems appropriate to the individual who is experiencing the pull towards individuation. Jung termed these images mandalas. Such images often assume the form of a circle squared, or surrounded by a square, the circle being subdivided into regular divisions of four.

There is the possibility that individuation could be mistakenly thought of as no more than acceptance of one's own personal qualities, in other words what it is that makes 'me' an individual. However, Jung went to great lengths to indicate that this is not the case. He was concerned with the way in which as part of the individuation process the psyche transcends the immediate desires of the ego to embrace collective concerns:

> Individualism means deliberately stressing and giving prominence to some supposed peculiarity, rather than to collective considerations and obligations. But individuation means precisely the better and more complete fulfilment of the collective qualities of the human being... .[42]

However, with this desire for the fulfilment of collective qualities come certain potential dangers. To accept the unconscious is to accept the shadow side, the repressed and dangerous aspect of the human psyche, and it also involves accepting the anima/animus by realising that within each individual there is a strong contrasexual element that needs to be integrated within consciousness,

behaviours and attitudes. It is also to open oneself to an experience of the collective myths, fantasies, and symbols of mankind, and to experience the numinosity of archetypal power. It is to accept that, temporarily at least, the ego and consciousness have lost control.

Individuation is not about becoming a perfect person, but is about accepting the imperfections and oppositions that are latent in the psyche; and to accept the shadow and the anima is to accept that the psyche is not perfect:

> ...there is no light without shadow and no psychic wholeness without imperfection. To round itself out, life calls not for perfection but for completeness; and for this the 'thorn in the flesh' is needed, the suffering of defects without which there is no progress and no ascent.[43]

The main dangers of the individuation process are twofold. First there may be a narcissistic preoccupation with the psyche. Secondly, and more importantly, the trauma that an individual undergoes while being exposed to the unconscious may result in anti-social behaviour or even psychotic breakdown. This indicates the importance of the analyst's role as someone able to understand and interpret the wealth of symbolic and mythological material that is freed as the unconscious is embraced.

There is one further and very important point that is implicit in all that has been said about the individuation process. Individuation is something that happens not just to individuals but also to cultures. If the individual is really a microcosm of humankind, then it should be expected that a change such as individuation could apply not just to the individual, but also to an entire culture. According to this model, cultures individuate, they become aware of the diversity and opposition within them, and they come to accept their shared, collective unconscious qualities.

> Every advance in culture is, psychologically, an extension of consciousness, a coming to consciousness that can take place only through discrimination. Therefore an advance always begins with individuation, that is to say with the individual, conscious of his isolation, cutting a new path through hitherto untrodden territory. ...If he succeeds in giving collective validity to his widened consciousness, he creates a tension of opposites that provides the stimulation which culture needs for its further progress.[44]

This chapter has sought to find some points of contact between the analytical psychology of C G Jung and film theory. While some points of correspondence have been found, this amounts to little more than finding points of contact between the two theoretical systems. There are two logical developments from this position. The first is to apply Jungian theory in a film analysis. Derived from this is a second step, which is the development and testing of a model designed to overcome any difficulties encountered in the analysis. The model should serve to deepen the understanding and

application of the psychological theory, and thereby reveal deeper and previously unexplored levels of film narratives.

Notes

1 c.f. C. W. 7: 103n.
2 Jarvie, I. C., *Towards a Sociology of the Cinema*, (London, 1970): p4.
3 Monaco, P., *Film and Myth and National Folklore*, in, *The Power of Myth in Literature and Film*, ed. Carrabino, V., (Tallahasse, 1980): p39.
4 C. W. Vol. 8: 718.
5 c.f., Dictionary of Analytical Psychology: p26.
6 Wright, B., *The Long View*, (London, 1976): p11.
7 C. W. 8: 417.
8 Monaco, P., *Cinema and Society: France and Germany during the Twenties*, (New York, 1976): p84.
9 C. W. 10: 395.
10 There are some points of contact between Jung's notion of opposition and Lévi-Strauss' concept of binary opposition. Both regard opposites as fundamental to the structure of myth but for Lévi-Strauss these oppositions serve to pull apart the myth. [c.f. Lévi-Strauss, C., *Mythologiques: Le cru et le cuit*, (Paris, 1964].
11 C. W. 11:102.
12 Tyler, P., *Magic and Myth of the Movies*, (London, 1971): p57.
13 Tyler, P.: p89.
14 C. W. 7: 110.
15 c.f. Jaffé, A., *The Myth of Meaning in the Work of C. G. Jung*, (Zurich, 1983): p52.
16 C. W. 8: 342.
17 c.f. Samuels, A., *Jung and the Post-Jungians*, (London, 1985) p207-244.
18 For a detailed anthropological account of what constitutes a 'rite of passage' c.f. Gennep, A. V., *Rites of Passage*, Translated Vizedom, M. B., Caffee, G. L., (London, 1960).
19 C. W. 8: 406.
20 C. W. 15: 105.
21 Tyler, P.: p91.
22 C. W. 9,I: 28.
23 C. W. 9, I: 28.
24 Monaco, (1976): p75.
25 C. W. 6:401.
26 C. W. 9, I: 291.
27 C. W. 8: 505.
28 C. W. 8: 482.
29 Wright: p9.
30 C. W. 12: 129.
31 C. W. 8: 555.
32 C. W. 7: 210.
33 Wright: p8.
34 C. W. 8: 558.
35 Monaco, P., (1980): p37.
36 C. W. 8: 555.
37 *Critical Dictionary of Jungian Analysis*, (London, 1986):p76.
38 C. W. 13: 20.
39 A subsequent variation on this technique involves entering into a fantasy dialogue with the images and characters in the paintings, dreams etc. This process is termed 'active imagination'. For a detailed account of the technique and its use in a therapeutic setting c.f. Barbara Hannah, *Encounters with the Soul: active imagination as developed by C.G. Jung*, Sigo Press, 1981.

40 c.f. C.W. 11: 296-448.
41 C. W. 11:755.
42 C. W. 7: 267.
43 C. W. 12: 208.
44 C. W. 8: 111.

3

A Film Analysis: *Tightrope*

Abigial Manette (Deana Durbin): *I can still hear them call you guilty, guilty, guilty – and every time they said it, I knew it was meant for me too.*

Christmas Holiday, (Robert Siodmak: 1944)

The purpose of this chapter is to develop the study of the 1984 *film noir*, *Tightrope* (Richard Tuggle: 1984) and use it as a case study to demonstrate the applicability of analytical psychology as a method for film analysis. Throughout, there will be a focus on the special relationship that exists between the detective and criminal; the role of the detective's process of individuation will be explored. Underlying the film's surface of character and narrative, the analysis will reveal that there exists a hidden series of mythological and archetypal patterns, which other types of film analysis leave unexplored. The analysis moves between film, psychology and mythology, using each element to inform the other. The result is a diverse yet unified structure. As Hillman comments, this approach is not unusual in analytical psychology:

> We seek to reflect back and forth between the two, myth and psyche, using them to provide insights for each other, preventing either from being taken on its own terms only.[1]

As mentioned in the previous chapter, the plot of the film is deceptively simple. A serial killer is murdering prostitutes; each victim is tied with handcuffs and red ribbon, before being raped and then strangled. The detective Wes Bloch (Clint Eastwood) is in charge of the investigation. However, as the film progresses he gradually becomes implicated in the murders as each prostitute that he visits (firstly on a private basis, secondly as detective) is subsequently murdered. During this time, Bloch meets Beryl – a woman's self defence tutor – and she begins to provide for him a sense of stability amidst the chaos of the investigation. Eventually, Bloch succeeds in discovering the criminal, who turns out to be an ex-policeman. In the final sequence of the film, the murderer is trapped and, after a lengthy chase, captured by Bloch. A last struggle ensues, in which the murderer falls under a moving train and is killed.

The opening shot of the film provides a context for the rest of its imagery. It is night and the camera is flying over the city. As it crosses a wide river, the sound track is filled with laid-back jazz; a single improvising alto sax, simple bass and drums provide a musical cue, which later in the film comes to characterise the underworld of prostitution. This nocturnal imagery sets the tone for the film; the murders all happen at night, as do Bloch's trips to the New Orleans prostitutes. The shot is mirrored in the film's closing, which, once more, is a night-time view of the city; so from beginning to end, the film is wrapped in darkness. Occasionally, some daylight invades this landscape and on such occasions 'work', in the police station or at home, is permitted. But as soon as Bloch revisits the prostitutes, the film is once more plunged into the murky depths of crime and vice.

In mythological terms, this is a representation of the underworld. The film depicts this as the home of murder and perverted sexual acts. But in psychological terms, this imagery stands for the shadow side of the psyche, which is typically characterised by its negative and destructive nature. (The relevance of the concept of the shadow will be explored in more detail below.) Given this, it is therefore unsurprising that the opening is quickly followed by the first murder. The disruption of everyday life is, as well as being a normal narrative device, appropriate in mythological terms. The sequence starts in a dark, night-time street; emphasising the sense of threat, the lighting is low key. However, before the murder and rape are committed, the scene changes to show Bloch during the day where, in a somewhat banal scene, he is playing with his children and even befriends a stray dog.

These opening moments establish an opposition: Bloch lives in a nocturnal world of prostitution and crime, which is set against his diurnal world of family and police work. To simplify, the daytime represents the 'normal' or 'good' aspects of Bloch's life, that in psychological terms equate with consciousness. By contrast, the night stands for the 'evil', or repressed shadow-world, of Bloch's unconscious. The only person who moves between these two worlds is Bloch, and this suggests he has an affinity with them both. At home he is a stereotypical father, yet in the underworld he moves from prostitute to prostitute in his search for the killer – and also on his own sexual search. This duality is the prerogative of Bloch, who remains both alone and an outsider: at home he has no wife, and at work he does not have a partner; wherever he is, he remains isolated.

Associated with the daylight world of consciousness, is Bloch's persona. This psychological term refers to the outer mask that is worn to face the world. In other words, it is an image of oneself behind which it is possible to hide, and Bloch, in identifying strongly with his persona, does just that. As is typical of the persona of the detective, Bloch is a loaner. In *Tightrope*, this alienation is combined with an almost fanatical loyalty to his work as a detective, although this loyalty does not necessarily extend to the police force. Again, this serves to emphasise Bloch's isolated nature as, while he works for an institution, he only occasionally works with his colleagues; he chooses instead to carry out his investigations alone – he is 'a-loner'.

One significant element in Bloch's persona is his police handcuffs. On the one hand, they are part of his official police paraphernalia. However, they also show his attachment to the underworld and to the shadow-criminal; as mentioned, both Bloch and the killer use handcuffs during sex. Thus there is a sense in which the outer image of the persona actually pre-figures the inner image of the shadow. If Bloch is to achieve psychological growth, it will be necessary for him to discover this for himself. Without this capacity for an inner life, the persona remains in isolation and the shadow becomes suppressed. This carries with it, its own set of dangers. As Jung comments:

> Mere suppression of the shadow is as little of a remedy as beheading would be for a headache. To destroy a man's morality does not help either, because it would kill his better self, without which even the shadow makes no sense. The reconciliation of these opposites is a major problem, and even in antiquity it bothered certain minds.[2]

Bloch's psychological tasks are twofold. First he must pass the persona phase of his individuation and secondly he must accept his shadow. This will result in the expansion of his consciousness and the recognition that the psyche does possess collective qualities. It may also lead to a relationship, for the detective no longer sees himself as an isolated individual but as a person with collective qualities. This process, which equates with the early stages of individuation, can be seen in *Tightrope*, and is explored in detail below. At present, it is sufficient to note that Bloch's awareness of his shadow occurs at the same time as his new relationship with Beryl starts.

The danger, posed by a period of introspection, is that Bloch may get drawn into the shadowy underworld of the unconscious. This is a world that, like his mythological ancestors Theseus and Pirithous, he may be unable to return from. Yet it is to this world that the shadow calls him, and it is to this call that Bloch responds. Indeed, that he is called into the underworld is evident both in his professional duties, as a policeman, and in his personal sexual life (although as mentioned these elements are inter-linked). Bloch's sexual life involves him not only in visiting the prostitutes whom he interviews as a policeman, but also includes various forms of perverted sex which involve, for example, using his police handcuffs. This serves to confirm his affinity and association with the underworld. As the archetype psychologist James Hillman comments:

> So, Heraclitus, as one psychologist to another, across the centuries I read you as saying that for this troublesome distinction between emotion and soul, between the perspective of vitality (Dionysos) and the perspective of the psyche (Hades), sexual fantasy holds a secret....The Hades within Dionysos says that there is an invisible meaning in sexual acts, a significance for soul in the phallic parade, that all our life force, including the polymorphous and pornographic desires of the psyche, refer to the underworld of images.[3]

It is this that Bloch has to recognise: namely, that all life forces refer to the underworld of the psyche and that these must be eventually accepted and integrated into consciousness.

Within the mythological language of *Tightrope*, the criminal becomes an outer personification of the detective's inner shadow. Once this is recognised, it becomes clear that the detective is not only on an outer search to discover the murderer of the prostitutes. He is also on an inner search, to discover and to recognise his shadow. For the detective, the correspondence between the inner psychological world and outer real world is important, and there are several points in the film where this becomes clear. In the first of these instances Bloch is talking to a criminal psychiatrist who comments:

> Once you started going after him you became closer to him than anyone else.

> There's a darkness inside all of us, Wes. You, me, and the man down the street. Some of us have it under control, some act it out, the rest of us try to walk a tightrope between the two.

This insight is reinforced by one of the characters who remarks to Bloch of the killer, 'He said you were just like him'. Interestingly, this sequence follows one in which Bloch falls asleep clutching a photograph of himself and his wife on their wedding day. Instead of acknowledging his own shadow qualities in the present, it is almost as though he is holding on to an image, or an illusion, of the past.

Maybe this lack of shadow awareness is why his wife left him, however, for the viewer. Nonetheless, the following dialogue between Beryl and Wes Bloch seems to hint that this may have been the reason for his wife's departure, (also cited in Chapter One).

Beryl:	Do you investigate many sexual crimes?
Bloch:	Why?
Beryl:	Just wondered if they'd affected you
Bloch:	They did make me want to treat my wife a little more tenderly
Beryl:	How did she respond?
Bloch:	She said she wasn't interested in tenderness....

When Bloch comments to Beryl about a prostitute whom he recognises in the street, 'I only made those sort of friends after my wife left', it is clear that his involvement with prostitutes only started after he separated from his wife. It seems that Bloch still does not recognise what parts of his psyche belong to consciousness, and what parts are projections from his objective psyche. He has yet to recognise that the shadow-criminal, whom he his tracking, is in fact part of himself. As Jung has commented:

> Again, the view that good and evil are spiritual forces outside us, and that man is caught in the conflict between them, is more bearable by

far than the insight that the opposites are the ineradicable and indispensable pre-conditions of all psychic life, so much so that life itself is guilt.[4]

Later in the film, the association between Bloch and his shadow is made even more explicit. Bloch dreams that a black masked figure attempts to strangle Beryl, his new girlfriend. After a struggle, she manages to pull the mask off the attacker, only to reveal Bloch's own face – at which point he wakes up sweating with fear. The meaning is self-evident and clear: the shadow is a projection of the negative aspects of the detective's psyche. Just as the detective wears his persona as a mask to the outer world, so too the shadow forms a mask to the inner world, and it is this mask that Bloch must learn to recognise. In *Tightrope*, the shadow-criminal takes to adopting masks at different points: a black mask; a grotesque mardi-gras mask; and a clown's make up. It is almost as though the shadow is parodying the shifting persona of the detective.

It is also clear that Bloch is afraid of his shadow, and there are various well-founded reasons for his fear. Firstly, the shadow represents the opposite of all that his persona and professional life stand for: as a detective, he is concerned with law and order, while the shadow embodies the antithesis of these qualities. Secondly, the film if full of references to Bloch's anxieties and self doubts, of which the following conversation with Beryl is typical:

Beryl: I'd like to find out what's underneath the front you put on.

Bloch: Maybe you wouldn't like what you find.

The danger, for Bloch, exists in his over identification with the persona, and his refusal to accept his shadow. The problem is that identification with the persona means that the inner world is ignored. Unfortunately for him, this does not mean that the contents of the unconscious will vanish. Instead, what happens is that they grow in strength and, like water behind a dam, threaten to eventually overflow and flood into consciousness. Bloch's over identification with his persona is evident at several points. The first instance occurs when he abandons his children, to start the murder investigation. And he repeaets this pattern of behaviour later in the film, when he hurriedly leaves Beryl to return to his work, and to the underworld of prostitution. Here, ensconsed in the darkness, he thinks he is safe; as one of the prostitutes comments, 'You can't ever get close to a cop'. Yet ironically it is here that he is closest to his shadow (on one occasion 'the shadow' even watches him having sex with a prostitute). In fact, contrary to what he thinks, Bloch's real safety exists in the daylight world and in his relationship with Beryl. The imagery of the film suggests this by placing Beryl almost exclusively in day-time settings, which puts her in the position of a compensatory opposite to the prostitutes; Beryl belongs exclusively to the diurnal world. By contrast, the prostitutes are alluring and seductive at night, but in daylight are shown only as corpses; it is almost as though they are nocturnal creatures that, like vampires, cannot survive in the sun. In setting up these contrasts, the film acts an exposition of the complex

psychological dialogue that takes place between consciousness and the shadow. Bloch is faced with a dilemma: either he can succumb to the enticements of the underworld, or, having accepted his shadow, he can return to the daylight world – more prepared for his relationship with Beryl.

Bloch's attraction to the underworld is a constant theme of the narrative. Initially, the viewer is presented with an image of Bloch as model policeman. He responds quickly to a call for him to come to the police station, and yet he still finds time to stay at home and play with his children. Apparently, he is as concerned about his family life as his work, and yet even here the speed at which he goes to work, pausing to say only the briefest of goodbyes, hints that his devotion to duty is overly zealous. The suspicion that behind this exterior of devotion there is something corrupt is confirmed when Bloch is shown about to have oral sex with the female co-worker of the first murdered prostitute. In an interesting moment, that is a sort of quasi-parapraxis, Bloch 'accidentally' leaves behind his neck-tie and in so doing unwittingly indicates how he is symbolically linked with the underworld.

The final encounter between Bloch and the criminal takes place at night. The whole of this sequence is given a highly mythological, almost cosmological, atmosphere, as bolts of lightning and thunder explode in the sky. This is a recapitulation of the scene near the beginning of the film where one of Bloch's fellow police officers remarks to him while looking at a new moon, 'Do ya think it brings out the crazies?', to which Bloch replies, 'Yeh. Always'. Both of these sequences have a curiously overt mythological tone which sets them apart (coming as they do – one at the beginning of the film, the other at the end – they enfold the narrative of the film).

The confrontation between detective and killer takes place as Bloch chases the criminal through a graveyard; the combination of thunderstorm and graveyard combine to reinforce the mythological and symbolic structure of the film. Throughout this sequence, Bloch is kept in a spotlight cast by a police helicopter, while, by contrast, the murderer tries to hide behind the tombstones; the killer is still trying to conceal himself in the shadows of the underworld – after all, Hades is the god of the dead. But even here, the detective is protected by the mandala-like circle of white light cast from the helicopter, and this contrasts noticeably with the earlier images in the film, in which Bloch is immersed in darkness. Much as the circular light from the new moon initiated the investigation, so too the circular light from the helicopter's search beam apparently closes it. Both of these are symbolic moments in the film: one indicates the start of the detective's quest, while the other heralds its closure.

The act of pushing the killer under the train also has symbolic meaning – namely, that Bloch has overcome his shadow. Indicating his changing priorities, he leaves the body of the criminal behind; he does not follow the normal police protocols of waiting for the investigating team, nor does he go down to the station to start on the inevitable paperwork; instead, he just walks off into the city with Beryl. In fact this picture of Bloch and Beryl, arm in arm, forms the

final image of the film, and from here the camera pulls back into the night sky. It seems as though the detective has accepted that he, like everyone else, has a shadow side and this recognition enables him to continue his relationship with Beryl.

What follows, in summary form, is the sequence of events that chart Bloch's psychological transformation.

1.	Bloch's wife leaves him	He enters the underworld
2.	First murder	Becomes involved with the case
3.	Following murders	Becomes entangled with the underworld
4.	Bloch meets Beryl	Bloch is forced to look beneath his persona, and begins to accept the shadow
5.	Final murder	Bloch is able to solve the case and hence regain control over his psyche
6.	Destroys shadow-criminal	Bloch is able to leave the underworld with Beryl

Thus, in the circular construction of the film, a stability is established: before the film started, Bloch had a wife and two children; now, at the end of the film, the situation is almost the same. What has changed is that Bloch has come to terms with at least some of the darker side of his own psyche.

Having discussed the images of the archetypes persona and shadow in *Tightrope*, we now have the opportunity to look further into the film's mythology. Occurring throughout the film is the idea that both murder and sex are illusory. Interestingly, none of the murders are shown on screen, and this helps to give the sense that they are illusions – after all, the viewer never actually sees them happening. Similarly, in scenes with the prostitutes, the actual sexual act is never shown; all that the viewer sees is the prelude to sex. Like the murders, the sexual acts assume a phantom like aspect on acount of their absence from the film. Developing this theme, the prostitutes also sell illusory sex, including oral sex and hand sex. In a way, they do not have the status of characters, but are rather relegated to the level of functionaries: identified by the particular sexual act that they perform, they have, in other words, become totally identified with their personas and as such remain entrapped within the underworld context. The illusory, or shadowy, qualities of both the murders and the sexual acts also support the idea that Bloch is on a search for his shadow.

The prostitutes are presented in sharp contrast to the other woman in the film – Beryl. The strongest difference between Beryl and the prostitutes is in the way that Bloch treats them sexually. With the prostitutes, Bloch has whatever form of sex that they are offering, including bondage and using handcuffs. Once he has had sex, he leaves, even if he does later return to a different prostitute for a different type of sex. These sexual practices are in contrast to the way in which

he treats Beryl. The first time that Beryl and Bloch make love, Beryl picks up a pair of handcuffs that are beside the bed. Bloch explains that he only uses them when he needs control and when he feels threatened – 'With these no one can get to you, eh?', Beryl comments. After this she, in an almost sacrificial gesture, offers her hands to be handcuffed. Perhaps she is hinting to Bloch that he has good reason to feel threatened. Whatever, Bloch refuses her offer as apparently she is not to be subjected to the same sort of sexual control as the prostitutes.

This contrasts with an earlier scene in a gym where Bloch and Beryl are using the same large exercise machine. Here, the imagery is given a highly sexual, although comical, tone, with close-ups of interlocking levers, thrusting pistons, and synchronised movements between Beryl and Bloch. At this stage in the relationship their sexual imagery is illusory and mechanical, and as such – tonally speaking – it more properly belongs to the underground image world of the prostitutes. However, Bloch still seems afraid, but of what the viewer can not be sure. Perhaps he is aware that real sex, with a real woman, involves a degree of commitment and trust that he does not have to have, and indeed is unable to have, with the prostitutes.

For Bloch, sex with Beryl becomes an almost initiatory ritual through which he accepts his shadow side. It shows that even though he may still feel imperfect, he is able to trust someone, and her willingness in this both affirms Bloch and forces him to accept his shadow side. Significantly, it is shortly after this that Bloch has the dream where he is the shadow killer: and it is with this insight that he is able to face the murderer, and swiftly solve the case.

As mentioned, part of the methodology of analytical psychology involves the uncovering of mythological parallels as a way of understanding the images under consideration. This enables the analyst to reflect between image, myth and psychology – letting the one inform the other. To some extent this has been happening throughout the chapter: for example, the world of crime has been seen as a parallel with the mythological underworld of Hades. However, there is one theme in particular for which it may prove useful to examine a mythological motif, and this is the theme of bondage or binding. This theme is of central importance in the film, acting as it does as a metaphor for Bloch's compulsion for control.

When looking at mythological parallels to this image, the Scandinavian myth of Tyr stands out. In this myth, an animal called the Frenis Wolf is threatening the lives of the gods. The only remedy to the situation that they can see is to find a way to tie it up. Eventually, a harmless looking, but magical, cord is found, and the Frenis Wolf agrees to let himself be bound round the neck, but only on the condition that Tyr puts a hand in the wolf's mouth. Tyr does this, and loses his hand as the wolf is killed.

The Jungian Clarke Branson has commented on this myth and notes that, 'BINDING thus becomes important in Northern symbolism. In a way of initiation, men attending certain assemblies were bound and thus humbled for

the occasion.'[5] Here, what is significant is the mythological insight that binding can be a form of initiation. For Bloch, almost the opposite is true: binding initiates him into the underworld and, conversely, not binding returns him to the 'normal' world. This is reflected in the film in that once Bloch has had sex with Beryl without using the handcuffs, he ends his sexual visits to the prostitutes. The reason for this is simply that he has been initiated out of the underworld.

Another point of correspondence between the Frenis Wolf myth and *Tightrope* is the severed hand. In the myth, it is Tyr who loses his hand; in *Tightrope*, it is the criminal whose arm is severed. As mentioned, this happens in the closing moments of the film when Bloch pushes the body of the killer under the train and the arm is severed from the body – still grasping Bloch's throat. In Freudian terms, this is classic castration symbolism, but from a Jungian point of view, death (and loss of a limb is in essence a partial death) indicates the dying of one part of the psyche. Such death prefigures its opposite, namely birth. Thus the death of one part of the self, indicates the rebirth of another part of the psyche. (Interestingly, just as the Frenis Wolf was strangled by the magic chord, so too the killer in *Tightrope* strangles his victims.) To some extent, both *Tightrope* and the myth of Tyr seem to deal with initiation and the shadow. In the film, Bloch is first initiated into the underworld of the unconscious, and there, by virtue of his struggle with the shadow, he assimilates it into consciousness. This re-initiation, or return to consciousness, is symbolised by the killing of the shadow figure and the establishment of the relationship with Beryl.

This analysis has used analytical psychology as a method for analysing a film. It has proved a useful tool in revealing the criminal as a projection, and personification, of the detective's shadow. It has also been shown that the film contains concealed mythological references, and also possesses a hidden structure of symbolic transformation – namely Bloch's initiation. A logical extension of this analysis would be to develop a more systematic approach for applying the psychology, thus allowing a clearer distinction to be made between the archetypal pattern, image, myth, symbol and psychological theory. In turn, this would enable a clearer exposition of the film's mythological and psychological themes.

Notes

1 Hillman. J., *The Dream and the Underworld*, (New York, 1979): p24.
2 C. W. 11: 133.
3 Hillman, (New York, 1979): p44-45.
4 C. W. 14: 206.
5 Branson, C., *Howard Hawks: A Jungian Study*, (Los Angeles, 1987): p42.

Part Two

The Case for the Defence:
Archetypes and Symbols

4

Archetypes – The Hypothesis

Dix Steel (Humphrey Bogart): *It was his story against mine, but of course I told my story better.*

In a Lonely Place, (Nicolas Ray: 1950)

Jung did not invent, nor even propose, the idea of the archetype. Indeed, throughout his writings, Jung is keen to acknowledge the importance of a historical dimension to his work. He does this in terms of the intellectual antecedents of his psychological hypothesis, and also in the way that he uses mythological material to understand the psychological meaning of images – of which more later. Precursors to his psychological adaptation of the principle of the archetype can be found in the numerous theories which are concerned with how 'structuring potentials' are inherent in the universe. One of the earliest of these theories can be found in the work of Plato, who conceived of a system in which 'original ideas', existing before the world was created, dwelt in the minds of the gods, and from those 'ideas' came all matters and reason.[1] These 'ideas' can be regarded as collective in that they contain within them 'common qualities'. Thus the 'original idea' 'hero' has many shared 'common qualities' with all other heroes, which are archetypal in as much as they hypothesise a universal system through which the world can be understood and ordered. In the eighteenth century, Kant conceived of a series of innate fundamental categories, within an *a priori* schema, by which the world could be organised. Interestingly, these categories are dynamic and enter into the constitutions and composition of their material, in much the same way as an archetype may mould its subject. As Kant argues:

> First, then, if we have a proposition which in being thought is thought as NECESSARY, it is an A PRIORI judgement.... Secondly, experience never confers on its judgements true or strict, but only assumed and comparative UNIVERSALITY, through induction.[2]

Finally, in the nineteenth century Schopenhauer conceived of a system of prototypes, which he regarded as the original and unchanging form of all things. That he influenced Jung, can be seen constantly in Jung's writings.[3] This Jungian view of the structure of the unconscious is markedly different to the Freudian model, which regards the unconscious as primarily containing

repressed personal sexual material. Jung accounts for this possibility where it forms one aspect of the unconscious, an element that he termed the 'Personal Unconscious'.

One of Jung's insights was that this model of universal form might be helpful in understanding not just the concrete material world, but could also usefully be applied in helping to understanding the psychological world and particularly the unconscious. In suggesting the archetype as a theoretical construct that structured both the inner and outer world, Jung anticipated some of the developments of modernist and postmodernist thought. As the Jungian Christopher Hauke has pointed out, 'Out of this reflexivity a new "object" emerged – one that paradoxically belonged to the Subject and was Other at the same time. This was the Unconscious.'[4] Put another way, the archetypes, as the structuring potentials of the unconscious, signify the existence of the unconscious through images. These images also embody a signified; they suggest that meaning is something that does not belong just to the present, and that there is a latent, and developmental aspect to the images of the objective psyche.

Thus from 1912, when Jung conceived of the psychological archetypal, two factors can be isolated. First, the universality of the archetypal as a structuring potential, and secondly the notion that the archetype straddles the divide between the conscious and the unconscious. To these conditions two further factors can be added: one, depth; and two, autonomy. The term *depth* indicates the belief that the archetypes form the lowest or most basic levels of the objective psyche. The term *autonomy*, on the other hand, indicates the existence of these patterns outside of specific cultures and personal psychologies. Five years later, in 1917, Jung had started to develop his theory. By that point he had refined his view to suggest that the objective psyche expressed itself through a series of interrelated dominant images. These recurring dominant images he called 'nodal points', and they formed the archetypal cores around which other subsidiary archetypes gathered. As Samuels comments, the archetypal centres were regarded as:

> Special nodal points around which imagery clustered…The important thing to note in the move from primordial image to dominant is that the innate structure…is regarded as more and more powerful, to the point where it becomes actor rather than acted upon.[5]

It was not until 1919 that Jung introduced the term 'archetype'. By this point, he was particularly aware that any theory of how images or information is passed on through time, is in danger of succumbing to the Lamarkian fallacy. This states that, '…the evolutionary origin of adaptations lies in the adaptation of individuals during development and the hereditary *transmission of these acquired adaptations….*'[6] (my emphasis). In terms of analytical psychology, this would suggest that memories of specific ancient experiences (the acquired characteristics) are passed on, generation to generation. This would fit very neatly with archetypal theory, but as Darwinian theories were to show, this

view of evolution was not sustainable. However, while images and behaviours can not be inherited, it is possible that triggers for specific patterns of behaviours are. As Samuels has noted:

> The archetype is seen as a purely formal, skeletal concept, which is then fleshed out with imagery, ideas, motifs and so on. The archetypal form or pattern is inherited but the content is variable, subject to environmental and historical changes.[7]

This distinction between form and content became important for Jung, as did the transcultural and transhistorical aspects of the archetype, as is demonstrated in the following observations:

> The concept of the archetype, which is an indispensable correlate of the idea of the collective unconscious, indicates the existence of definite forms in the psyche which seem to be present always and everywhere…This collective unconscious does not develop individually but is inherited. It consists of pre-existent forms, the archetypes, which can only become conscious secondarily and which give definite form to certain psychic contents.[8]

> The archetypal representations (images and ideas) mediated to us by the unconscious should not be confused with the archetype as such. They are very varied structures which all point back to one essentially 'irrepresentable' basic form. The latter is characterized by certain formal elements and by certain fundamental meanings, although these can be grasped only approximately.[9]

A concrete example of this distinction between archetypal form, which is more accurately termed *pattern*, and its contents, or *image*, would be the figure of the hero. Here, the image of the hero represents the embodiment of the archetypal pattern. This image may shift and change, perhaps being – at one time or another – a warrior-hero, or a detective-hero, or even an intellectual-hero, and so forth. While the form 'hero' remains constant, the content, in this example the image of the detective, warrior and so on, is influenced by cultural factors. (The same model holds good for material that is personal. In this case, personal histories, upbringing, and cultural and life experience, influence the images that the archetypal patterns adopt.) Therefore, when looking at archetypes as cultural patterns, we should be able to trace a consistent pattern or form associated with a developing image, and both these factors can be indicators of a culture's psychological state. That is to say, the psychological condition of a culture calls forth both the relevant archetypal pattern, and moulds the image within which the pattern finds expression. The relationship of the archetypal hypothesis – as it applies to the individual, and its relevance in understanding the psychological condition of cultures – is something that came to fascinate Jung. As Hauke has noted:

> In much of his later work, from 1928 onwards, Jung's psychological writing emphasised the social and historical context of what he called

the modern psyche. He was not only interested in the content and treatment of neurotic and psychotic disturbances in the patients he saw, but was also focused on how the psyche of twentieth-century Western men and women was very much a product and development of a general evolution in human consciousness.[10]

Therefore, in the terms of analytical psychology, if the images a culture produces are to be understood, it is important that the archetypal aspect they have adopted at any one time is subject to scrutiny and analysis. But there is a problem: Jung is presciently postmodernist in his assertion that these images and patterns are ultimately unknowable.

Contents of an archetypal character are manifestations of processes in the collective unconscious. Hence they do not refer to anything that is or has been conscious, but to something essentially unconscious. In the last analysis, therefore, it is impossible to say what they refer to... The ultimate core of meaning may be circumscribed, but not described. Even so, the bare circumscription denotes an essential step forward in our knowledge of the pre-conscious structure of the psyche... .[11]

The saving grace is that even though neither image nor pattern may be fully understood, the basic archetypal forms or patterns can nonetheless be detected over periods of time, even if their contents vary. It is the role of the analyst to strip away the layers of cultural encoding to reveal the basic archetypal forms, and to then discern the relationship of these forms to the culture and/or individual, as appropriate. If a psychological understanding of the way cultures function is to be achieved, then there must be an examination of both form and content, pattern and image – the totality of the archetypal experience.

So far, within archetypal theory, four key elements have been identified: universality, collectivity, depth and autonomy. It is suggested that if these elements are to be comprehended within the cultural context, reference must be made to the dynamic and formal aspects of the archetypal. In using the term 'dynamic', Jung was referring to the energy of the archetypal pattern which is its motivating force. It is this force which propels both the psyche and culture, in a predictable fashion, towards an integration of the consciousness with the unconscious. As Whitmont notes, 'The objective psyche, as an *a priori datum*, imposes *upon* our subjective selves the forms and limitations which determine the quality of our experiences'.[12]

However, of more immediate interest are the images and situations through which the archetypes are represented. Whitmont identifies three key points at which these representational experiences occur, that is to say, times at which the pattern and its image are activated and can therefore be detected. (It should be noted that whilst Whitmont is writing about the personal clinical situation, his observations hold good for the cultural.)

1. ...in the analytical situation when complexes have been understood and dealt with but when a step beyond the understanding of their

personal genesis is required' [in other words, as part of a normal maturation of life growth process]...

2. Archetypal images may appear spontaneously when inner or outer events which are particularly stark, threatening or powerful must be faced...

3. In cases of imminent or acute psychosis and in cases of demonic or religious 'possession', the objective psyche takes over... [At this point as the objective psyche is composed, in part, of the archetypal core, archetypal patterns and images will be seen in profusion].[13]

If a culture is undergoing any of the above changes, then it would be expected to provide the cultural analyst with a particularly rich period of archetypal imagery. For example, the movies of 1940s *film noir* are often seen as reflecting the social changes that were taking place in American society at that time. For example, the film theorist Sylvia Harvey, in 'Women's Place, The Absent Family in *Film Noir*',[14] takes a broadly sociological look at the changing image of the family and its increasing instability. However, it is also possible to look at *film noir* from a psychological perspective. The American involvement in World War II meant that, psychologically as well as in other ways, the US had to come to terms, once more, with the darker aspects of being one of the most powerful countries in the world. The world of *film noir*, with its dark streets (enhanced as they were shot night-for-night), canted camera angles, and alienated characters, was not just the result of war-time restrictions on film budgets (on the contrary, shooting night for night is more expensive). It can equally be seen as an embodiment of psychological symbolism that represented the growing unrest felt in American society, at again being involved in the horrors of international warfare. As we shall see later, in analytical psychology there is the assumption that while attempting to balance itself, the psyche also throws up compenstatory images. This sheds some light on why, at the same time as *film noir*, there were romances like Ester William's first film *Bathing Beauty* (George Sydney: 1944), musicals such as *Up in Arms* (Elliott Neugent: 1944), which provided the film premier for Danny Kaye, and melodramas such as *A Stolen Life* (Curtis Burnhart: 1946). Interestingly, a similar phenomena happened during the American Depression of the 1930s. Here, the dark side of society found its symbolism in *Dracula* (Tod Browing: 1930), *Frankenstein* (James Whale:1931) and *The Mummy* (Karl Freund:1932). In contrast, the compensatory opposite can be found in the altogether lighter films of *Love me Tonight* (Rouben Mamoulian: 1932) and *Flying Down to Rio* (Thornton Freeland:1933). Occasionally, a film such as *The Gold Diggers of 1933* (Mervyn Le Roy: 1933) combined both themes. Mostly, the film is a light, visually glamorous, musical comedy, with musical routines that were choreographed by Busby Berkeley. But the number *Remember my Forgotten Man* records the movement of American men from the trenches of World War I, to the hopelessness of life on the dole.

As in the previous examples, it is possible to start from a known psychological situation, and from this make some deductions about the expected type of

imagery. However, the conventional Jungian analytic procedure is the reverse: it starts with whatever images the objective psyche presents, and then places these in relationship to the individual or culture. It is this process which allows the psychological conditions of the subject to be deduced, making it an inductive methodology. It is this process which we will be deploy when we analyse the films in later chapters.

By 1946, Jung was still making a clear distinction between archetype and image, or form and content, and he continued to stress the dynamic aspect of archetypes; accordingly, his writings at this time emphasised the way in which the formal aspects of the archetype determine the development of the psyche.

> Now the archetypes do not represent anything external, non-psychic, although they do of course owe the concreteness of their imagery to impressions received from without. Rather, independently of, and sometimes in direct contrast to, the outward forms they may take, they represent the life and essence of a non-individual psyche. Although this psyche is innate in every individual it can neither be modified nor possessed by him personally. It is the same in the individual as it is in the crowd and ultimately in everybody. It is the pre-condition of each individual psyche, just as the sea is the carrier of the individual wave.[15]

In fact, Jung goes on to develop this thought and suggests that the archetypes are the ultimate structuring potential for both individuals and humankind.

> ...our personal psychology is just a thin skin, a ripple upon the ocean of collective psychology. The powerful factor, the factor which changes our whole life, which changes the surface of our known world, which makes history, is collective psychology, and collective psychology moves according to laws entirely different from those of our consciousness. The archetypes are the great decisive forces, they bring about the real events, and not our personal reasoning and practical intellect...the archetypal image decide the fate of man.[16]

Notwithstanding the above comments, even towards the end of his life in 1961, Jung was still anxious to state that total understanding of an archetype, and hence its full psychological comprehension, can never be achieved.

> Not for a moment dare we succumb to the illusion that an archetype can be finally explained and disposed of. Even the best attempts at explanation are only more or less successful translations into another metaphorical language (indeed, language itself is only an image). The most we can do is to dream the myth onwards and give it a modern dress. And whatever explanation or interpretation does to it, we do to our own souls as well, with corresponding results for our own well-being. The archetype – let us never forget this – is a psychic organ present in all of us.[17]

In summary, Jung postulated the existence of an archetypal core which embraces all the archetypes, and which is composed of dynamic and formal aspects. The archetypal patterns liberated from this core indicate the psychological condition of the culture, or individual, that frees them. The general characteristics of these archetypes are that they possess: depth, collectivity, autonomy and universality. It is the archetypal patterns, not the contents (images), which possess these attributes. Archetypes transcend historical and cultural boundaries; it is the archetypal patterns – not contents (images) – that influence the development of individuals and cultures, causing them to take account of the objective psyche.

The Classification of Archetypes

Up to this point, archetypes have been treated as belonging to one common core, and this core was seen to be the possessor of both dynamic and formal energies. In fact, this core is composed of various discrete or individual archetypes which, whilst interrelated, possess in their individuality the attributes of the larger core. Jung also noticed a tendency for these individual archetypes to become personified. Given the variety and complexity of archetypal patterns and images, it seems important to have some method for their organisation. Without this there is the danger of confusion. There are a variety of ways by which to organise archetypes; three such systems will now be examined, in order to identify the most appropriate one for use in understanding the psychological role of films.

Perhaps the most conventional, and traditional, way to organise the archetypes is to start from the outside – that is, to start from the world and work inwards to the unconscious. Using this approach, the first archetype encountered is the 'persona'. This term originally referred to the mask worn by Roman actors, but Jung used it to mean the mask that we put over our inner selves to encounter the outer world.

> The persona... is the individual's system of adaptation to, or the manner he assumes in dealing with, the world. Every calling or profession, for example, has its own characteristic persona....A certain kind of behaviour is forced on them by the world, and professional people endeavour to come up to these expectations. Only, the danger is that they become identical with their personas – the professor with his textbook, the tenor with his voice. Then the damage is done; henceforth he lives exclusively against the background of his own biography....One could say, with a little exaggeration, that the persona is that which in reality is not, but which oneself as well as others think one is.[18]

The second archetype, encountered on the inward journey, is the shadow, also referred to as the inferior function. The shadow, as hinted at in the previous chapter, represents the part of the psyche that we dislike. Consequently, it appears to consciousness as the 'inferior' part of the personality. The danger is

that because the shadow is so intensely disliked it may come to form a separate splinter personality, normally the same sex as the person concerned, and this is precisely what occurred in *Tightrope*. In the following two extracts, Jung explains the shadow's negative qualities:

> I should only like to point out that the inferior function is practically identical with the dark side of the human personality. The darkness which clings to every personality is the door into the unconscious and the gateway of dreams, from which those two twilight figures, the shadow and the anima, step into our nightly visions, or remaining invisible, take possession of our ego-consciousness.[19]

> The shadow personifies everything that the subject refuses to acknowledge about himself and yet is always thrusting itself upon him directly or indirectly – for instance, inferior traits of character and other incompatible tendencies.[20]

Finally, and most removed from the outerworld, we have the contrasexual archetypes of animus and anima. According to Jung, the animus represents what is masculine in woman and the anima, the feminine in man. Jung's psychology therefore prepares the way for an inclusive theory of human sexuality; one in which men and women can experience the full range of what are traditionally conceived of as separate gender roles.

> Anima and animus may appear as human figures, but they may be more accurately seen as representative of archetypal patterns. For example, anima speaks of imagination, fantasy and play, while animus refers to focused consciousness, authority and respect for facts. Nowadays, it is widely regarded as fallacious to link such psychological traits to sex. Anima and animus can be understood as representing alternative modes of perception, behaviour and evaluation.'[21]

These figures, like the shadow, are likely to be projected onto other people that we encounter; however, unlike the shadow, these archetypes are projected onto people of the opposite sex. Thus men project the anima onto women, and, conversely, women project the animus onto men. Gray has noted that:

> For a man, the anima is rooted in the mother archetype, which is to say the organizing factor of all things feminine from the devouring mother to the Virgin Mary...Similarly, the animus in the female is rooted in the father archetype which is again the organising principle of all things masculine.[22]

It is important to reiterate that the anima tells us nothing about the psychology of women; nor does the animus inform us about the psychology of men. Rather, what is interesting is that both archetypes reveal something of the cultural attitudes attached to gendered identities, and the masculine and feminine traits associated, apparently exclusively, with these identities. What tends to happen is that the contrasexual archetype, in its unconscious state, is

unknowingly projected onto the opposite sex and the erroneous assumption is made that it tells us something about the essential nature of men and women. (This is something to which we will return when discussing the figure of the *femme fatale* in classic Hollywood *film noir*.

Conventional Method for Classification of Archetypes

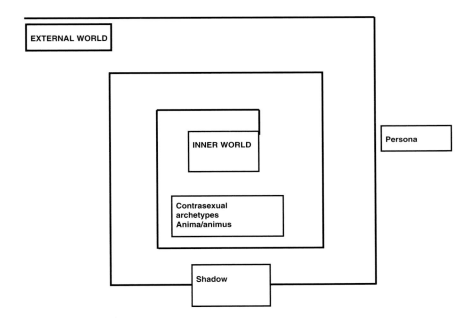

Another widely used method for ordering archetypes[23] is to divide the archetypal core into four main categories:

> First there are the 'shallow' archetypes such as persona and shadow, then 'archetypes of the soul' (animus and anima), then 'archetypes of the spirit' (wise old man and woman), and finally the Self.[24]

The main problem with this method is its rigidity and its use of ill defined terms like spirit and soul. Also, the term spirit could perhaps better be applied to the contrasexual archetypes, rather than the wise old man or woman. Jung identified these latter figures as characters who can appear during the individuation process as guides.

There exists the danger, with these concrete approaches, that the archetypes are dealt with in a strict and predictable order. For example: persona, shadow, anima/animus, Self. This would be an overly simplistic interpretation of Jung's thought; one which does not take into account his insistence that every situation be treated as fresh and original.

Alternative Method for the Classification of Archetypes

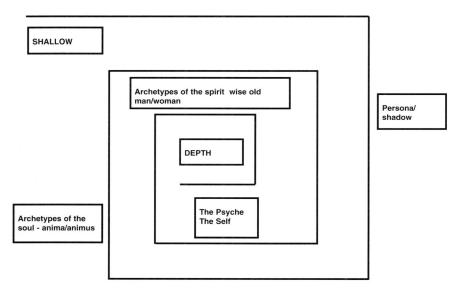

A less formal system for classifying archetypes (which also overcomes these limitations) involves first finding an archetypal theme, and then seeing how various archetypal patterns and their associated images gather round it. For example, creation myths use differing imagery from one culture to another, and at different times. Yet at a deep structural level, the narrative content remains constant. This fits our expectation that these myths would attract different collections of archetypes, and that these archetypes would vary according to the specific psychological needs of each culture. In his paper *Introducing not Self,* the psychotherapist Stein develops a system of archetypal themes.[25] He identifies both single archetypes, and also aggregates of archetypes (anima/animus, shadow, etcetera), which he regards as composites of individual archetypal patterns. He notes:

> I therefore make a distinction between discrete archetypes as such, and more or less abstract aggregates like animus, anima, shadow…The refutation of the linear arrangement in preference to a framework of planes permits…archetypal images to be placed on the lower, earlier, more archaic, more consolidated, more resistant level of the self…it is postulated that individual constituents arrange themselves in pairs of opposites… archetypes as the constituents of the self are interrelated and this interrelatedness is teleological, ie serves the well-being of the individual as a whole.

This method for classifying archetypes is illustrated in the following diagram.

A Model of Stein's Method of Archetypal Classification

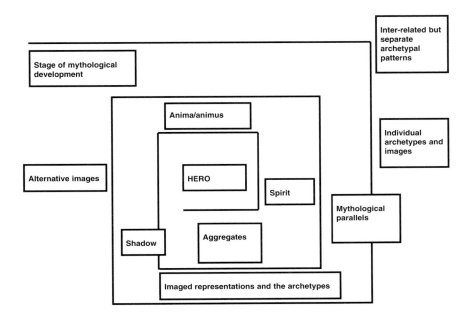

What is important is the fluid (or organic) nature of this model, as this allows for the possibility of a variety of archetypal images clustering around the same pattern. For anyone interested in the analysis of images, this is a useful way of approaching archetypes as it allows a number of different archetypal images, possibly from different cultures, historical periods, and even films, to gather around one central archetypal pattern. This leads to a fuller understanding of the formal and dynamic aspects of the archetype, and it offers an insight into the archetypal forces at work. This gives a better psychological insight into their meaning.

To summarise our findings so far, the objective psyche consists partly of an archetypal core which contains archetypal patterns. These archetypal patterns have the potential to structure the psyche and to regulate its development. Jung termed this the individuation process. The patterns, which are transpersonal, transhistorical, and transcultural, are expressed in a variety of images and differ from age to age, and culture to culture. In trying to organise archetypal forms, it is useful to select an archetypal theme, and to then see how various images cluster around it. These images can then be analysed to reveal their composition as both aggregate and discrete archetypal patterns, symbols and mythologems. In carrying out this process, the opposites of the archetypes, symbols and themes should be explored. These elements are interrelated and teleological, ie: they serve the well being of the psyche and are part of the individuation process.

A Model for the Application of Analytical Psychology in the Archetypal Analysis of Images

The final part of this chapter is concerned with the creation and evaluation of a model that helps to conduct a broad, archetypal analysis of a film. The task of creating a model from analytical psychology, that includes all the above points, is complicated by Jung's general remarks about the nature of the unconscious. For example:

> The unconscious is the matrix of all metaphysical statements, of all mythology, of all philosophy (so far as this is not merely critical), and of all expressions of life that are based on psychological premises.[26]

Given the encompassing nature of this statement, it is difficult to see how any model can be of use. The analytical psychologist M L von Franz has adopted this position in the following observation:

> Many people have criticised the Jungian approach for not presenting psychic material systematically. But these critics forget that the material itself is a living experience charged with emotion, by nature irrational and ever changing, which does not lend itself to systematization except in the most superficial fashion.[27]

Franz is right to draw attention to the organic and changing nature of the psyche. But this does not preclude the possibility of producing a clear, yet organic, model that is sufficiently responsive to allow for the changing nature of the material itself. While remaining alert to the dangers of exclusion and oversimplification, and despite the reservations of von Franz, the model provides one way to use analytical psychology to analyse films. As such, it provides a starting point, and a set of prompts, for conducting an enquiry into the archetypal nature of fiction films. It aims to present the previous points on archetypal theory in a more manageable form. (How this model assimilates the theoretical findings of the chapter will be discussed shortly.)

The model in its current form, illustrated below, does not include areas such as the psychology of the director (although, with the relevant type of theory, it could be extended to include this aspect). Nor does it explicitly examine the narrative of the film, (although in analysing narrative elements – such as myth themes and symbols – the narrative itself is examined *passim*). Neither is the model supposed to examine any specifically filmic techniques such as camera-work or editing. However, a consideration of these factors could, potentially, be derived from an analysis of the film's 'language', which is taken to include the *mise-en-scène*, the characters, and so on. How these elements relate to the wider myth/psychological themes, and how they are connected to specific filmic devices (such as editing) will become clear during the application of the theory in film analysis.[28]

Analytical Model

	Archetypal Pattern	Mythologem
Archetype's Image		
Mythology		
Individuation Process		

The model consists of six active squares, the outer squares being used only to label the axes. Reflecting Stein's observation, that all the parts of the analytic system are interrelated, it shows the changing and 'organic' relationships that exist between the different elements of archetypal analytical analysis. This allows for a flexible, yet formalised, approach to film analysis.

Before starting with an examination of the archetypal pattern column – which will be seen in relationship with the rows labelled, archetype's image, mythology, and individuation process – it is important to approach this exercise with a cautionary note. When imposing a formal scheme on something as slippery as an archetype, it is important to remind ourselves that archetypes are ultimately unknowable; so no matter how integrated the analysis, the archetypes will essentially remain mysterious. As Jung comments:

> No archetypes can be reduced to a simple formula. It is a vessel which we can never empty, and never fill. It has a potential existence only, and when it takes shape in matter it is no longer what it was. It persists throughout the ages and requires interpreting ever anew. The archetypes are the imperishable elements of the unconscious, but they change their shape continually.[29]

Thus it is not the intention of this model to reduce the archetype to a 'single formula', but to regard it as part of an integrated system composed of five elements: archetype's image, archetypal pattern, mythology, mythologem and the individuation process.

Starting with a consideration of the archetype's image, as it relates to the concept of the archetypal pattern, it is important to uncover exactly what pattern or patterns are being used at any given moment: for example, is it the hero, the father, the trickster or perhaps the wise old man; and what shape

(images) do these patterns take in the film? This, in turn, questions what these patterns are in opposition to. Both Jung and Stein stress the importance of the fact that opposites can be then reconciled as part of the individuation process. Thus the key questions for this square are: what archetypal patterns are revealed, how are they expressed and what are they in opposition to?

Progressing to the relationship between archetype's image and mythology, we need to look at two factors. First, what is the mythology of the film – how is its general imagery characterised and how does this relate to the archetypal patterns and images? Secondly, and more importantly, what are the historical parallels to the images? It is important that these parallels relate to the archetypal pattern. As Jung notes:

> The history of religion in its widest sense (including therefore mythology, folklore, and primitive psychology) is a treasure-house of archetypal forms from which the doctor can draw helpful parallels and enlightening comparisons for the purpose of calming and clarifying a consciousness that is all at sea. It is absolutely necessary to supply these fantastic images, that rise up so strange and threatening before the mind's eye, with some kind of context so as to make them more intelligible. Experience has shown that the best way to do this is by means of comparative mythological material.[30]

If Jung's advice is followed, we should attempt to discover as many mythological parallels to the film's central archetypal pattern as possible. Even if the myths may appear to differ widely, providing they inform about the movement and direction of the central archetypal pattern, then their use remains legitimate. The guiding questions raised by this part of the model are: what are the mythological parallels for the uncovered pattern, and how do they inform the impetus of the central archetypal pattern?

The last of the squares in this row prompts a consideration of the individuation process in the film, and of how this is reflected in the archetypal patterns and in the oppositions that are being unified. As already stated, opposition is vital to the Jungian argument, and because of this it is important to actively seek out opposition, and to see how the individuation process overcomes these apparent differences. As Samuels has commented:

> For Jung, bipolarity is the essence; it is a necessary condition for psychic energy ... Jung suggests that it is fruitless to search for the primary member of a pair of opposites – they are truly linked and cannot be separated; they involve each other... It is certainly true that Jung was influenced by Hegel, that he did conceive of psychological process in terms of discrimination and then synthesis of opposites. The experience of synthesising the opposites involves a process of balancing or self-regulation. Jung refers to this as compensation...Compensation may initially appear in the negative guise of symptoms. It is not to be thought of as implying that balance is regularly or easily attainable.[31]

Once this column is completed, we will have examined the following aspects of the film: the interrelationship of the archetypal pattern and its associated imagery; the historical parallels to this pattern and their imagery; how both the images and patterns relate to the individuation process, and noted how this process is visualised in the material under consideration.

The second column is concerned with the relationship between the mythologem and the archetype's images, and with the mythology and the individuation process. The first of these relationships derives from a consideration of the mythologem and the archetype's image. At this point we should attempt to discern the main theme of the myth and to see how this is connected to the images of the archetypes in the film. However, it would be unusual to find an uncomplicated statement of the mythologem clearly exposed and stated in the film. Whitmont explains why:

> To act out a mythologem literally would be stark madness. It is always a question of how much may be realized in terms of what is humanly, practically and ethically possible. Hence the archetypes too may have to be resisted and bargained with – in order to assimilate them in forms of what is realistically possible, but never are they to be lightly disregarded.[32]

As a result of this, the mythologem may be well concealed amongst the images, and it may become necessary to 'strip away' much of the film's language, symbolism and mythology to uncover the central myth theme. This is not an easy skill, and can best be acquired through a diverse knowledge of mythological themes, as this way the analyst becomes familiar with the recurring motifs.[33] Thus the central questions for this square are simply: what is the main theme and what are its auxiliary themes?

This interaction, between the mythologem and the archetype's images, may result in the production of mythological images. The archaic themes, which are the property of the mythologem, are constantly expressed and re-expressed in fresh and appropriate imagery. As Jung comments:

> We have to imagine a millennial process of symbol-formation which presses towards consciousness, beginning in the darkness of prehistory with primordial or archetypal images, and gradually developing and differentiating these images into conscious creations.[34]

Continuing this concept of 'symbol formation' in the model, prompts us to examine the interaction between the mythologem and the mythology. The reason behind this is that when the myth theme and the mythology interact, the symbols, which belong to the depths of the objective psyche, can be released. To once again quote Whitmont:

> Thus we are forced to resort to a cognitive mode which our rational development has tended to by-pass: the symbolic mode, which in the historical development of the human mind is found to be the active

element in the formation of recurrent mythological images.... This mythologem-forming symbolic approach is thus an approach to reality, especially to psychic or transpersonal or cosmic reality, which concedes our inability to know this reality in intellectual terms.[35]

The Analytical Model and its Central Guiding Questions

	Archetypal Pattern	Mythologem
Archetype's Image	What archetypal patterns are revealed, how are they expressed, and what are their opposite patterns?	What is the main myth and what are its auxiliary myth themes?
Mythology	What are the mythological parallels to the uncovered pattern, how do these parallels inform as to the impetus of the central archetypal pattern?	What symbols are iberated in this myth, and how do they relate to both the archetypal pattern and individuation process? What oppositions do they contain?
Individuation Process	What oppositions are being unified in the individuation process?	How do the myth themes relate to the individuation process?

Thus the questions for this square are: what symbols are liberated in this myth, how do they relate to the archetypal pattern and the individuation process, and what oppositions are contained with these symbols?

Finally, the mythologem needs to be viewed as an integral part of the individuation process. As von Franz has observed:

> ... beneath the surface a person suffering from a deadly boredom that makes everything seem meaningless and empty. Many myths and fairy-tales symbolically describe this initial stage in the process of individuation.[36]

However, the mythologem may also describe a more advanced stage of the individuation process. Thus it becomes necessary to discover the correlation between the individuation process and the way in which it is reflected in the mythologem, mythology, archetypal pattern and archetype's image. Once this is achieved, it should render a detailed understanding of the stage that individuation has reached, and its visual depiction. So the question for this square is quite simply: how do the myth themes relate to the individuation process?

Once this column is completed, the film analysis will have examined the myth theme, seen this in tandem with the mythology of the film, and observed the resulting symbols. It will have seen how the theme, the symbol and mythology all interrelate and are expressed in the imagery of the individuation process. In conclusion, this has been a short introduction to the model, intended only to give a general overview and provide a context. Developing this, the next chapter is a brief example of how the model can be applied in a practical film analysis.

Notes

1 c.f. C. W. 8: 154.
2 Kant, I., *Critique of Pure Reason*, Translated Smith, N. K., (London, 1929), B4.
3 c.f. C. W. 14:129, C.W. 9,.I:123f, C.W.12:149.
4 Hauke., C, *Jung and the Postmodern: The Interpretation of Realities*, (London, 2000): p28.
5 Samuels: p24.
6 Smith, M., *The Theory of Evolution*, (London, 1958). This edition, (London, 1966): p13.
7 Samuels: p25.
8 C. W. 9, I: 89-90.
9 C. W. 8: 417.
10 Hauke, 2000 p34.
11 C. W. 9, I:265.
12 Whitmont, E. C. *The Symbolic Quest: Basic Concepts of Analytical Psychology*, (Princeton, 1978): p79.
13 Whitmont: p73-74.
14 Harvey, S., 'Woman's Place: The Absent Family, in, *Film Noir'* pp 35-46, in Kaplan (ed) *Women in Film Noir* (London: 1999).
15 C. W. 16: 354.
16 C. W. 18: 371.
17 C. W. 9, I: 271.
18 C. W. 9, I: 221.
19 C. W. 9, I: 222.
20 C. W. 9, I: 513.
21 Samuels, A., Shorter, B., Plant, F., *The Father, Contemporary Jungian Perspectives*, Ed. Samuels, (London, 1985): p250.
22 Gray, R., *Archetypal Exploration: An Integrative Approach to Human Behviour*, (London, 1996) p. 84.
23 c.f. Samuels, A., *Jung and the Post Jungians*, (London, 1985) p:32.
24 ibid p:32.
25 c.f. Stein, L., 'Introducing not Self', *Journal of Analytical Psychology*, Vol. 12: 2 (1967).
26 C. W. 11: 899.
27 von Franz, M. L., 'The Process of Individuation', in: *Man and His Symbols*, Ed. Jung. C. G. and von Franz, M. L. (London, 1964). This edition, (London, 1978): p167.

28 Indeed it might be more profitable to think of the term 'mythology' as including these specifically cinematic elements. If such an extension was made, it would be necessary to demonstrate how this mythology of form relates to the central mythologem of a given film.

29 C. W. 9, I: 301.

30 C. W. 12: 38.

31 Samuels, A., *Jung and the Post Jungians*, (London, 1985): p293.

32 Whitmont: p128.

33 This idea has a parallel in genre theory, in which a single film is viewed in the context of a variety of similar films and from this the 'conventions' of the genre arise. c.f. Grant. B.K., editor, *Film Genre: Theory and Criticism*, (Methuen, 1977): p31.

34 C. W. 11: 469.

35 Whitmont: p34.

36 von Franz: p170.

5

Re-reading *Blade Runner*

Howard (Robert Ryan): *I don't think I ever loved anyone, and I know that no one ever loved me.*

Beware My Lovely (Harry Horner: 1952)

Introduction

The function of this chapter is to use the model that was introduced at the end of the previous chapter to analyse *Blade Runner* (Ridley Scott: 1982). This science fiction *film noir* is well suited as an example for the model because, even though it is a well-known film and often examined by film scholars, none of the current analysis of the film has drawn attention to its rich variety of symbolic, mythic and archetypal themes. Giving us a cue as to what to look for, the analytical psychologist Luigi Zoja has suggested that Hollwood films have a particular role in presenting images of the mythological heroic.

> As the guiding force of the Western world, America has also invented the form of narrative that dominates it. Hollywood has written the codes that control modern narrative and has thereby established the nature of the modern hero: we are presented with men and women who choose, who align themselves with the powers of goodness, who entrust its redemption to wilful action, and who never doubt its final triumph.[1]

However, as the analysis will show, *Blade Runner* is atypical in that the certainty and surety of the hero is under question. What Zoja is right to point towards is the capacity of Hollywood narratives to voice cultural hopes and desires, and to express fears and anxieties. In examining *Blade Runner*, from the perspective of analytical psychology, we will re-read the film and reposition it as not just a film-text, but also as a psychological artefact.

Blade Runner is set in Lost Angeles, 2019, with a narrative that is structured and centred round Chinatown. The hero-detective, Deckard, is brought out of retirement from the police 'Blade Runner Section', with orders to capture and destroy (or 'retire') some escaped replicants. Replicants are biogenetic robots – supposedly perfect humans – which have been created for specific tasks; for

example, there are replicants who are warriors and replicants who are prostitutes. Whatever their role, all replicants share an inability to experience emotions, and in this respect they are very much less than human. The replicants have escaped from the 'off world colonies' because they discovered that their life expectancy is only four years, and they plan to persuade their 'maker', Tyrell, to extend their longevity. Deckard hunts down and retires all but one replicant, Rachel. Rachel has mysteriously started to develop and experience emotions, and Deckard too finds his feelings getting out of control. Eventually they fall in love, and escape together to live in the open countryside of 'the north'.

Archetypal Pattern and Archetype's Image

The clearest and most easily identifiable archetypal pattern in *Blade Runner* is the hero. This is embodied in the image of Deckard – a hero-detective who is on a mission, or a quest. The metaphor of the quest operates on two distinct levels. The most straightforward of these is shown in his search to track-down and retire the replicants. But there is another quest. As the film progresses, Deckard finds that he is plagued with emotions, even though as a Blade Runner he is not supposed to have feelings. In one sense the narrative of the film is not just about 'retiring' replicants, it is also concerned with Deckard's personal search to understand himself and his job as a Blade Runner. In achieving these personal insights, he must understand his psychological relations with the people around him. (It is this activity of bringing the objective psyche into consciousness that characterises the individuation process.) If the characters that he encounters throughout the film are regarded partly as characters in their own right, and also projections of various aspects of Deckard's psyche, then his quest is revealed as part physical and part psychological. One clear example of this type of projection is the character of Rachel, who personifies certain elements of Deckard's anima. As this analysis progresses, we will see the importance of Rachel as an anima figure, representing, for Deckard, the power of emotion and providing the opportunity for him to escape the confines of the city and leave behind his role as Blade Runner. Perhaps, as well as being a story about replicants, *Blade Runner* is also a quasi-mythological story about a symbolic search for self-understanding and the desire to acknowledge and embrace the anima. Jung comments:

> The persona, the ideal picture of a man as he should be, is inwardly compensated by feminine weakness, and as the individual outwardly plays the strong man, so he becomes inwardly a woman, i.e., the anima, for it is the anima that reacts to the persona.[2]

However, before the individuation process can get underway and Deckard can accept the task of understanding and integrating his anima, he needs to acknowledge that the psyche exists in a state of opposition and tension. For Deckard, this realisation starts when he first meets Rachel, who her maker Tyrell describes as 'More than human'. Of course Rachel is also less than

human, as Deckard discovers when he realises that she is a replicant – although she is unaware of this fact. This gives Rachel an ambiguous quality that reflects her role as a recipient of Deckard's unconscious projections and fantasies; indeed, he relates to her as a projection of his anima and not as a replicant. It is after this first meeting with Rachel that Deckard realises he is beginning to change; he is starting to enter the world of emotions, a world that, as a rational Blade Runner, is new and strange territory for him. This is obvious in his remark, 'Replicants weren't supposed to have feelings, neither were Blade Runners. What the hell was happening to me?'

However, before he can really accept and integrate his anima, he must first come to terms with other aspects of himself. These elements are personified by the other replicants. For example Zhora, as an erotic dancer, symbolises the sensing part of Deckard; and when that aspect is 'retired', he is able to move deeper into the psyche. After despatching her, Deckard comments, 'There it was again. Feeling in myself for her, for Rachel.' By contrast, the replicant Roy personifies the aggressive and warrior-like aspects of Deckard's persona. Towards the end of the film, Deckard has to quite literally do battle with Roy before the replicant finally 'dies'. It is only after this final confrontation that Deckard is able to escape the confines of the city with Rachel; and with the potential to live in wholeness and peace in the countryside. The replicant Pris embodies a violent and negative expression of the anima that unsuccessfully attempts to kill Deckard by crushing his head between her legs. This serves to point up the ambiguity that he feels towards the whole process of self-discovery; he is both drawn to it but also afraid. This is progress for Deckard because this type of ambiguity needs to be accepted: it is part of they way in which the anima can be integrated into consciousness.

Development of Hero Deckard

Hero – meets anima – Rachel
Hero – retires sensation self in Zhora
Hero – retires anima's negative aspects in Pris
Hero – overcomes the old warrior-self and moves through to intuitive phase
Hero – integrates his anima, Rachel

While discussing specific archetypal figures in *Blade Runner*, it interesting to speculate on the appearance of, what may be, the archetype of the wise old man. Jung comments on this archetype noting:

> … figuratively speaking, he is the 'informing spirit' who initiates the dreamer into the meaning of life and explains its secrets according to the teachings of old. He is a transmitter of the traditional wisdom. But nowadays the fatherly pedagogue fulfils this function only in the dreams of his son, where he appears as the archetypal father figure, the 'wise old man'.[3]

The figure of Gaf is, in some ways, a transmitter of such advice, but he his also a somewhat mysterious character. His age is uncertain, but he seems older than the hero; he is possibly oriental and throughout the film doesn't say much. In narrative terms, he remains one step ahead of Deckard and, with apparent foresight, seems to know where the hero can be found. Gaf communicates partly through the models that he creates. His partial silence gives him an air of mystery that calls to mind the saying from the Tao, 'Those who know do not speak; those who speak do not know'.[4] This hints at one of the film's central themes, namely: illusion. While Gaf does not speak, he still exhibits great insight as his symbolic communications give him a proximity to the objective psyche.

Archetype's Image and Mythologem

As mentioned, the quest is one of the central narrative themes of *Blade Runner*. However, it is a quest for self-understanding which, in mythological terms, is expressed in imagery of new life from old, or, as Jung might put it, as a rebirth of the psyche. The image of the quest is also a metaphor of the individuation process, and this suggests that there is a link between the mythologem of the film, and its archetypal patterns. To mix the language of *Blade Runner* with the terminology of analytical psychology, Deckard is engaged on the retirement of the old psyche and subsequent resurrection of the new, partly individuated, Self. This marks an extension of the myth theme to include a progression from life, to a death of the old life, to a new life. The narrative articulates this theme at its closure when Deckard remarks of the replicant Roy, 'His questions were the same as ours. Where have we come from? Where are we going? How long have we got?' In the world of symbols, these themes of life and death are connected. As Jung notes:

> For in the secret hour of life's midday, the parabola is reversed, death is born. The second half of life does not signify ascent, unfolding, increase, exuberance, but death, since the end is its goal. The negation of life's fulfilment is synonymous with the refusal to accept its ending. Both mean not wanting to live, and not wanting to live is identical with not wanting to die. Waxing and waning make one curve.[5]

As already mentioned, there is a secondary myth theme of illusion, and as we will see this is, in turn, connected to the themes of life and death. From the beginning of the film, the narrative and *mise-en-scène* of *Blade Runner* are preoccupied with images. The giant Coca-Cola advert, which features an oriental woman drinking, recurs throughout the film. There is the photograph that provides a vital clue in tracking down a replicant, and the old pictures which sit on Deckard's piano. As post-modernist criticism has made clear, images are not real; they are representations of reality that have an ambiguous and illusory quality. But it is not just images that are illusions in *Blade Runner*: the replicants also have an illusory quality in that they look human, but are not. In an attempt to make them feel human, their creators at the Tyrell Corporation

gave them other people's memories. This compounds their illusory quality, as their existence and sense of self is based on a deception – they have no real memories and no feelings. So the replicant Pris is like a toy doll, and in one scene she even moves in an animated, clockwork fashion. Zhora's illusion is different. With a replicant snake, in a sleezy Chinatown bar, she performs as an erotic dancer selling the illusion of sex. While Roy has seen many fantastic sights, he is unable to possess that wonder, because he has no feelings – he is hollow or soulless. Finally, though not a replicant, Sebastian is also an illusion; on account of having a disease called 'Medusila Syndrome',[6] he appears to be in his 50s, while in fact he is only twenty-five. This idea – that paradox and illusion provide true understanding and insight – is central to many oriental philosophies. Perhaps this goes some way to explaining why the film is partly set in Chinatown, and suggests another link to the wise old man, Gaf. As the Tao comments:

> Everything is its own self; everything is something else's other...where there is life, there is death; and where there is death, there is life...whether in construction or in destruction, all things are in the end brought into unity...[7]

This resonates with the previous quote from Jung ('not wanting to live is identical with not wanting to die'[8]) and indicates how the themes of life, death and illusion are connected. Thus the central mythologem and the archetype's images are united in the themes of life-death-life (or rebirth), and illusion – both of which stress the ambiguous and transitory nature of existence. Both themes find a futher expression in the subsidiary metaphor of the quest, which is both the search for the replicants and the search through illusion for reality – even if this reality is ultimately an illusion. The quest is also an allegory for the individuation process and this is clearly connected to the rebirth theme. For Deckard, individuation is intimately bound up with his search. It is this search that takes him into the depths of the unconscious as, for him, part of individuation is a coming to terms with the ambiguity of his life and therefore with the ambiguity of his reality.

Mythology, the Archetypal Pattern and Images

The questions we are prompted to consider are: what mythological parallels can be found for the rebirth and illusion themes, and how do these inform us about the archetypal pattern and its images?

The visual backdrop of *Blade Runner* is a wet one! The film is set against a background of almost constant rain; even when it is not on screen, it can be heard on the soundtrack. While Riddley Scott has written about the practical necessity of this – to obscure some badly made sets, and the limited size of the lot – in narrative terms there is still a symbolic quality to the rain. The importance of water in the film gives a clue as to where to look for appropriate mythological parallels.

Rain, and flooding in particular, are common mythological themes. For example, the Hindu myth of how Manu survived the flood:

> When he was washing himself, a fish came into his hands. It spoke to him the words 'Rear me, I will save thee!' 'Where-from wilt thou save me?' 'A flood will carry away all these creatures: from that I will save thee'... he attended to (the advice of the fish) by preparing a ship; and when the flood had risen, he entered into the ship...The flood swept away all creatures, and Manu alone remained here.[9]

The Babylonian flood-creation myth told by Ut Napishtim to Gilgamesh, after he had crossed over the sea of death, has similar qualities. Notice that even in the telling of the story, death and creation are linked:

> The wide land was shattered like a pot! For one day the south storm blew, submerging the mountains, overtaking the people like a battle...When the seventh day arrived the flood (carrying) south storm subsided in battle.... And all mankind had returned to the clay.... The dove was sent forth, but came back; there was no resting place for it and she turned round...[10]

A final example of the flood-creation myth is the well-known story of Noah. Here, as in the myths cited above, the created world is wiped out by a flood, and once purged it is repopulated by the animals and people who were protected in the ark:

> The water swelled above the mountains, covering them fifteen cubits deep. And all flesh died that moved on the earth, birds, domestic animals, wild animals, all swarming creatures that swarm on the earth, and all human beings...Then God said to Noah, 'Go out of the ark, you and your wife, and your sons and your sons' wives with you. Bring out with you every living thing that is with you of all flesh – birds and animals and every creeping thing that creeps on the earth – so that they may abound on the earth, and be fruitful and multiply on the earth'.[11]

As in the Gilgamesh flood creation myth, a dove is sent from the ark. The symbolism of the dove will be explored in detail in the myth/mythology section. But it is worth noting that the dove, along with the symbolism of water, is directly linked with the initiation ritual of baptism. In this Christian ceremony, water symbolises the washing away of the old life so that one can be 'born again' into a new life in Christ. It was at the baptism of Jesus that the Holy Spirit descended in the form of a dove: 'And when Jesus had been baptized, just as he came up from the water, suddenly the heavens were opened to him and he saw the Sprit of God descending like a dove and alighting on him'.[12] The Christian tradition is not alone in possessing an initiation ritual that uses water. To choose two myths from many, there is Diksha, a Hindu, initial ritual of rebirth,[13] and from a Western source there comes the Irish myth of Cuchulainn's initiation.[14]

In the search for parallels to the central myth, it is interesting and helpful to divert briefly to literature and the storm images in Shakespeare's play, *King Lear*. The central, and pivotal, act of the play occurs during a tempest; by this point in the story Lear is already a broken man; he has fallen from his role as monarch to, quite literally, a state of naked humanity. However, this is a temporary condition that he will move through, and in so doing achieve a greater depth of human understanding. The irony is that as a ruling monarch Lear in fact controlled nothing, while here, in his madness, he calls upon the elements to destroy the world.

> Blow, winds, and crack your cheeks! Rage! Blow!
> You cataracts and hurricanes, spout
> Till you have drenched our steeples, drown'd the cocks!
> You sulphurous and thought-executing fires,
> …
> Strike flat the thick rotundity o'er the world,[15]

The start of *Blade Runner* echoes this type of apocalyptic imagery, where jets of fire soar into the sky. Lear needed the storm to wash away the old psyche, or, in apocalyptic imagery, to destroy the old Lear, so that a different person could emerge the other side of the storm. Deckard, Lear-like, also needs – as part of his psychological development – to loose his old-self. The rain imagery in *Blade Runner* also recalls, albeit in a less violent manner, the storm imagery of *King Lear*.

Blade Runner is concerned not only with individual renewal, but also with creation and re-creation on a cosmic scale. The constant rainfall over the city symbolises this universal dimension. As if to emphasise this, the film opens with a night shot of rain and lightning enveloping the city. Thus, as a hero, Deckard is elected to face – in microcosm – the life-death-life process of his personal individuation, so that he is able to aid in the macrocosm of the culture's individuation process. Much as Christ died to save the world, so too Deckard dies to the old-self to aid his society. Interestingly, at the end of the film Roy, the warrior, extracts a nail from a piece of wood and plunges it into the palm of his hand, deliberately creating the marks of the stigmata. And Deckard, as already noted, has to pass on to the next stage, leaving the dead and 'crucified' Roy behind.

Mythology and Mythologem

It seems appropriate to start this section with a reminder of the importance of symbols in analytical psychology – later chapters will develop a more detailed, and theoretical, assessment of their significance. Until then, the following quotation may prove helpful in pointing us in the right direction.[16]

> We only understand that kind of thinking which is a mere equation, from which nothing comes out but what we have put in. That is the working of the intellect. But besides that there is thinking in

primordial images, in symbols which are older than the historical man, which are inborn in him from the earliest times, and, eternally living, outlasting all generations, still make up the ground work of the human psyche. It is only possible to live the fullest life when we are in harmony with these symbols; wisdom is a return to them.[17]

The key point to keep in mind during the analysis of the symbols in *Blade Runner* is that while all symbols contain a variety of possible interpretations, and by their nature seek to reconcile opposites, it is possible, throughout the narrative of the film, to detect a unifying theme. *Blade Runner* is permeated with symbols that are concerned with growth through contradiction. For example, how can death lead to life, or how can illusion expose reality?

One of the first symbols we encounter in *Blade Runner* is the constant rain. This symbol has already been analysed in some depth, and we saw how the narrative of the film can be understood in terms of flood creation myths. Deckard, like all others in the city, suffers from the effects of the rain, and if he is to survive this symbolic flood, then he must move forward in his individuation. One of the symbols for Deckard's ongoing individuation is the eye, and, through several close-ups, the film draws our attention to this key symbol. (Eyes are very important in *Blade Runner* because, with the use of 'Voight-Kampff' equipment, they are the way in which a replicant can be detected.) Eyes indicate sight, but in the world of symbols, opposites are unified, and the eye indicates outward conscious sight, but inward blindness. In other words, Deckard has no 'insight', or if you prefer, he lacks self-awareness.

It is a cliché that 'eyes are the windows of the soul', but in the case of the replicants this observation holds good. They possess no feelings or emotions, and, while they are outwardly human, they remain inwardly cold and alien. Because of their inability to feel, the replicants are blind to reality, much as Deckard is blind to the reality of life's ambiguities and illusions. If he is to progress with individuation, Deckard must accept the paradoxical and illusory aspects of his psyche, and this involves accepting the objective psyche with its symbolic communications. (It will be remembered that symbols, paradoxically, seek to reconcile oppositions, and that ultimately their interpretation is subjective.)

Again, it is in *King Lear* that we find a similar type of imagery. At the moment when Gloucester, because of his blindness to what happens in the world, has his eyes gouged out, he comments, 'I have not way and therefore want no eyes; I stumbled when I saw'.[18] It would seem that Deckard needs to have this type of symbolic insight. Again, but this time turning to oriental sources, the Buddha comments, 'The eye, O priests, is on fire; forms are on fire; eye-consciousness is on fire; impressions received by the eye are on fire'.[19] This is directly applicable to the film's imagery – especially at the start of the film where jets of flame curl around the edge of a giant close-up of an eye. Symbolically, this suggests a need for a change in Deckard's conscious awareness. Images and forms received from the eye are on fire; the old illusions are destroyed and hence can be transcended precisely though an acceptance of their illusory qualities.

It is with this realisation that Deckard starts his quest in Chinatown. In detective films this is traditionally a place of crime, wisdom, treachery and yet security. The detective seems peculiarly at home in such a place, perhaps due to its closeness to the intuitive world of the 'mystical east'. In *Blade Runner*'s Chinatown, the atmosphere is claustrophobic and polluted, the people talk in 'city speak', a babbling conglomeration of Western and Eastern languages. The chaos in the city calls to mind the Biblical myth of the tower of Babel. This Babylonian imagery provides a link back to the flood creation myths (two of which came from Mesopotania) and forward into the film's developing imagery, as the first place Deckard visits on his quest for individuation is the Ziggurat of the Tyrell Corporation.

The Ziggurat, a Babylonian religious building with stepped sides, symbolically depicts the upward climb in search of spiritual truth. However, its highest point, which is a flat roof, is empty – ultimately nothing is found – *imago ignota*. Inside the Tyrell building the atmosphere of Mesopotanian religion continues with a pyramidic background, and a warm yellow light which gives the atmosphere a numinous charge. It is in this semi-divine environment that Deckard first meets Rachel, who, as discussed above, represents a projection of his anima's positive aspects. With a series of close-ups, the attention of the viewer is also drawn to an owl, the first of three symbolic animals to be encountered in *Blade Runner*.

It is worth noting how dominant this theme of illusion is in *Blade Runner*. Even two of these animals, the snake and the owl, are replicants, in other words they are unreal animals. This is made evident in a close-up of the owl where, again, it is the strangeness of the eye that reveals it as a replicant. The symbolism of owls is complex, but in mythology they stand for wisdom and its opposite: foolishness. They can also symbolise death:

> On a Sumerian tablet dating from 2300-2000 B.C. a nude goddess is depicted flanked on either side by an owl. She is believed to be the goddess of death. In Semitic countries the owl is usually regarded as ominous and in Persia is spoken of as 'the angel of death'....[20]

As we might expect, the owl also symbolises the opposite of death – that is, new life and procreation: '...in Israel little grey owls are considered good omens when they appear near the crops'.[21] Additionally, Chetwynd notes that the closest animal to the goddess Athene was an owl, and he adds that Athene is the, 'personification of the anima'.[22] This supports the interpretation of Rachel as Deckard's anima.

The second symbolic animal is a snake. After Deckard meets Rachel he returns to the city. Here he first finds Zhora, the sensation aspect of his ego. Her job as dancer with a snake in an erotic cabaret show, suggests the figure of Eve and the creation myth of the Garden of Eden. However, the symbolism of the snake is varied. For example, snakes can move on both land and water, and these are symbols of the conscious and unconscious respectively. The flying snake may

symbolise the liberated anima, and the Gnostic image of the Uroboros, depicts a snake, in a circle, eating its own tail. The opposition contained within the Uroboros is clear: like Deckard, the snake renews its-self by destroying its old-self – quite literally, it eats its own body. For Deckard, this self-destruction takes the form of retiring replicants. Again, apparent contradictions in the symbol in fact tell us something about the archetypal pattern and mythologem.

The final symbolic animal does not occur until the end of the film when Roy, at the moment of his 'death', releases a dove. The symbol of the dove unites several of the sub-themes in *Blade Runner*. First, it ties together the two flood creation myths as both Noah and Gilgamesh sent forth doves from their arks in search of dry land. This idea of re-creation is echoed in the ritual of baptism where the holy spirit is received; and as mentioned at Jesus' Baptism, this took the symbolic form of a dove. Thus the dove symbolises both rebirth into new life and the holy spirit. It is interesting to note that the Greek world for spirit, also meaning either wind or air, is *pneuma* (this will be returned to shortly). The Hebrew word for the same concept is *ruach* which means breath. It was this *ruach* (the breath of god) that hovered over the surface of the deep, in the first Genesis creation myth. Finally, bringing us full circle, the Latin for the concept of spirit is anima. So through the symbol of the dove, we discover that anima is the concept which unites the themes of creation, death, life and rebirth.

The Individuation Process

The process that ties together the themes, symbols, and concepts in *Blade Runner* is the individuation process. This is most clearly represented in the image of the quest, and in the creation-re-creation and initiation myths. The following is an exploration of Deckard's individuation process that tries to work out his progress by the end of the film. After Roy releases the dove, Deckard is free to accept his anima, and the final shots of the film are of Deckard and Rachel flying through the air as they escape from the city. Finally, it has also stopped raining and now they are in the temperate regions of the, seemingly, individuated psyche. At this point, a voice-over reveals that Rachel, unlike the other Nexus Six replicants, does not have an incept date, and consequently no one knows how long she will live. Perhaps the message is that the spirit lives eternal.

The creations of Gaf give additional weight to this reading. He creates three small objects – a bird, a matchstick man and a unicorn – and leaves these for Deckard to discover at different points in the film.[23] The creation of the bird comes first, and seems to suggest Deckard's potential freedom; it also pre-echoes the symbolism of the dove which occurs at the end of the narrative. The matchstick man may refer to Deckard's need to accept the many aspects of the psyche which make him human. However, the unicorn is the most interesting symbol and this occurs almost immediately after the dove at the end of the film. According to Jung, 'In Christian picture-language the unicorn, as well as the dove, is a symbol of the spermatic Word or Spirit'.[24] Gaf seems to have

recognised the need for Deckard's individuation. When he visited Deckard's flat he did not retire Rachel, who was sleeping there, but instead left a symbol of Deckard's future life.[25] However, the symbol of the unicorn is complicated.[26] As Jung notes:

> The horn of the unicorn acts as an alexipharmic, because it expels the poison from the water, and this refers allegorically to the baptism of Christ... rightly as it applied to Christ baptized, who, like the chosen son of unicorns, sanctified the streams of water to wash away the filth of all our sins.[27]

But in this final section of the film there remains an ambiguity: has Deckard really achieved individuation or not? From the above reading it is tempting to conclude that he has reached the anima stage of individuation, but this is by no means certain. Rachel, as a personification of his anima, still exists as a separate entity and does not yet live in him. Also, Deckard still tries to tell Rachel what to do – 'trust me' he requests: so rather than trusting in her, he trusts himself and requires her to do the same. There is a sense in which he seems stuck at this stage; he has not reached the end of his quest. At this point in his life, Deckard seems content to live with illusion: he exchanges the illusions of the city for those of a super-lush countryside valley (the first 'natural' sequence of the film). Does he think that this environment is better suited to the anima which he still projects onto Rachel? As already stated Deckard does not know how long Rachel will live. Is he anxious about this? Does this indicate some future development in their relationship? These questions remain unanswered and, for the viewer, this seems right.

However, by the end of the film the tone seems optimistic; Deckard has done well on his quest and has progressed down the road of self-knowledge. Who is to say where it will end? As the Tao remarks:

> The valley spirit never dies.
> It is named the Mysterious Female.
> And the Doorway of the Mysterious Female
> Is the base from which Heaven and Earth sprang.
> It is there within us all the while;
> Draw upon it as you will, it never runs dry.[28]

In the film, it is the symbolic images of water, baptism, and cleansing which are brought forth and joined in the theme of rebirth. All the different strains in the film seem united in the main theme, which is a representation of the individuation process. It appears that the analytical archetype model has enabled the discovery of a series of latent mythological motifs. These connect in a coherent, but hidden, manner with the symbolic structure of the film, and provide *Blade Runner* with a unified, but concealed, form. Further, underlying these elements, the model has also identified a representation of one stage in the individuation process, and examined how this links to the subsidiary theme of illusion. Ultimately, the hero is seen as someone who experiences the

individuation process. On a cultural scale, this suggests a latent unconscious need for individuation; a need which the film, in some small way, both compensates for and expresses.

One of the interesting areas in *Blade Runner* is the role that symbols have within the film. The next chapter explores this theme and provides a theoretical examination of how analytical psychology views the symbolic function. The chapter also applies the theory directly to film analysis, and this develops both the theoretical basis and practical application of the model.

Notes

1 Zoja, L., *Analysis and Tragedy*, in Casement, A., (eds) *Post-Jungians Today: Key Papers in Contemporary* Analytical Psychology, (London, 1998): p41.
2 C. W. 7: 309.
3 C. W. 12: 159.
4 *Tao Te Ching*, in *From Primitives to Zen*, Ed. Eliade, M., (London, 1977). This edition, (London, 1983): p600.
5 C. W. 8: 800.
6 Medusa was also connected with illusion. She was the only mortal of the three Gorgan sisters. All who saw her turned to stone. As a result she could only be looked at safely via a mirror; only her reflection, that is her illusion, was safe.
7 Eliade, (1977): p602-603.
8 C. W. 8: 800.
9 Eggeling, J., Trans. *The Sacred Books of the East*, (Oxford, 1982): p216-218.
10 Speiser, E. A., trans. *Ancient near Eastern Texts*, (Princeton, 1950): p60-72.
11 The Bible. *New Revised Standard Version: Anglicized Edition. Genesis* 7: 20-21, and 8: 15-17, (London, 1989).
12 The Bible, *Matthew* 3: 16.
13 c.f. Eliade, M., *Birth and Rebirth*, (New York, 1958) p54.
14 c.f. Eliade, (1958) : p85.
15 Shakespeare, W., *King Lear* Act III, Scene II, lines 1-9.
16 For a detailed discussion of what constitutes a symbol, c.f.Whimont, *The Symbolic Search*: p159.
17 C. W. 8: 794.
18 Shakespear, *King Lear*, Act IV, Scene I, line 19.
19 Buddha, *The Fire Sermon*. From: *The Teachings of the compassionate Buddha*, ed. E.A. Burtt, (New York 1955). This edition, (New York, 1982) p97.
20 Warner, R., *Encyclopaedia of World Mythology*, (London, 1970): p220.
21 Warner: p220.
22 Chetwynd, T., *A Dictionary of Symbols*, (London, 1982): p36.
23 The bird and unicorn are origami pieces and there may be an extra reference to the creation myths, as each animal is made from a single square of paper.
24 C. W. 5: 492.
25 It seems only reasonable to indicate that on a few occasions the unicorn can symbolise evil, but here that does not seem to be the case. (c.f. C. W. 12: 522).
26 As a point of information there is some evidence to suggest that the fish Manu hooked, cited above was unicorned. C.f. C. W. 12: 533.
27 For a detailed account of the unicorn's symbolic role, c.f. C. W. 12: 518-554.
28 *Tao de Ching*, in Eliade (1977): p595.

6

The Symbolic Search

Gilda (Rita Hayworth): *I can never get a zipper to close. Maybe that stands for something. What do you think?*

Gilda (Charles Vidor: 1946)

This chapter has two functions: first, it provides a detailed examination of what analytical psychology means by the term 'symbol'; and secondly, it applies this theory to the analysis of two detective films. The first section establishes a general context for understanding symbols and this develops into a specific psychological consideration of how symbols function within the objective psyche. Having established a clear and theoretical base, it is applied in the film analyses. The two films chosen are *Sleuth* (Mankiewicz: 1972), and *The Woman in the Window* (Lang: 1944). Looking at two extracts from these films indicates how they give expression to apparent oppositions within the narrative, and also to how they prepare the way for the psychological development of the film's central characters.

A Context for Understanding Symbols

The Western intellectual tradition is routed in a mechanistic rationalism that emerged in the Sixteenth and Seventeenth centuries. With it came the dominant image of the 'world machine', which conceived the universe as a large and intricate piece of celestial engineering. This view pervades the scientific discoveries of Galileo, the philosophical dualism of Descartes, and later the observations of Newton and Darwin.[1] It also extends to the modern psychologies of psychoanalysis, behaviourism and cognitive psychology. As a result of this, the behaviourist Skinner is able to write, 'What we need is a technology of behaviour...comparable in power and precision to physical and biological technology'.[2]

However, there is a growing dissatisfaction with this mechanistic paradigm, and it has been extensively criticised by such writers as Bateson (1972, 1979), Sheldrake (1981), and Capra (1975, 1982). What is emerging, from their criticism, is the need for a new holistic, and systemic, view of the world. From the Jungian perspective, this insight comes as no surprise. As Capra has commented:

Indeed, it seems that Jung's approach was very much on the right lines and, in fact, many of the differences between Freud and Jung parallel those between classical and modern physics, between the mechanistic and holistic paradigm.[3]

The analytical psychologist Andrew Samuels has used this as something of a post-Jungian rallying cry. His suggestion is that analytical psychology is not only well-placed to understand and analyse what is happening in society, but could, and should, lead cultural change.

So we can not only join in a cultural move that's going on in the universities and in society generally, we can lead it, because our very work has always depended on going beyond the conventional subject-object divide of classical Cartesian science.[4]

Fundamental to this is an emphasis that runs throughout Jung's writings, in which he insists that rationalism is an attitude that lacks both the capacity for introspection and the ability to form symbols. The reasoning behind this generalisation is that symbols can only be formed, or released, from the unconscious when an introspective and non-rationalistic approach is adopted. This is consistent with the Jungian position that the objective psyche provides the basis for psychological development and regulation. Consequently, if we are to have a psychologically healthy life, then we must pay attention to our inner lives – to our unconscious.

Whitmont states this classic Jungian position clearly (it is important to note that in using the term 'image', he is referring specifically to the symbolic image).

Not only is the presence of the image not pathology but the loss of awareness of the image dimension (which is the loss of contact with inner reality, as we shall see) gives rise to pathology.[5]

What Whitmont means by this is that an awareness of symbols is an essential part of psychological development. Thus, from the perspective of analytical psychology, it is important to adopt, at least to some degree, an introverted attitude, as this provides a route through which symbols can be released into consciousness. In the final analysis, Jung suggests that it is only the symbol that can connect us with our deepest and most fundamental problems.

Reason must always seek the solution in some rational, consistent, logical way, which is certainly justifiable enough in all normal situations but is entirely inadequate when it comes to the really great and decisive questions. It is incapable of creating the symbol because the symbol is irrational. When the rational way proves to be a *cul de sac* – as it always does after a time – the solution comes from the side it was least expected.[6]

It also concerned Jung that, while the old symbols were dying, society did not appear to be creating new symbols that could replace these disappearing

images. He felt that somehow Western society had disconnected itself from the unconscious, and that scientific rationalism was at the root of this problem. As a result, a vital part of Jung's endeavours involved finding ways that modern society could reconnect itself to its fading psychological heritage.

> I am convinced that the growing impoverishment of symbols has a meaning. It is a development that has an inner consistency. Everything that we have not thought about, and that has therefore been deprived of a meaningful connection with our developing consciousness, has got lost.[7]

Principally, he found this lost heritage in myths, and the symbols they contain. Jung discovered, in mythological motifs, a series of patterns he felt were expressions of the archetypes of the objective psyche. In clinical work, it became his task to help the patient recognise these myths, and to assimilate their archetypal patterns and symbols into consciousness.[8] Initially, it might seem from Jung's remarks that he believed contemporary Western society to be devoid of symbolic products, but this was not the case. What he actually suggested was that while the conscious life of Western society might seem sterile, under the surface, in the unconscious, there was a hidden life of myths and symbols. As he poetically commented:

> Since the stars have fallen from heaven and our highest symbols have paled, a secret life holds sway in the unconscious. That is why we have a psychology today, and why we speak of the unconscious.... Our unconscious, on the other hand, hides living water, spirit that has become nature and that is why it is disturbed. Heaven has become for us the cosmic space of the physicists, and the divine empyrean a fair memory of things that once were. But 'the heart glows', and a secret unrest gnaws at the roots of our being.[9]

This partially resolves the conundrum of why symbols occur in the films of a society that, from the Jungian perspective, should be without symbols. The suggestion is, quite simply, that films form part of the symbolic life of society.

For Jung, the symbol is quite different from its everyday counterpart, the sign. The main distinction is that a sign indicates something that is immediately present, while a symbol refers to something which is outside the moment; it is unknown and contains elements that are unconscious. Another way of making this distinction would be to say that a sign is an image which is understood by consciousness; by contrast, a symbol is an image which is currently not understood by consciousness. While the ego is attracted to the symbol, and is able to grasp part of its meaning, total comprehension eludes its grasp. As Jung notes:

> A term or image is symbolic when it means more than it denotes or expresses. It has a wider 'unconscious' aspect – an aspect that can never be precisely defined or fully explained. This peculiarity is due to the fact that, in exploring the symbol, the mind is finally led towards ideas of a transcendent nature, where our reason must capitulate.[10]

To reiterate the point, symbols 'lie beyond the grasp of reason' and hence cannot be fully understood by the rational part of the psyche, namely consciousness. Indeed, if an attempt is made to understand a symbol in literal, rational terms, then it may become corrupted and cease to be effective. As Jung observed:

> A symbol loses its magical or, if you prefer, its redeeming power as soon as its liability to dissolve is recognised. To be effective, a symbol must be by its very nature unassailable.[11]

Of course, symbols may be used by the conscious, or rational, part of the psyche. The imagery of many religions demonstrates this type of conscious construction. One example is the elaborate, highly structured nature of the Christian Eucharist, in which the signs of bread and wine are transformed to become symbols of the 'real presence' of the body, and blood, of Christ. This sacrament invokes the process of symbolic transformation, in which the move from sign to symbol takes place. (However, even here unconscious factors such as 'projection' and *'participation mystique'* are brought into operation by the priest and congregation, without which these symbols would lose much of their value.[12])

Reflecting the unconscious elements of symbols, analytical psychology does not normally regard symbolic imagery as available to the manipulation of consciousness. Instead, symbols are regarded as spontaneous communications from the unconscious, which is to say both the personal unconscious and the objective psyche. This distinction between the two types of unconscious is important because it is possible for an individual to release a symbol whose meaning is highly specific and personal. While an image may assume a symbolic significance for an individual, others may be quite unaware of the symbolic association and consequently will remain mystified as to why the image is important. These individual symbols present themselves in a variety of ways, including as dreams, through painting, in films, etcetera. It may be possible from these representations to draw conclusions about their creator's personal unconscious. For example, from the symbols found in a film, or series of films, it might be possible to make some deductions about the director's psyche.[13] This type of symbol is properly the property of the personal unconscious, and as such is not really of relevance to this discussion.

What is of concern here are the more general, or 'universal', symbols which originate from the objective psyche. 'Water' is one such symbol. As examined in the previous chapter, it contains a diversity of meanings, including: baptism, purification, castration, regeneration, the objective psyche, danger, death, etcetera. Jung has placed a special significance on these symbols as he regards them as fundamental elements in the psyche.

> But besides that there is a thinking in primordial images, in symbols which are older than historical man, which are inborn in him from the earliest times, and, eternally living, outlasting all generations, still

make up the groundwork of the human psyche. It is only possible to live the fullest life when we are in harmony with these symbols; wisdom is a return to them.[14]

As is evident from the previous quote, Jung thought that the process of symbol formation, and liberation, was imperative. As we have just suggested, the origins of symbolic images can be found in either inner unconscious images or in the translation of everyday images. In the latter case, objects that surround us in the world are abstracted from their original settings and become imbued with the properties of the unconscious (like the bread and wine of the Eucharist). As a result of this transformation, as well as being signs of the outer world, these images become symbols of an inner psychological life.

Part of the work of the individuation process is to incorporate both types of symbols into the functioning of consciousness. In other words, as part of the individuation process, the individual becomes aware of his or her own processes of symbolic formation, and of how symbols are liberated and transformed. Even once these symbols have been brought into consciousness, Jung insists that ultimately they remain unknowable.

> Moreover apperception translates the observed fact into a seemingly (incommensurable) medium – into a psychic event, the nature of which is unknowable. Unknowable, because cognition cannot cognize itself – the psyche cannot know its own psychic substance.[15]

From the perspective of analytical psychology, symbols are neither rational, nor irrational. Instead they are conceived as non-rational, and provide a way that concepts, which apparently lie beyond the realm of consciousness, can be presented. These non-rational communications, which the conscious mind is unable to understand, belong to the intuitive and unconscious parts of the psyche.

> But the (psychic) event can also manifest its unconscious aspect – and this is usually the case – in a dream. The dream shows this aspect in the form of a symbolic image and not as rational thought.[16]

In turn, these 'symbolic images' are liberated by, and from, the objective psyche. Here it is evident why Jung preferred the term 'objective psyche' to what has become the more popular notion of the collective unconscious. The objective psyche is *objective* precisely because it is independent of the personal unconscious and of consciousness, and the symbols it liberates offer 'objective' advice and guidance to the psyche. If heeded by consciousness, this can assist in the progress of the individuation process.

As we have established, the symbol as the property of the unconscious, communicates that of which the ego is unaware, and which consciousness cannot comprehend. Therefore, the symbol originating from the unconscious exists in a compensatory attitude to consciousness[17] and possesses a general, collective meaning. It also has a personal meaning. As Jung writes:

> The symbol is thus a living body, *corpus et anima*; hence the 'child' is such an apt formula for the symbol...In this sense I hold Kerenyi to be absolutely right when he says that in the symbol the world itself is speaking. The more archaic and 'deeper', that is the more physiological, the symbol is, the more collective and universal, the more 'material' it is.[18]

It will be recalled that the individuation process involves the integration of the conscious and unconscious aspects of the psyche as a unified whole. As the objective psyche is central to individuation, its symbolic communications should be both observed and encouraged, as attending to the symbolic function lets the psyche proceed with its individuation. In other words, the symbol can be thought of as an image that combines conscious and unconscious elements. While it originates from the objective psyche, it is also partly comprehensible to consciousness, otherwise it could have no meaning. However, at the same time, its fullest meaning will always remain hidden in the depths of the unconscious. As Jung has commented (again in poetic mode), 'The symbol is the middle way along which the opposites flow together in a new movement, like a watercourse bringing fertility after a long drought'.[19]

Representations of the objective psyche occur in a number of images, not just symbolic images, and as a result they can prove tricky to recognise. In archetypal dreams, the objective psyche may be disguised as an 'evil woman', or a 'wise old man', or maybe a 'speaking animal'. However, underlying these appearances there is a general principle which aids the analyst in his or her attempts to recognise and understand its actions. As Whitmont has noted, 'At best we can speak of it indirectly by describing human behaviour – the behaviour of others and also our own subjective experience, as if a potential, encompassing wholeness were ordering the action of the parts.'[20] Therefore, one of the important functions of the objective psyche is that it orders and liberates the potential for a united psyche.[21] As such, symbols are the bridge between the unconscious and conscious parts of the psyche; they represent its potential for wholeness.

To summarise, symbols are different to signs, and one of the distinctions is that symbols cannot be comprehended by ego-consciousness. Symbols play an active role in the individuation process, and guide in a compensatory manner (they may also symbolise wholeness of the psyche, as in mandala images). Symbols are also the products of the unconscious and, although they cannot be fully understood, expose levels of the unconscious that would otherwise remain hidden.

Symbols in Films

This section applies the theory we have just explored to examine the role that symbols have within films. It will show that symbols are a uniting force that draw together and express tensions in the film. In this context, symbols primarily work in two ways either as a summary of what has gone before, or

preparing the narrative ground for subsequent developments. In mediating between consciousness and the unconscious, symbols represent oppositions and apparent contradictions in a film. Demonstrating the above, we will examine two short sequences from a couple of detective films. This will show how the symbols in these sequences can be seen as part of two different, but inter-related, narrative contexts. The first is the film plot, the second is a mythological narrative.

The first film we will look at is *Sleuth* (Mankiewicz: 1972). The passage that forms the basis of this analysis is the opening sequence in which Milo Tindel (Michael Caine) attempts to find Andrew Wyke (Laurence Olivier) who has hidden himself at the centre of a hedge-maze. Roughly speaking, the plot of the film revolves around Milo Tindel's arrival at an English country house in search of Wyke. He intends to ask permission to marry Wyke's estranged wife Taya. Wyke persuades Tindel that, in order to keep his would-be-bride in the style to which she is familiar, he will need vast financial resources and suggests an insurance fraud as a means of raising the money. He describes a plan in which Tindel, dressed as a clown, is to rob the household safe. He will then sell the jewels and Wyke will claim the insurance. Tindel agrees to this, but Wyke's real plan is to use the imaginary robbery as a way of murdering Tindel. Wyke shoots Tindel with a blank, although Tindel does not realise this and passes out. Two days later Tindel returns disguised as a police inspector to extract his revenge by playing an equally macabre game in which he frames Wyke for Taya's murder. Eventually, he reveals his disguise and is then really shot by Wyke, who hears police sirens at his door. Tindel utters the last words of the film, 'Andrew, don't forget. Be sure to tell them it was just a bloody game'.

The film starts as Tindel enters the labyrinth in the garden of Wyke's house. The entrance to the maze is marked with a large stone snake, and the paths contain other stone statues of mythological beasts and large mirrors. Eventually, a piece of the hedge swings open to reveal the centre of the maze — what Wyke refers to as, 'outdoor inner sanctum'. Throughout, Wyke can be heard reading the end of a detective story that he is writing; thus, in typical symbolic fashion, the end of one narrative marks the start of another.

In many ways, the image of the labyrinth suggests much of what is going to happen in the film. It alerts viewers to expect a narrative of twists and turns, of concealed alleys and hidden horrors. They are not disappointed, and one of the pleasures of the film is participating in the game of second-guessing the narrative. In this way, the viewer becomes a type of detective and, in so doing, joins the Master Game player Wyke and his apprentice Tindel.[22]

In mythology, if not always in modern fiction, the labyrinth is often associated with death; this is the case in *Sleuth* whose plot revolves around a series of murders — some real, some illusory. The connection between death and labyrinths occurs in many myths, perhaps the most well-known of which is Theseus and the Minotaur. Another is a Melanesian myth where the souls of the dead are carried across the waters of death to enter the underworld.[23]

>it (the soul) perceives a female guardian sitting before the entrance, drawing a labyrinth design across the path, of which she erases half as the soul approaches. The voyager must restore the design perfectly if he is to pass through it to the Land of the Dead. Those who fail, the threshold guardian eats.[24]

This tells us that one gateway to the underworld (which, psychologically, is the underworld of the objective psyche) is through a labyrinth. Both Tindel and the film's viewers are drawn into this world.

From the perspectives offered by both mythology and symbolism, it comes as no surprise to find that the entrance to the labyrinth in *Sleuth* is guarded by a large stone snake. Traditionally, snakes are the sacred animals of the labyrinth, [25] although they were eventually replaced by pigs, bulls, and finally horses. This link with snakes is an ancient one and the mythologist Joseph Campbell cites the example of, 'This symbolism of the serpent of eternal life appearing in the paleolithic period on the reverse of a plaque bearing on its obverse the labyrinth of death...'.[26] The labyrinth in *Sleuth* is therefore a complex symbol, which contains images of death and life. The initiate must learn its paths, for the point of a labyrinth is to find the way to its centre, and then the exit. In psychological terms, the symbolic act of entering the labyrinth, and the labyrinth itself, are images of the individuation process. The paths represent the difficult, quasi-magical and mythological underworld that all who accept the work of individuation enter. Interestingly, in his book, *The Birth of Philosophy*, Colli brings together many elements that can also be found in *Sleuth*.

> The geometric form of the labyrinth with its unfathomable complexity, invented through a bizarre but perverse game of the intellect, alludes to ruin, to the world peril that lies in wait for man when he dares to confront the animal god.[27]

For Tindel, entering the labyrinth involves facing his shadow qualities – the numinous qualities of the animal god.[28] In *Sleuth*, these shadow qualities are first symbolised in the archaic stone statues of gorillas and ogres, which serve as a visual reference to the ancient and dark-side of the psyche. Subsequently, the mirrors of the labyrinth symbolically suggest the new version of himself that Tindel is going to expeience – the as yet unrealised shadow of his psyche. Chetwynd comments:

> The ego confronts its own Shadow as a figure thrown upon the wall or reflected in the glass, projected into the outside world. Symbolism does not distinguish clearly between reflections and shadows – children sometimes share the confusion on this point.[29]

As the film progresses it gradually becomes clearer how Tindel is assimilating his shadow qualities, indeed it is almost as though they have begun to possess him. This is evident in his return to the house, now disguised as Inspector Doppler (alluding to the German for double). It appears that Tindel is able to

control his shadow: he doesn't want to kill Wyke and wishes only to extract a psychological revenge. But Wyke exhibits less control and becomes boastful about his psychological gamesmanship:

> Let me tell you Inspector that I have played games of such complexity that Jung and Einstein would have been proud to have been asked to participate in them. I have achieved flights of the mind and flights of the psyche.

Wyke's attitude means that eventually his shadow overwhelms him, and he passes into the psychological arena of affect and invasion. Despite initial appearances, in many ways the two characters are actually similar. Tindel has to recognise that the distorted reflections of himself in the mirrors of the maze were not just an illusion, but were also images of the shadow side of his psyche; Wyke has to realise that the games of the psyche are not illusory, but real. However, in this he is ultimately unsuccessful and is overwhelmed by his shadow. Much as the Cretan labyrinth claimed Icarus, its creator's son, so too this labyrinth claims, as its victim, the game-master's apprentice.

To conclude, the preceding analysis shows how the symbol of the labyrinth in the opening moments of the film prefigures much of the later imagery. It does this in three ways: first, it prepares the viewer for a complex and 'deceptive' narrative; secondly, it mythologically indicates a descent into the underworld; and thirdly, it symbolises individuation.

The second film, *The Woman in the Window* (Lang: 1944), seems initially to be different in many ways from *Sleuth*. This *film noir*, set amid wet, night-time city streets, seems a complete contrast to the English Country House that provides the setting for *Sleuth*. But underneath the apparent diversity, the two films actually have a great deal in common. (If we remember that these films share the same mythologem, namely the quest motif, and that they are both broadly detective films, then the underlying affinities seem less surprising.)

The Woman in the Window starts with Richard Wanley (Edward G. Robinson), a professor of criminology, giving a lecture on the ethics of crime. After finishing his talk, and on the way to his club, he notices a painting of a beautiful woman in a shop window. He arrives, discusses the picture with his friends, and eventually falls asleep while reading the *Song of Songs*. On waking, he goes outside for a last look at the picture and, to his surprise, the real woman, Alice, (Joan Bennett) appears. From here on Wanley is drawn deeper and deeper into a criminal underworld. First, Alice persuades him to help murder her husband. Wanley does this, but finds himself involved with the police investigation and in helping them to solve the crime that he has committed. At the same time, he and Alice are being extorted by a blackmailer (Dan Duryea). Wanley plans a second murder, which fails, and Alice poisons herself. At this point, Wanley wakes up to discover that the whole episode has been an unpleasant dream.[30]

The passage that we are going to examine occurs near the beginning of the film, and is where Wanley falls asleep and the dream sequence starts. The indication to

the viewer that a dream has started is the dissolve between Wanley reading the *Song of Songs* and him being woken up by one of the club's stewards. There is also his comment to the steward, 'Will you remind me when it's ten thirty? Sometimes I'm inclined to lose track of time'. The verbal clues are easily missed, and the dissolve is a normal cinematic device that is used to indicate the passing of time. It would seem that Lang intended to keep the viewer, along with Wanley, unaware that the film is actually a dream. One of the consequence of this is that it increases the viewer's identification with the criminal. Making the film a dream also resolves this difficult situation, as it makes the crime 'unreal'.

In interpreting the above passage symbolically, it is important to remember that this is supposed to be a dream. In this way the film is further away from 'reality' than other films; not only is the film a fiction, but it is a fiction which represents a dream. This gives us the psychological cue to interpret the film in a psychological manner. In the terminology of analytical psychology, it would be reasonable to see Alice as a projection of Wanley's anima. Being attractive and highly sexual, her night-time appearances and underworld life style means that she possesses many typical anima attributes. In some ways she is the typical *femme fatale* figure who lures ineffectual weak men to their destruction. This reading of Alice, as a projection of Wanley's anima, is given extra weight by James Hillman who has observed that the figures we meet in dreams are aspects of our own psyche.

> What walks through my dreams is not actual other persons or even their soul traits mirrored in me (ikons or simulacra of them), but the deep, subjective psyche in its personified guises.[31]

Like the film as a whole, the sequence cinematically deals with the union of opposites: the *coniunctio* of anima and ego. This is hinted at in Wanley's selection of the *Song of Songs* as his choice of reading. Here, the lonely professor reaches for the most erotic and sensual book in the Bible. It is as though he knows he must delve into his unconscious fantasies; it is almost as though he is giving himself permission to dream. This, in itself, is reminiscent of a passage in the *Song of Songs* where the bridegroom falls asleep to awaken his heart.

> I slept but my heart was awake.
> Listen! my beloved is knocking.
> Open to me, my sister, my love,
> my dove, my perfect one.[32]

However, because it involves entering the darkness of the underworld, the process of anima assimilation is not straight-forward. Just as Milo entered the labyrinth in *Sleuth*, so too Wanley enters the darkness of a nightmarish dream to face the *femme fatale*. As Jung notes:

> Filling the conscious mind with ideal conception is a characteristic of Western Theosophy, but not the confrontation with the shadow and the world of darkness. One does not become enlightened by imagining figures of light, but by making the darkness conscious.[33]

The difficulty of this encounter is also evident in the *Song of Songs*. As Edinger observes:

> The encounter in the garden includes pain as well as pleasure. The Bridegroom is wounded:
>
> 'You ravish my heart,
> My Sister, my promised bride,
> You ravish my heart
> With a single of your glances.'
>
> ...One aspect of the *coniunctio* is that opposites are seen by each other...which has a wounding or violating effect.[34]

For Wanley, wounding comes in the shape of the murder that he is driven to commit. But of course the whole film turns out to be a dream and therefore, in one sense, unreal. Much as the games played in *Sleuth* were an illusion, so too the fatal attractions of Alice prove to be only a fantasy. However, dreams are an important part of the objective psyche's life; they play an active role in the work of individuation. As Jung noted, what may be an illusion or dream for us, may be very real to the psyche.

> But what is 'illusion'? By what criterion do we judge something to be an illusion? Does anything exist for the psyche that we are entitled to call illusion? What we are pleased to call illusion may be for the psyche an extremely important life-factor...Nothing is more probable than that what we call illusion is very real for the psyche... .[35]

According to Hollywood logic, the dream in *The Woman in the Window* made the murder unreal, but from the psychological viewpoint the opposite is true. As Tyler notes, 'But the fact is that in making the professor's crime occur *in his dream* its psychological reality, its mental precipitation, this alone, is established'.[36]

This analysis of the opening moments of the dream sequence has shown that the symbols, and their associated mythological and psychological themes, prepare the way for later development. In part, this is the function of all opening sequences, but what is significant in this sequence is the way that the symbols (and myths) foretell the psychological destiny of Wanley. In other words, throughout the film there is a process of symbolic transformation which mirrors the development of the narrative. As in *Sleuth*, the symbols contain, and express, the oppositional themes of the film. The concatenation of elements, combined with their gradual assimilation into consciousness (the *coniunctio*), is an integral part of Wanley's individuation.

The analyses of *Sleuth* and *The Woman in the Window* have shown how symbols can give expression to apparent oppositions within the narrative. The symbols are also linked to the individuation of the films' central characters, and as such they indicate the psychological development of these characters. Now that the theory and application of the symbol has been demonstrated, we are able to

progress to the final area of the analytical model, and explore its theoretical basis and application in film analysis.

Notes

1 c.f. Capra, F., *The Turning Point* (London, 1982). This edition (London, 1987). *Passim.*

2 Skinner, B. F., *Beyond Freedom and Dignity*, (New York, 1975) p3.

3 Capra, F., *The Turning Point*, (London, 1982). This edition, (London, 1987): p397.

4 Samuels, A., *Will the post-Jungians Survive?*, in Casement, A., (eds.) *Post-Jungians Today: Key Papers in Contemporary Analytical Psychology*, (London, 1998): p29.

5 Whitmont, E. C., *The Symbolic Quest*, (Princeton, 1978) p27.

6 C. W. 6: 438.

7 C. W. 9, I: 28.

8 This explains why the analytic model, established in Chapter Four, places symbols as part of a mythological and psychological process. Responding to the need for a holistic approach, it uses the environment of the myth to assist in understanding the symbol's meaning.

9 C. W. 9, I:50.

10 C. W. 18: 417.

11 C. W. 6: 401.

12 For a full account, c.f.. Collected Works. Vol, 11: 296-448. (*Transformation Symbolism in the Mass*).

13 For an accessible and detailed example of this type of analysis, c.f. Branson, C., *Howard Hawks, A Jungian Study*, (Los Angeles, 1987).

14 C. W. 8: 794.

15 C. W. 18: 419.

16 C. W. 18: 420.

17 The assumption that underlies analytical psychology is that the objective psyche gives direction to psychological growth. One of the ways that it achieves this is by liberating images, thoughts, dreams and other creative activities, which are in opposition to ego-consciousness. Thus someone with a mother complex might find their objective psyche liberating images of the father, or perhaps more subtly, the anima. As these images are the opposite of what ego-consciousness expects, they are said to exist in a compensatory attitude, or opposition, to ego-consciousness.

18 C. W. 9, I: 291.

19 C. W. 6: 443.

20 Whitmont: p15.

21 A specific symbol of wholeness, identified by Jung, is the mandala. This is an image of balance, and represents the integration of the conscious and unconscious aspects of the psyche, c.f. C.W. 12: 122-331, *The Symbolism of the Mandala*.

22 Perhaps the best player of all is the audience: having solved the puzzle of the narrative, and thereby vicariously played the game, viewers are free to leave the cinema.

23 For another labyrinth that also leads to the underworld, C.f. Beckwith, M. W., *Hawaiin Mythology*, (Yale, 1940): p157.

24 Campbell, J., *Primitive Mythology*, (New York, 1959). This edition, (London, 1984):p68-69.

25 c.f. Campbell, J., *Primitive Mythology*, (New York, 1959). This edition, (London, 1984): p197.

26 There are numerous myths which regard the snake as a symbol of life, c.f. Campbell, J., *Primitive Mythology*, (London, 1984): p388. There is also the interesting Hindu myth in which the giant snake Vasuki is used to move a mountain to churn up the ocean and produce soma, which is the elixir of immortality. However, as might be expected in symbolism, it also produces a deadly poison.

27 Colli, G., *The Birth of Philosophy*, (Milan, 1975): p29.

28 There is an interesting literary parallel to this in Hermann Hesse's novel, *Steppenwolf.* In this novel, Harry Haller believes himself to possess a personality which is half man and half wolf. In the search for enlightenment (individuation – here the integration of his

shadow), he enters a magic theatre for which the entrance fee is his sanity and also the life of his love, Hermanie, whom he kills. This magic theatre is very like a magic labyrinth, and the theatre's many pathways and doors conceal projections of Haller's character, some of these are beautiful while others are ugly and painful. Unfortunately for Haller, he never succeeds in dissolving these projections and integrating their contents into ego-consciousness. Consequently, he appears not to progress with his individuation, as he notes at the end of the novel, 'I would traverse not once more, but often, the hell of my inner being. One day I would be a better hand at the game'. The title sequence of *Sleuth* is a series of miniature 'magic' theatres each containing a reconstructed scene from one of Wyke's fictional murder stories. And like Haller in *Steppenwolf*, Tindel enters into the fictional world of drama and illusion to discover some previously hidden aspect of himself.

29 Chetwynd, T., *A Dictionary of Symbols*, (London, 1982): p261.

30 The elements of *The Woman in the Window* are very similar to a film that Lang was to direct a year later (*Scarlet Street*, Diana Productions – Universal, 1945). Both are set in a city and make use of the classic *noir* wet city streets, hideous rooms full of bizarre objects and with typical low-key, high contrast lighting. In both films, Edward G. Robinson plays a sexually frustrated lonely man who becomes the victim of a *femme fatale* played by Joan Bennett. This preoccupation of Lang's is interesting and it indicates either some outworking of his own psychology or, more likely, it is an expression of a collective psychological need. (c.f. C. W. 10: 195). The evidence for this is the large number of other films which have broadly similar plot themes and situations. For example, *Laura* (Dir. Otto Preminger, Twentieth Century Fox, 1944) and *Double Indemnity* (Dir. Billy Wilder, Paramount, 1944). Parker Tyler also notes that this upsurge in films of this type reflects '…the inevitable albeit sub-conscious interest aroused in the public by the conception of war as murder and, following this line of thought, the conception of murder as psychological…'.

31 Hillman, J., *The Dreams of the Underworld*, (New York, 1979): p98.

32 The Bible, *Song of Songs* (AKA *Song of Solomon*), 5:2.

33 C. W. 13: 335.

34 Edinger, E. F., *The Bible and the Psyche*, (Toronto, 1986): p141-142.

35 C. W. 16: 111.

36 Tyler, P., *Magic and Myth of the Movies* (London, 1971): p167.

7

Individuation and the Detective

Johnny Rico (James Darren): *Maybe I'm gonna die. You've got even bigger problems - you're gonna live.*

The Brothers Rico (Phil Karlson: 1957)

This is the last of the theoretical chapters. It has two sections. First, there is a general, and brief, introduction to the individuation process. This is followed by a more detailed exploration of individuation in which each phase is examined and its relationship to the detective film is developed. Analytical psychology suggests that individuation is an inherently natural process that is both psychological and biological.[1] As Humphrey has noted:

> I cannot hope to summarise here the extensive research through which Jung claimed to have established the existence of particular archetypes. But, assuming the phenomenon to be genuine, I would propose a biological function for archetypal dreams: they will give the dreamer advance knowledge of certain universally significant human experiences, experiences of which he as a natural psychologist cannot afford to remain ignorant.[2]

While in one sense archetypes may be reducible to their biochemical origins, in psychological terms they remain 'living', dynamic and organising structures.[3]

Typically, the individuation process is thought of as something which starts in the latter half of human life: that is, after thirty-five. It is only at this point that the archetypal patterns are constellated and the contents of the unconscious and objective psyche released. However, more recent Post-Jungian thought regards the first half of life, which is characterised by the awareness of ego identity, as an integral part of individuation.

> The first half (of life) is characterised by the need for a differentiation from the unconscious matrix, the indistinct uroboros from which the individual psyche gradually emerges. What encourages the formation of a conscious centre of the personality, the ego, is called by Neumann the tendency towards *centroversion*, the 'innate tendency of a whole to create unity within its parts and to synthesise their differences in unified systems'.[4]

Some theoreticians regard the centroversion stage as a precursor to individuation. However, it seems more satisfactory to regard individuation as a process which spans from birth, or possibly conception, to death. (One of the contributions that the British psychologist Michael Fordham made to child psychology was to take Jungian ideas and apply them to early life.[5]) During the second half of life, the process of centroversion continues as the ego takes an active role in synthesising opposites and in the differentiation of the conscious and unconscious parts of the psyche. As Carotenuto observes:

> The task of the second half of life is the harmonisation at a higher level of the various parts of the personality; it is the conscious realisation of the tendency towards centroversion of which the ego is no longer the passive object but the conscious protagonist. The extreme differentiation of consciousness, with the deep split that it creates within man, is also the means for beginning that search for totality which according to Jung characterises the process of individuation.[6]

Individuation is concerned with overcoming the 'deep split' between the conscious and unconscious elements in the psyche that is caused by the act of differentiation. It is further concerned with the reconciliation of all opposites and opposition, its ultimate aim being to stabilise the psyche as a complete whole. Thus the contrasexual archetype of anima, or animus, becomes integrated and reconciled with the biology of the individual. As can be imagined, the path that the individuation process maps out is not an easy one. Hence, in the symbolic language of the unconscious, it often assumes the image of a winding road, a labyrinth or a quest. As Jung notes:

> But the right way to wholeness is made up, unfortunately, of fateful detours and wrong turnings. It is a *longissima via*, not straight but snakelike, a path that unites the opposites in the manner of the guiding caduceus, a path whose labyrinthine twists and turns are not lacking in terrors.[7]

With its concern about the integration of opposites, individuation is about becoming whole, not about being perfect: it is about the *acceptance* of elements such as the shadow, not about attempting to repress or remove them. Individuation is about realising the fullness of human potential and this includes an acceptance of humanity's darker side. As Hillman comments:

> The process of individuation or the work of soul-making is the long therapeutic labour of lifting repression from the inhumane aspects of human nature. This process eventually embraces psychopathology untransformed. Self-realisation involves the realising in consciousness of the psychopathic potential one prefers to call inhumane.[8]

At first sight the term individuation can appear slightly misleading, for while individuation is about the realisation and development of an individual's own unique potential, it also involves the acceptance of collective ties.

...we do not sufficiently distinguish between individualism and individuation. Individualism means deliberately stressing and giving prominence to some supposed peculiarity rather than to collective considerations and obligations. But individuation means precisely the better and more complete fulfilment of the collective qualities of the human being, since adequate consideration of the peculiarity of the individual is more conducive to better social achievement than when the peculiarity is neglected or suppressed.[9]

To recap, for Jung the process of individuation is primarily about becoming aware and realising the latent unconscious elements in the human psyche. This involves the acceptance of contradictions, oppositions and of individual psychological complexes. As a result of this process, an individual's level of conscious awareness is raised as he or she becomes aware of previously concealed elements in their psyches. This increase in conscious awareness does not resolve the tensions in the psyche, but instead it 'transcends' them by bringing them out into consciousness, so that they can be understood. As consciousness is increased, so more complexes are made conscious and this creates a greater self-awareness of individual and collective qualities. As Jung puts it:

> Self-reflection or – what comes to the same thing – the urge to individuation gathers together what is scattered and multifarious, and exalts it to the original form of the One, the Primordial Man. In this way our existence as separate beings, our former ego nature, is abolished, the circle of consciousness is widened, and because paradoxes have been made conscious the sources of conflict are dried up.[10]

However, it would be a mistake to think of the individuation process as a panacea. As Jung commented above, individuation is a treacherous and lengthy quest. It is concerned with identifying problems, or, to be more technical, complexes, and in their conscious realisation, not their removal. Individuation should not be thought of as an easy option, but as a life process in whose participation there is no choice. Being human means experiencing and living the difficulties of individuation.

> The serious problems of life, however, are never fully solved. If ever they should appear to be so it is a sure sign that something has been lost. The meaning and purpose of a problem seem to lie not in its solution but in our working at it incessantly. This alone preserves us from stultification and petrifaction.[11]

It would be incorrect to regard individuation as somehow superior or separate from the archetypes, as it is the archetypes that govern or control the process. Hillman has noted that Jungians, in their emphasis on visual and mythosymbolic material, tend to take processes literally. In reality, individuation is not a physical process but does provide one useful metaphor

though which to examine the workings of the psyche, and for most Jungians and Post-Jungians it is the principle method.

> Where existentialists neglect process, Jungians literalise it. Because the process of individuation is an archetypal fantasy, it is of course ubiquitous and can be 'demonstrated' in texts and cases, just as any archetypal fantasy has its manifestation in historical events. But this process is not the axiomatic law of the psyche, the one purpose or goal of ensouled beings...*individuation is a perspective*. It is an ideational tool: we do not see individuation, but by means of it.[12]

For general purposes the individuation process can be divided into four sections, namely: formative, dispositive, perfective, and differentiative. The formative phase represents the progress of ego-centroversion in which the ego is established and separated from the general matrix of the unconscious. As such, it is an important phase in individuation but for this chapter's method the remaining three phases are of more importance because they deal with the development of the ego. The dispositive phase consists of dispensing with a fixed persona and instead learning to adopt the appropriate face for the occasion. The perfective phase is concerned with making conscious the unconscious clusters of archetypal patterns, and involves recognising their existence and their compensatory nature. The final differentiation phase consists of differentiating between conscious and unconscious parts of the psyche. This is not as simple as it may at first appear as apparently conscious events, for example the intense dislike of someone or something, may turn out to involve the projection of an inner unconscious complex. The process of differentiation is vital, for without an awareness of the distinction between the conscious and unconscious, the synthesis of these opposites, which occurs later in individuation, cannot be achieved.

Differentiation is principally a cognitive process, although it is not exclusively rational, for throughout this phase the dialogue between ego and unconscious presents symbols, myths, and dreams and so on. As has already been argued, these unconscious communications are not readily available for rational analysis as they represent trans-rational truths, or insights not yet grasped by the conscious part of the psyche. The Jungian Moreno has commented on this and emphasises the importance of understanding, and active participation, during differentiation.

> First we must understand the meaning of the fantasies produced, then we must experience them to the full, which demands not only perception, discussion and passivity, but above all active participation.[13]

The process of analysis is therefore equivalent to Moreno's stage of understanding the fantasies. As already mentioned, the very act of making these fantasies conscious helps the cultures and individuals concerned to acknowledge the oppositions contained within the objective psyche. (This explains Jung's term for the increase in consciousness – the 'Transcendent Function'.)

During differentiation, as consciousness is increased, the centre of the personality moves from the outer ego to the inner psyche, and the constellation of this new archetype of the Self represents the final phase. While individuation may assume many forms, as individuals and communities each experience it within their own unique environment, there is one pattern that recurs repeatedly and represents the norm.

Schematic Diagram of the Individuation Process

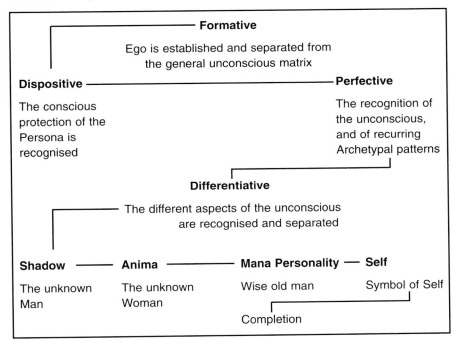

The first steps in the dispositive phase are marked by the recognition that every individual, or indeed culture, possesses a persona. To recap, the term persona refers to the mask, or personality, that is worn to confront the world. The persona is an archetype, and when we recognises it as such, the mask is removed to reveal the true nature of the unconscious. Thus once the persona has been consciously identified it can be, to use Jung's phrase, 'transcended'.

> True, whoever looks into the mirror of the water will see first of all his own face. Whoever goes to himself risks a confrontation with himself. The mirror does not flatter, it faithfully shows whatever looks into it; namely, the face we never show to the world because we cover it with the *persona*, the mask of the actor. But the mirror lies behind the mask and shows the true face.[14]

On recognising the persona the shadow appears, followed by the anima who is projected onto the outer world. It is vital to pass through this perfective phase

and to recognise the anima projections, for without this the shadow cannot be identified nor can the anima be integrated. In the following quote, Jung uses the word 'weakness' not to describe something that is inferior but rather to indicate that the contrasexual archetype is underdeveloped.

> The persona, the ideal picture of a man as he should be, is inwardly compensated by feminine weakness, and as the individual outwardly plays the strong man, so he becomes inwardly a woman, i.e., the anima, for it is the anima that reacts to the persona. But because the inner world is dark and invisible to the extraverted consciousness, and because a man is all the less capable of conceiving his weaknesses the more he is identified with the persona, the persona's counterpart, the anima, remains completely in the dark and is at once projected... [15][16]

In terms of the figure of the detective, one of the earliest personas that we encounter in films is the 'Gentleman', or 'Thinking detective', typified by Philo Vance in *The Kennel Murder Case* (Curtiz: 1933). Later characters created by Hammett (Sam Spade) and Chandler (Philip Marlow) embody the quite different, and altogether more earthy, persona of the 'Hardboiled' detective. This transformation is accompanied by a move from using the intellect to solve crimes, to a reliance on hunches, tip-offs, informers and lucky-breaks. These new irrational elements paper over the narrative cracks and lapses of logic in detective films, while at the same time they manage to preserve a patina of intellectual respectability. In so doing, they sustain the illusion that the process of detection is based on fact and reason. In fact, this is far from the case, as is suggested by Chandler's apocryphal remark on the set of *The Big Sleep*, that even as the author he didn't know 'who done it'. This helps us to realise that the detective's search for truth is much more than an intellectual pursuit; it is a metaphor of the drive towards individuation. Thus the solving of a crime comes to represent, symbolically, the resolution of a complex, and a movement into the next stage of individuation.

In the previous quote, Jung remarked that the 'inner world is dark and invisible to extraverted consciousness'. The result of this is that if anyone is to look into the inner world, then ego-consciousness must adopt an introverted attitude. As already mentioned, the unconscious can only be understood or comprehended in the language of consciousness, so the result of the inner journey is an increase in conscious awareness. In other words, the 'vocabulary' of consciousness is expanded to include the findings of this introspective quest.

The first archetype that is encountered after the persona is the archetype of the shadow and typically Jungians regard the recognition of the shadow as the first true step in individuation. It will be recalled that the shadow may be defined as the negative side the psyche, the aspect of humanity which ego-consciousness has pushed into darkness. However, as might be expected, as a result of the psychological principle of opposition, the shadow also has good qualities and contains parts of the personality which, due to personal circumstances, have not been fully developed.

If the repressed tendencies, the shadow as I call them, were obviously evil, there would be no problem whatever. But the shadow is merely somewhat inferior, primitive, unadapted, and awkward; not wholly bad. It even contains childish or primitive qualities which would in a way vitalise and embellish human existence, but it is 'not done'.[17]

The shadow belongs mainly to the personal unconscious, that is, to the part of the psyche that has been conditioned through personal environmental circumstances. However, it is still an archetype and, as such, it possesses a collective and numinous quality. Of course numinosity is by no means a universally good quality, and when the shadow, after a period of cultural repression, breaks out, the numinosity which the archetype carries with it contributes its 'evil'.

And indeed it is a frightening thought that man also has a shadow-side to him, consisting not just of little weaknesses and foibles, but of a positively demonic dynamism. The individual seldom knows anything of this; to him, as an individual, it is incredible that he should ever in any circumstances go beyond himself. But let these harmless creatures form a mass, and there emerges a raging monster; and each individual is only one tiny cell in the monster's body, so that for better or worse he must accompany it on its bloody rampages and even assist it to the utmost.[18]

If the archetypes are left latent or repressed in the psyche, then the damage caused by not integrating the archetypes is formidable. It might initially appear that processes of not accepting the shadow are solely an individual matter. However, this is not the case because these autonomous elements tend to become personified. This personified image can be contained within an individual's psyche, or it can be projected onto the outer world and this inevitably affects his or her relationships. As Moreno comments, 'The unconscious does the projection and the projection changes the world into a replica of one's own unknown face, which isolates the subject from his environment'.[19]

The detective and his shadow

We have already begun to see how the world of *film noir* provides a suitable setting against which the psychological interaction between detective and criminal can be played out. The high contrast and low-key lighting of these films provide an atmospheric and quasi-mythological environment. Deep shadows, shooting at night, and wet, reflective city streets provide elements that become the psychological aspects of the *mise-en-scène*. Perhaps this dual function goes some way to explaining their longstanding appeal and continued use in films such as *Hammett* (Wenders: 1982), and *Farewell My Lovely* (Richards:1975). As we have already observed, projection of the shadow isolates the subject from his or her environment. For the detective, this isolation manifests itself in a variety of ways. The narratives of detective films

often centre around locations in which the detective is a stranger, for example, Chinatown. Alternatively, it may be just an intensely crime-ridden city where any force for good is out of place. Sometimes the detective has a physical or psychological handicap, suffering from forgetfulness or over-intellectualisation. In later developments, the detective works not as a private-investigator but as part of a police force. Even here, he is often a maverick cop who goes outside the official structures of law enforcement, as in *Dirty Harry* (Siegel: 1971). While the detective may be physically set apart from the world of crime, he remains psychologically part of that world, for in actuality the underworld is an extension and shadow-toned projection of his own unconscious. Thus there exists a tension between the world of crime and the detective's own ego dialogue with the shadow.

This tension is an integral part of the individuation process. As we know, the detective in pursuing the criminal, is actually chasing his own shadow and by extension the crimes that he is trying to solve operate as metaphors for his projected psychological complexes. However, culturally the detective is not just an individual as the archetypal dimension to his character means that he comes to stand as a collective representation of ego-consciousness. Likewise the criminal represents not only the hero's shadow but also a shared darkness which the mechanism of the cinema quite literally projects. Naturally our instinct is to deny this process but such resistance is unwise as it is an attempt to stop the natural functioning of the archetypes. However, complexes are not easy to recognise:

> ...the cause of the emotion seems to lie, beyond all possibility of doubt, in the *other person*. No matter how obvious it may be to the neutral observer that it is a matter of projections, there is little hope that the subject will perceive this himself. He must be convinced that he throws a very long shadow before he is willing to withdraw his emotionally-toned projections from their object.[20]

Once the shadow has been identified, then the problem of how to cope with this part of the personality raises its head. Jung suggests that there are three possible solutions: repression; suppression; and assimilation. Given the mostly unpleasant nature of the shadow, both repression and suppression seem tempting options. The difference between them is as follows:

> Repression is a sort of half-conscious and half-hearted letting go of things...a looking the other way in order not to become conscious of one's desires. Freud discovered that repression is one of the main mechanisms in the making of a neurosis. Suppression amounts to a conscious moral choice...(it) may cause worry, conflict and suffering, but it never causes a neurosis. Neurosis is always a substitute for legitimate suffering.[21]

It has already been mentioned how dangerous repressing the shadow can be. The same is true of suppression as this also causes the shadow to intesify and

prevents further progress being made with individuation. Recognition, or differentiation, of the shadow and its acceptance (assimilation) are significant stages in individuation.

> The shadow is a tight passage, a narrow door, whose painful constriction no one is spared who goes down to the deep well. But one must learn to know oneself in order to know who one is. For what comes after the door is, surprisingly enough, a boundless expanse full of unprecedented uncertainty...It is the world of water, where all life floats in suspension; where the realm of the sympathetic system, the soul of everything living, begins; where I am indivisibly this *and* that; where I experience the other in myself and the other-than-myself experiences me.[22]

In line with Stein's suggested method for classification of archetypes, the shadow needs to be seen not so much as a discrete archetype, but as more of an aggregate. Looked at this way, the persona prefigures the shadow, and the persona and the shadow both herald the arrival of the contrasexual archetype. As we move further with individuation, so the archetypes become more powerful and numinous. At each stage the archetypes are differentiated and accepted by ego-consciousness.

The problem that we are left with is how to exist with the dark side without becoming dark ourselves? Of course there is no easy or simple answer to this problem. Individuals and cultures alike need to find the solution in the manner that is appropriate and meaningful for them. But find the solution they must, as shadow and ego, light and dark, have to co-exist. Part of the answer to the cultural dimension of this puzzle may lie in a better understanding of how and why we invest images, and in particular films, with a psychological significance. The enduring elements of Hollywood cinema might well be better understood if cinema is repositioned as a medium that is both materialist and psychological.

The contrasexual archetype

We have already explored the way in which Jung described what he felt to be the poverty of Western rationalist thought, the division of the psyche in recognisable archetypes and the process of projection. Hauke neatly summarises this position as follows.

> For Jung, the modern psyche manifests as a partial, fragmented version of its potential, dominated by an overly rational consciousness, and with the tendency to project onto others and the world unconscious contents that are denied by the dominant culture.[23]

For Jung, gender, as opposed to biological sex, is one of those identities that are partially denied to us by the dominant culture. In understanding how gender is constructed, Jung suggested the existence of the contrasexual archetypes, otherwise referred to as the anima and animus. The classical Jungian view is that to understand the contrasexual archetype it is important to know of its universal

significance in mythology, comparative religion, literature, film and indeed wherever it can be recognised. However, recent Post-Jungians have been more critical of this mythologically based approach and have reworked it into a less historically determined theory of gender. In devising a method that is suitable for use in the analysis of film, we will attempt to draw on some of the insights of the Post-Jungian position while not losing the opportunity for the mythological amplification of these themes.

We earlier considered the idea of the contrasexual archetype as though the anima and animus were actual concrete figures. However, Andrew Samuels suggests that it is a mistake to interpret these images in an overly literal sense.

> Animus and anima images are not of men and women because animus and anima qualities are masculine and feminine. Rather, for the individual women or man, anatomy is a metaphor for the richness and potential of the 'other'.[24]

The distinction that Samuels alerts us to is the difference between gender and biological sex. The contrasexual archetype is concerned with the cultural attitudes which define and build-up our gender identities. Samuels is right to note that there is more to gender identities than the contrasexal archetype, and that differences of biology also create a sense of 'other'. However, there is still the danger in this type of analysis that we get drawn into an overly simplistic situation in which men are seen as adopting feminine traits and women as adopting masculine behaviour. Zabriske has characterised this, noting:

> When Jung's personal associations to feminine qualities and masculine qualities were projected into his analytical psychology, they became static. It is as if the archetypes fell into matter and re-emerged as stereotypes.[25]

Perhaps the reason for this is that in much of his writing Jung appears to confuse the archetype of the anima with real women. While he realised the dangers of this, and warned against it, he still made the mistake himself, and in so doing assumed that the anima tells us something about the psychology of women. In as much as women may have constructed a gender identity partly by accepting identities that are in part male fantasies, this may be true. However, to internalise these unconscious projections is of course destructive for both men and women. Despite these problems, the strength of Jungian theory lies in the potential it has to offer the opportunity to deconstruct culturally defined gender identities and to create an inclusive theory of human sexual identity. Consequently, it is important to ensure we do not fall into the same trap as Jung. While the anima is personified in female form she is not human nor does she represent the totality of female influences on man. For example, both mothers and wives exert a strong influence on men, but they are not the anima, although they may have anima qualities projected onto them.

The following table indicates some of the images and qualities that Jung suggested the anima and animus adopt. Like the shadow, the contrasexual

archetype possesses both positive and negative qualities; and as archetypes they dwell in a realm which is numinous, magical and dangerous – in other words, 'mythological'. In analysing the figure of the detective, the image of the anima is of particular interest as, in the detective myth, it is imbued with the fantasy of a hidden wisdom (Sophos) which the detective needs if his quest for individuation is going to be successful.

Anima Images –	Bad	Good or Bad	Qualities
Good			
Beautiful woman	Ugly woman	Animals	Moody, vague,
Angel(Angulos –	Serpent	Birds	Prophetic
messenger)			
Nymph	Witch	High Priestess	Feeling for
Sophia	Siren	Moon and lunar	nature
(Sophos – wisdom)	Lorelei	images	Personal love
	Femme fatale		
Animus Images –	Bad	Good or Bad	Qualities
Good			
Physical man	King of Dead	Sun and Solar	Cold, obstinate, 'I
Romantic man	Handsome	images	am right'
	stranger	King	Arrogance
Man of action	Death	Father	Fatalistic, 'All I
Spiritual man	Robber		want is love'
	Murderer		
	Bluebeard		

Extracted from, von Franz, M.L., *The Process of Individuation*, in *Man and His Symbols*, editor Jung, C G , (London, 1964). This edition, (London, 1978): 186-198.

However, Andrew Samuels has been keen to point out what he considers to be the dangers inherent in this type of image based and mythological approach.

What is omitted is the ongoing role of the prevailing culture in the construction of the 'feminine' and a confusion develops between what is claimed to be eternal and what is currently observed to be the case. It is here that the deadweight of the heritage of archetypal theory is felt – but as the mirror image of Jung's problem. He assumed that there is something eternal about women and, hence, about femininity.[26]

Jung may well have made this mistake and its warning is duly noted. But the error Samuels makes is in assuming that myths are of necessity historical. In fact, both Film Studies and Media Studies have been quick to identify how contemporary mass media create and circulate modern myths, albeit often with a historical resonance. Thus the pressure that 'the prevailing culture' exerts can certainly form part of the analytical approach. As we shall shortly see, many of the images and emotions that von Franz identifies as anima attributes map neatly onto the characters encountered in detective films.

For the detective, the process of anima assimilation involves him in accepting, and then using, the 'feminine side' of his personality. During this phase it is the role of ego-consciousness to identify and accept the functioning of the contrasexual archetype. The more personally this archetype is taken, the better because, as Moreno comments, '...the ego has to get the right idea of the power and factors ruling the "other world", the world of the unconscious'.[27] Broadly speaking this corresponds to some of the positive attributes of the anima. For example, the detective's reliance upon the hunch places a value on 'intuitive functioning' which in western culture is traditionally regarded as a feminine (anima) attribute. The hunch is of course central to the detective's search for truth and it is important that he understands the process by which he arrives at his intuitive hunches.[28] This involves dividing the ego from the anima contents with the result that the anima may be projected in some concealed way. This makes the now disguised anima projection difficult to identify and so its integration with ego-consciousness becomes more difficult.

> Just as we tend to assume that the world is as we see it, we naïvely suppose that people are as we imagine them to be. In this latter case, unfortunately, there is no scientific test that would prove the discrepancy between perception and reality. Although the possibility of gross deception is infinitely greater here than in our perception of the physical world, we still go on naïvely projecting our own psychology into our fellow human beings. In this way everyone creates for himself a series of more or less imaginary relationships based essentially on projection.[29]

A simpler way of stating the above is, 'Projections change the world into the replica of one's unknown face'.[30] The detective does precisely this and projects the negative aspects of the anima which are personified in the figure of the *femme fatale*.

In *film noir* both the positive and the negative aspects of the anima can easily be seen. The good aspects reveal themselves in the detective's intuitive hunches while the negative qualities of the anima are projected onto the figure of the *femme fatale*. David Thomson has described how she inhabits a mystical, sexual and numinous world.

> She sauntered into innocent or weak lives, asking for a light but requiring the soul. She spread scent, languor, a mystically ultimate

sophistication or depravity, her silky legs and the legend that some crime undertaken in the dark would be as thrilling and as sweet as the unlimited, intricate experience she offered herself.[31]

Despite the somewhat tabloid style adopted by Thomson he clearly notes both the spiritual and sexual natures of the *femme fatale*. In these respects, her mythological ancestry resonates with figures such as the Sirens and Lorelei who also seductively lured men to their death.

However, it is important to stress that the *femme fatale* is only secondarily a sexual figure: primarily she is a personified projection of an archetype and because of this she is attractive as a numinous figure (Jung even referred to the anima as the archetype of the spirit). But as demonstrated by the Oedipus myth, there is a relationship between truth and sexuality and here too, in the *femme fatale*, sexuality and spirituality are interwoven. Just as the Delphic oracle needed to live in a cave, so the *femme fatale* needs the darkness of *film noir's* city streets. As Place notes:

> The characters and themes of the detective genre are ideal for *film noir*. The moral and physical chaos is easily expressed in crime: the doomed, tortured souls seem to be at home in the violent, unstable milieu of the underworld. The dark woman is comfortable in the world of cheap dives, shadowy doorways and mysterious settings.[32]

The visual style of *film noir* is established through the use of low-key and high contrast lighting, canted camera framing, extensive use of 'night time' locations and often a city environment. These technical elements combine to create a dark and threatening landscape within which to set the anima. As Place puts it, 'Visually, *film noir* is fluid, sensual, extraordinarily expressive, making the sexually expressive woman, which is its dominant image of women, extremely powerful'.[33] Before the advent of *film noir*, the *femme fatale* as a character in films was very much a minor figure, the forerunner of which was the gangster's moll. Throughout the 1930s the *femme fatale* becomes more important as typified by two of Sternberg's films, *The Devil is a Woman* (Sternberg: 1935) and *The Blue Angel* (Sternberg: 1930) whose very titles imply the presence of the anima.

The two films have similar plot structures, which suggests the presence of a single mythological/psychological motif. In *The Blue Angel*, Marlene Dietrich plays an alluring cabaret performer called Lola Lola, who succeeds in seducing the local school teacher, Professor Immanuel Roth. He falls in love with her and she willingly accepts his proposal of marriage. It appears that all is going well and that they will both live a happy life, but in the scene following the wedding breakfast the Professor is portrayed as a broken man. Stripped of his albeit pompous dignity, he is forced to work in a cabaret selling pictures of his wife — something he had vowed never to do. Unwittingly he has fallen foul of the warning in the song *Falling in Love Again* which Lola Lola sang for him:

> Men cluster to me
> Like moths around a flame
> And if their wings burn
> I know I'm not to blame.

He continues to sink even lower and as clown becomes the object of ridicule for the cabaret magician, who conjures up eggs only to break them over the Professor's head. His final ignominy is to return to the town where he had been the schoolmaster and while on stage to suffer the taunts of the crowd. At this point, Lola Lola takes a new lover and, unable to cope, the Professor returns to his old school room to die clutching his desk. It was the unknowing relationship with the *femme fatale* – with his own unrecognised feminine dimension – that robbed him of his desire to live.[34]

In the 1940s, and in *film noir*, the *femme fatale* comes to the fore. The figure is typified by actresses such as Veronica Lake in *This Gun for Hire* (Tuttle: 1942), Barbara Stanwyck in *Double Indemnity* (Wilder: 1944), Gloria Grahame in *The Big Heat* (Lang: 1953), and Hazel Brooks in *Sleep my Love* (Sirk: 1947) – and the list could easily be continued. The key to understanding the preponderance of anima images in *film noir* lies in the anima's negative qualities: quite simply, the negative anima needs darkness, sexuality and truth to exist. The anima embodies a deep cultural mistrust of the unconscious, which also indicates a mistrust of man's own 'femininity'. The *femme fatale* is at once a representation of the detective's anima and of a cultural anima. As Place notes, 'Myth not only expresses dominant ideologies – it is also responsive to the *repressed* needs of the culture. It gives voice to the unacceptable archetypes as well…'.[35]

Identifying the anima does not involve a separation from collective values. Instead, the collective nature of the individual is acknowledged while still asserting a person's original and distinctive characteristics. Interestingly, as Jung comments, 'Individuation does not shut one out from the world, but gathers the world to oneself'.[36] This provides a hint at the potential that analytical psychology has to be more socially responsive and politically active than is often the case.

> The fact that individual consciousness means separation and opposition is something that man has experienced countless times in his long history. And just as for the individual a time of dissociation is a time for sickness, so it is in the life of nations. We can hardly deny that ours is a time of dissociation and sickness….The word 'crisis', so often heard, is a medical expression which always tells us that the sickness has reached a dangerous climax.[37]

However, the crisis event may also represent a positive stage in the individuation process. The etymological root of crisis is the Greek *krisis*, which means decision. In individuation the separation of the anima, which may result in a 'crisis', also points towards acceptance of the anima as a quasi-autonomous figure in relationship with consciousness. This results in

the ego becoming the recipient of the anima properties and the detective is now able to move forward into a new phase of individuation.[38] Assimilation does not treat the anima archetype as a discrete archetype but regards it as related to the other archetypes of the objective psyche. As such the arrival of the anima is pre-figured in the persona and shadow stages, and its own arrival prepares the way for the final phases of individuation. These take the hero's search for truth and meaning even further into the unknown depths of the objective psyche, to a place where the figure of the wise old man dwells.

> Only when all props and crutches are broken, and no cover from the rear offers the slightest hope of security, does it become possible for us to experience an archetype that had up till then lain hidden behind the meaningful nonsense played out by the anima. This is the *archetype of meaning*, just as the anima is the *archetype of life itself*.[39]

The next development is marked by the appearance of mana personalities. The term 'mana' was borrowed by Jung from anthropology and is Melanesian in origin. It refers to a compelling 'supernatural' power that comes from the inhabitants of the spirit world. The English word charisma is a rough equivalent, meaning "of the spirit'. As Samuels *et al* put it, 'Mana suggests the presence of an all-pervading vital force, a primal source of growth or magical healing that can be likened to a primitive concept of psychic energy'.[40]

This mana energy should not be confused with numinosity, which refers only to the 'spiritual' element associated with archetypal functioning. Mana energy is rather the quasi-divine power which belongs to the magician, priest, doctor, trickster or saint. Figures possessing a mana personality are characterised by wisdom, knowledge, insight, reflection, and readiness to help those in peril. However, these characters have an ambivalent attitude and, depending upon decisions made by the individuating ego, can be a force for good and bad.

The principle stage at which these mana personalities occur comes after the anima and animus have been divested of their own magical force. The mana figures which occur at this post anima point appear as spiritual personalities, often in the same gender as the individual experiencing the mana energy. Typically, they occur as a wise old man or woman (Jung himself had a relationship with such a figure called Philemon, whom he both painted and spoke with repeatedly). Jung comments that these mana personalities adhere to:

> ... the desired 'mid-point' of the personality, that ineffable something betwixt the opposites, or else that which unites them, or the result of conflict, or the product of energic tension: the coming to birth of personality, a profoundly individual step forward, the next stage.[41]

The Phases of Individuation – Revised Schematic/Diagram

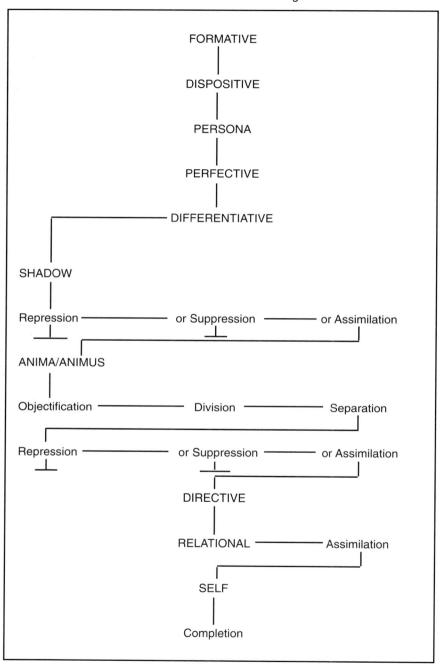

It is curious that detective films are characterised by a strange lack of mana personalities. This is especially interesting when other films – which share what is the same mythologem, the quest – are populated almost to excess with such figures. For example, the figures of Obi Wan Kenobi and Yoda in George Lucas' *Star Wars* films. Quite why such figures should be so rare in detective films is something of a puzzle. One explanation would be that the detective is just not psychologically ready for such advice. This said, mana personalities do occur and the character of Gaf in *Blade Runner* is such a figure; perhaps the emergence of these characters is one way in which the genre will develop.

While the archetypal process of individuation has been outlined in a linear fashion, the experience of individuation is much more akin to a spiral where the different stages lie above and below each other, all inter-relating as parts of a complicated system. In fact, the popular puzzle of the Rubik's cube serves as a useful metaphor, with the cube representing the psyche and the colours on the cube the archetypal patterns. Initially the colours are mixed up, but gradually, with various twists and turns, it is possible to complete one face – one phase in individuation. In completing this phase all the archetypes are used, and all revolve around the unseen, but essential, axis of the Self. Gradually each face of the cube is completed, but only at the expense of undoing previous work, as the first completed face must be undone before the next two can be completed – and so it continues. At the end of the puzzle each side is separate but still connected to the other faces. In other words, a balanced relational system has been created – one in which opposition is left behind in favour of a relational approach. As Moreno notes:

> The integration of the mana-personality through conscious assimilation of its contents leads us back to ourselves as an actual living 'Something' poised between two world pictures and their discerned potentialities. This 'something' is a virtual centre that claims everything. Jung calls this centre the self. The self is, therefore, the new archetype which will finally solve the problem of individuation.[42]

As mentioned, the final stage in the individuation process involves the archetype of the Self. The archetype of the Self is the centre of everything in the psyche, both conscious and unconscious, good and evil, feminine and masculine, etcetera. As such, the Self unites these opposites and acts as the axis of the entire psychic system. Samuels *et al* define the Self as:

> An archetypal image of man's fullest potential and the unity of the personality as a whole. The Self as a unifying principle within the human psyche occupies the central position of authority in relation to psychological life and, therefore, the destiny of the individual.[43]

Historically, Jung discovered the archetype of the Self as a spiritual concept in the oriental religious traditions of Hinduism and Buddhism where the Hindu teaching of atman particularly influenced Jung's thought.[44] The concepts teach

that the 'divine being pervades the whole world and is found eternally within the individual. Divine being is thus the supreme Self'.[45] Within the Hindu tradition, the Self is represented by images of wholeness or completion such as square circles or quaternities as Jung termed these mandalas. For him, they represent the Self as a centre of a balanced psychic system, and they depict the individuation process coming to a close. 'The mandala as the centre is the exponent of all paths. It is the path to the centre. To individuation.'[46]

The relationship between the Self and religious imagery is not foreign to occidental thought and can be found within the Christian tradition. The first chapter of Genesis comments,

> So God created humankind in his image,
> In the image of God he created them;
> male and female he created them.[47]

Again in the Christian tradition, the quaternity of the cross forms the basis for many mandala like patterns, and often these patterns are in-filled by a meandering line which suggests the psychic growth of individuation. However, Jung goes further than merely regarding the Self as the centre or axis of the psyche.

> The Self is not only the centre, but also the whole circumference
> with embraces both conscious and unconscious; it is the centre of
> this totality, just as the ego is the centre of consciousness.[48]

To conclude this chapter are two quotes, both of which acknowledge the inter-relationship of theory and subject in analytical psychology.

> He (the analyst) is not just working for this particular patient, who may be quite insignificant, but for himself as well as his own soul, and in so doing he is perhaps laying an infinitesimal grain in the scales of humanity's soul. Small and invisible as the contribution may be, it is yet an *opus magnum* ... The ultimate questions of psychotherapy are not a private matter – they represent a supreme responsibility.[49]

> Mankind is the only form of life yet known that can bear the tension of these two universes (conscious and unconscious), and perhaps bring them into harmonious relationship. Through the work of mankind the universe may become more conscious of itself. And the only known carrier of this immense process is the individual human being toiling in the personal and unique process of individuation.[50]

It is not possible, nor desirable, to make a clear distinction between the theory of analytical psychology and the object of its study. The psychological principles of analytical psychology are reflexive, meaning that they accept, as a psychological truth and necessity, that the theory will be changed by what it studies, and that in turn its subjects will be changed by the theory. Thus theory and subject are bound together in a dynamic, regulating system that mirrors and embraces the relationship between ego-consciousness and the unconscious.

Notes

1 c.f. C. W. 11: 444.
2 Humphrey, N., *Consciousness Regained: Chapters in The Development of the Mind*, (Oxford, 1983): p91.
3 c.f. Stevens, A., *Archetypes: A Natural History of the Self*, (London, 1982) : p72-73.
4 Carotenuto, A., *The Vertical Labyrinth*, (Canada, 1985): p119.
5 c.f. Sidoli, M., and Davies, M., (eds) *Jungian Child Psychotherapy: Individuation in Children* (London, 1988) and Fordham, M., *Jungian Psychotherapy: A Study in Analytical Psychology*, (London 1986).
6 Carotenuto: p120.
7 C. W. 12: 6.
8 Hillman, J., *Re-Visioning Psychology*, (USA, 1975): p188.
9 C. W. 7: 267.
10 C. W. 11: 401.
11 C. W. 8: 771.
12 Hillman, (1975): p147.
13 Moreno, A., *Jung, Gods and Modern Man*, (USA, 1970): p37.
14 C. W. 9, I: 43.
15 C. W. 7: 309.
16 The opposite is true for women: here the ideal picture for a women is compensated with a masculine weakness in the animus.
17 C.W.11:134.
18 C. W. 7: 35.
19 c. f. Moreno, (1970): P41.
20 C. W. 9, II: 16.
21 C. W. 11: 129.
22 C. W. 9, I: 45.
23 Hauke C., *Jung and the Postmodern: The Interpretation of Realities*, (London, 2000) p126.
24 Samuels, A., *Beyond the Feminine Principle* in Barnaby, K., and D'Acierno,P., (eds) *C. G. Jung and the Humanities: Towards a Hermeneutics of Culture* (London, 1990) p301.
25 *ibid*, p276.
26 *ibid*, p296.
27 Moreno: p54.
28 The Greek for truth or wisdom is *Sophos*, and the mythological roots of this lie in the proto-typical detective story of Sophocles's *Oedipus Rex*. It is interesting that the oracle lived in a cave. The word used by Sophocles for this case is *Stormion*, which means either a small mouth or vagina. At the centre of this *Stormion* rests the *Omphalos*, the centre of the world – literally its navel. It is there, in a vagina, at the centre of a cosmological mandala that Oedipus arrives to search for *Sophos*. Thus from its inception the detective myth links truth with the anima and female sexuality. As we will see, this pattern is repeated in detective films.
29 C. W. 8: 507.
30 C. W. 9: II: 17.
31 Thomson, D., *Deadlier than the Male*, (London, 1982) from 'The Movie', Vol. 3: p590.
32 Place, J., 'Women in Film Noir', from *Women in Film Noir*, Edited Kaplan, E. A., (London, 1978): p41.
33 Place: p36.
34 In *The Devil is a Woman*, Concha Perez, again played by Marlene Dietrich, succeeds in ruining the lives of the men she seduces. In this film Don Pascal is led up the garden path as Concha Perez extracts huge sums of money from him, before finally vanishing. She repeats this escapade a number of times before Don Pascal becomes disenchanted with her, and vows never to see her again. However, she still succeeds in engineering a duel between him and his closest friend, in which he is seriously wounded. So as in *The Blue Angel* the anima projection of the *femme fatale* manages to destroy the lives of those who try and possess her.

35 Place, J., *'Women in Film Noir'*, from *Women in Film Noir*, Edited Kaplan, E. A., (London, 1978): p36.

36 C. W. 8: 432.

37 C. W. 10: 290.

38 In practice, whether the detective's individuation moves past this point is uncertain. In fact some Post-Jungians such as Hillman and Samuels, see the individuation process as a life-long dialogue between consciousness and the objective psyche. The consequence of this is that individuation may never be fully achieved, for after all the objective psyche represents the totality of unconscious experience.

39 C.W. 9, I: 66.

40 Samuels, A., Shorter, B., Plant, A., *A Critical Dictionary of Jungian Analysis*, (London, 1986): p89.

41 C. W. 7: 382.

42 Moreno: p6.

43 Samuels, A. *et al.*, *A Critical Dictionary of Jungian Analysis*: p135.

44 For a more comprehensive account of the Hindu teachings on ātman c.f. *Chandogy Upanishad*, VI, B.

45 Smart, N., *The Religious Experience of Mankind,* (USA, 1969): p125.

46 Jung, C. G., *Memories, Dreams, Reflections*, (London, 1963): p195-196.

47 *TheBible,* New Revised Standardised Version, Anglicized Edition (Oxford, 1995), Genesis 1: 27.

48 C. W. 12: 44.

49 C. W. 16: 449.

50 Hall, J. A., *The Jungian Experience: analysis and individuation*, (Canada, 1986): p124.

Part Three

Guilty as Charged:
An Analysis of *Trancers*

8

Trancers: Movie as Psychological Myth

Gaye Dawn (Claire Trevor): *If I'd known you was gonna act this way, I never would have come here.*

Johnny Rosco (Edward G. Robinson): *If I'd known what you were like, you wouldn't have been asked.*

Key Largo (John Huston: 1948)

Introduction

The final part of this book is turned over to detailed analysis of the detective film *Trancers* (Charles Band: 1984), a low budget, B-movie. It applies the theory of the previous chapters to see how relevant and useful analytical psychology is as a tool for film analysis. The model used to guide the previous film analyses has undergone a revision: rather than looking at individuation at two separate points, there is now just one. (The rationale for this is that the individuation process is dealt with constantly throughout this section, and consequently the final chapter on individuation can be devoted to just considering the individuation of Jack Deth, the film's somewhat unlikely hero.)

As in the analysis of *Blade Runner*, the central guiding questions of the model are taken as the starting points for discussion, and are applied in the following order: archetypal pattern and archetype's image; archetype's image and mythologem; mythology and mythologem; mythology and archetypal pattern; individuation and archetypal pattern with mythologem. To start with, the chapter takes a character-based approach and stays close to the film, but as it progresses we broaden the field to include the mythological and archetypal foundations which are discernible in the film.

However, before we start, a cautionary note which reminds us that this type of analysis does not consist of searching for impressive archetypal patterns and images. Rather, a good film analysis should involve reflecting on the film in a sensitive and thoughtful manner; the film should be allowed to speak for itself. As Samuels comments:

> If analytical psychologists look solely for impressive, archetypal, numinous material, then they will be tempted to be over-active and over-suggestive... possession of a theory of development is just as likely to over-organise the patient's material, if it is misused, as adherence in an unselective way to a myth based approach.[1]

Trancers: A Plot Synopsis

The year is 2247 AD. Trooper Jack Deth resigns from the Angel City police force because his superiors have forbidden him to continue his vendetta against the 'trancers' who are the zombie-like followers of the evil Martin Whistler. However, Deth is summoned by the Council of Angel City, Spencer and Ashe, to discover that Whistler has taken a drug that enables him to travel backwards in time. He is currently hiding 'down the line', in the body of his ancestor Weisling. With more than just a touch of irony, Weisling turns out to be a twentieth century Los Angeles City Policeman. Deth follows Whistler 'down the line' and is sent back to 1984, where he takes over the body of his ancestor, Phil Dethon. Leena, Phil's latest girlfriend, at first thinks Phil has gone crazy but after she witnesses his fight with a trancer she finally believes his story. He eventually finds Spencer's ancestor Lavery, who unfortunately turns out to be a trancer and who also tries to kill him. Lavery is killed, probably by Whistler, and Leena is convinced that Deth is telling the truth and comes to rescue him. Together they track down Ashe's ancestor, Hap Ashby. Jack Deth lures Whistler into Chinatown by offering to swap Hap for a chance to live in the past with Leena. After a struggle, Deth injects Whistler with the antidote to the time travel drug which sends Whistler's consciousness back 'up the line' to the future, where he has already destroyed Whislter's body. Unable to return himself, Deth stays in Los Angeles with Leena.[2]

Archetype's Image and Archetypal Patterns

This section explores the archetypes that lie underneath the narrative surface of *Trancers*. They will be examined in accord with the principles of opposition and regulation. The archetypes of persona and shadow are viewed as a pair that regulate each other. Associated with this pair, but separate, is the archetype of the anima. To understand the importance of these archetypes to the film's hero Jack Deth, the archetype of the hero, will be located within its historical and psychological context. Finally, we will look in detail at the persona of Deth, and how it contributes to his character and relationships with the other archetypal figures in the film. No direct reference is made to individuation of the hero, nor to Jack Deth's specific individuation, as this is fully dealt with in later chapters.

Jung has commented that the hero has qualities that are general and collective:

> (The hero is) ... first and foremost a self-representation of the longing of the unconscious, of its unquenched and unquenchable desire for the

light of consciousness. But consciousness, continually in danger of being led astray by its own light and of becoming a rootless will o' the wisp, longs for the healing power of nature, for the deep wells of being and for unconscious communion with life in all its countless forms.[3]

This image of the hero as someone who is longing for the light of consciousness, and who is firmly rooted in the 'deep wells of being' (for which read the unconscious) is relevant for the detective in general but, as we shall see, it is particularly relevant to the character of Jack Deth. We established in the previous chapter that the detective's search for truth is an expression of his inner individuation. But here Jung uses the image of 'longing for light' as a metaphor for the general trend of all heroes to undertake individuation. Yet the detective is enveloped by a curious darkness which seems to hamper this quest. On the one hand, he is searching for light and truth, while on the other he exists in the dark underworld of crime and corruption. Actually, when we remember the principles of opposition and regulation, this is not a surprising state of affairs. It also makes the name of the detective in *Trancers*, Jack Deth, particularly appropriate. The connotations of the underworld, Hades, fear and darkness all suggest his affinity to the shadow figure of Whistler. This is relevant because in psychological terms it is only after the dark, criminal shadow has been defeated, that it can be assimilated into the totality of the psyche. The character of Deth contains these tensions between good and evil, between the hero and the shadow, and the conscious and unconscious. As a hero, he must accept his task to reconcile these opposites and, in so doing, accept the summons of the council, and go down the line to search for Whistler. As Jung notes, it is only after the hero has succeeded in his search that the shadow can be assimilated into consciousness:

> The hero's main feat is to overcome the monster of darkness: it is the long-hoped-for and expected triumph of consciousness over the unconscious...The coming of consciousness was probably the most tremendous experience of primeval times, for with it a world came into being whose existence no one had suspected before. 'And God said: "Let there be light!" ' is the projection of that immemorial experience of the separation of the conscious from the unconscious.[4]

It is worth noting that the development of the hero archetype is not separate, or divorced from, the culture; in fact the opposite is true. This means that there is a sense in which *Trancers* can be interpreted as a mythological representation of the American descent into the underworld, in which the hero's individuation mirrors the individuation of American culture. Just as Orpheus, on his quest for Eurydice, entered Hades, so too Jack Deth descends into the American underworld. These heroes do not enter this realm for themselves, but rather they act as agents for the culture to which they belong. Commenting on this collective responsibility, Neumann affirms the correspondence of the hero's underworld with the cultural underworld.

Thus the hero is the archetypal forerunner of mankind in general. His fate is the pattern in accordance with which the masses of humanity must live, and always have lived, however haltingly and distantly; and however short of the ideal man they have fallen, the stages of the hero myth have become constituent elements in the personal development of every individual.[5]

From this, we can see that in Jack Deth we are not just looking at the individuation of an individual, we can also see a reflection of a wider cultural move towards psychological growth. Lugi Zola has suggested that, '...to live in the Hollywood century means no longer to have any models for our lacerating conflicts, for our confrontation with the shadow'.[6] But I want to suggest the opposite; that the films of Hollywood clearly voice cultural fears and fantasies.

The opening voice-over monologue by Jack Deth sets up the richly mythological narrative, which suggest his affinity with the shadow. As a voice-over, and also as the opening of the narrative, it gives viewers an important first glance into this fantastic world, and into the character of Deth:

Last January I finally sighted Martin Whistler – out on one of the rim planets. Since then I've been hunting down the last of his murdering cult; he called them Trancers. Slaves to Whistler's psychic power, not really alive, but not dead enough. It's July now, and I am tired – real tired.

This opening acts as a symbolic overture for the film's subsequent narrative transformations. It provides a number of clues for the viewers, so that they too can take part in the mythological process of detection. First, we discover that Deth is a detective, or at least that this is one aspect to his persona. (Exactly what type of detective he is will become clear as we explore his character.) Secondly, there is his seemingly obsessive quest to hunt down the victims of Whistler and to ensure that they are 'dead enough'. Finally, the narrative is set in a world where psychic power with the possibility of mind control exists; detectives stand in opposition to the evil use of such fantastic forces. It is also important to acknowledge the 'spoof' element to this opening monologue, which is reinforced by the *film noir* style lighting, Deth's clothing, and visual and verbal quotes from other detective films. These elements establish the tone of the film, quickly and neatly.

In many ways, Deth is just a stereotypical detective, but he is also more than this might imply. It will be remembered that the persona is the archetype which helps us to negotiate the complex series of inter-relationships that exist between individual consciousness and society. It is a type of character mask that is designed to make an impression on others. As Jung observes:

It is probably no accident that our modern notions of 'personal' and 'personality' derive from the word *persona*. I can assert that my ego is personal or a personality, and in exactly the same sense I can say that my persona is a personality with which I identify myself more or less.

The fact that I then possess two personalities is not so remarkable, since every autonomous or even relatively autonomous complex has the peculiarity of appearing as a personality, ie, of being personified.[7]

As an archetype that enables social adaptation, it is of course important to acknowledge and use the persona; it is equally essential to recognise that it is only a façade, because to identify totally with it would lead to inflation of the ego. Jack Deth clearly knows about his persona. He is aware of his appearance and his clothes form an important part of the mask he adopts for the world. In the 23rd century he chooses to wear the stereotypical dress of a 20th century detective, an ill-fitting raincoat and unshaven face, contributing to the 'hard-boiled' persona. These tough qualities are underlined by the dress of the 'troopers' that surround him who, by contrast, are clean shaven and wear well-fitting uniforms. It is partly through this mask that Deth isolates himself from the world, as his traditional detective's persona seems curiously out of place in the future.

This persona gives viewers their first impression of Jack Deth, which is swiftly reinforced by the movement of the narrative. As he arrives on screen, Deth is driving an old, although futuristic, looking car. This again recalls the traditional persona of the detective. Then he 'singes' a trancer, resulting in its destruction. This section cuts to a scene in which Deth emerges from the ocean, where he has been exploring the sunken city of Los Angeles. In some ways, there seems to be a genre similarity between the personas of Deth and Ian Fleming's James Bond. Deth, like Bond, is physically strong, attractive to women, engages in dangerous activities like scuba-diving, and is himself dangerous. Also, like Bond, Deth is 'Licensed to kill', at least to kill trancers. As if to reinforce these firm impressions of Deth's persona, he is next shown entering the Council Chamber, again wearing his traditional detective's clothing. Here he accepts the Council request that he goes after Whistler, he flirts with engineer Ruby Rains and, enraging the Council, he destroys the body of Whistler. He is then sent down the line to protect the Councillor's ancestors. He arrives in the body of one of his distant relatives, Philip Dethton. Phil is shaving, but Deth looks in the mirror and wipes away the foam, leaving his stubble intact.

Apparently, he needs to carry his persona with him and this is quickly emphasised as Leena, a one-night-stand of Dethton's, is introduced. Deth discovers a drawer full of photographs of Dethton's past conquests, which once more contributes to the womanising, Bond-like aspects of his own persona. He quickly finds a raincoat like the one he left behind in Angel City and proceeds to wear it, even though it is hot outside. He next puts a cream in his hair with the remark that, ' Dry hair's for squids', and, to complete his duplicate persona, he starts driving an old car which belongs to Dethton. Again, Deth's persona isolates him from the other inhabitants of Los Angeles. It is only at the end of the film that Deth is really able to abandon this image. This occurs when Hap Ashby wears a raincoat identical to the one worn by Deth, so that Whistler is tricked into attacking the wrong person.

Despite this emphasis on the persona, it would be wrong to suggest that Deth is suffering from a persona identification. He seems to know what he is doing and his primary quest is clearly to capture the shadow figure of Whistler. Nonetheless Deth does hide behind the mask that the persona provides. This provides the first example of, what will become, a recurring theme in *Trancers* – that an outer defence marks an inner-battle. Or, put in the terms of analytical psychology, beneath the outer persona there exists an inner battle between the shadow and consciousness.

The firm's opening establishes the persona for Deth as follows:

(a) Old raincoat, stubble, car, singes trancers (traditional aspects of the detective).

(b) Underwater exploration (danger).

(c) Raincoat (persona).

(d) Fondness for women is shown with engineer Ruby Rains.

(e) Destroys the body of Whistler (independence).

(f) In Los Angeles he keeps the persona established in the opening sequences of the film: old raincoat, stubble, car, 'wet hair', a girl, quick singeing of another trancer – who is dressed as Santa Claus.

All this clearly makes us wonder why Deth has this dependence on his persona. It is almost as though the persona gives him some type of protection; it offers a character armour that defends him against the psychic power of Whistler. Perhaps Deth is worried about being tranced himself, perhaps 'squids' are tranceable, and this is why he greases his hair. The film leaves these issues unanswered, but the emphasis on the persona may indicate that he is indeed worried about falling prey to Whislter's power. At the very least there is some ambiguity on this point but, as mentioned, identification with the persona brings with it not strength, but ultimately weakness.

An example of how weakness steams from persona identification is found in *Detective Story* (William Wyler: 1951). The detective, played by Kirk Douglas, is a hardened and bitter man who, without mercy and without regard to the nature of the crime, prosecutes any law-breaker that he encounters. His wife tells him that, 'You are a cruel and vengeful man and you're everything you said you ever hated in your father'. As the story unfolds, it materialises that the detective had become entirely identified with the persona of a detective, and used this as a way of projecting a repressed hatred of his father. At the end of the film, he realises this and comments, 'I built my whole life on hating my father, and all the time he was inside me laughing'. His rigid code-of-honour extends to his marriage, in which he is unable to forgive his wife for having an abortion. The cost of this identification with the persona is high, as he

effectively commits suicide when he lets himself get shot by an armed criminal in the police station.

Returning to Jack Deth in *Trancers*, on the surface he could be classified as an extroverted-sensation type. Apparently all his energies are directed towards the outer world – after all, the work of investigation and trancer hunting affords little opportunity for introspection. Again, on first sight he seems to be a sensation type, motivated by a need for new experiences and sensual gratification. For example, in the opening moments of the film Deth orders a coffee, to which he gets the question, 'What, the real stuff, mister? That's gona cost ya'. But for Deth it is worth the money. The intellectual process of detection – the following of clues and the formulating of traps to capture Whistler – again all seem to indicate an extroverted sensation attitude. However, this is only one view of Deth's persona and as a hero and a detective there is another side to him. Intuitively, he knows that to get deeper into his psyche he has to adopt a feeling attitude and let himself become ' affected' by the quest. He has to come to terms with his search and let the effects of descending into the underworld possess him, yet he has to remain in control so that he does not enter into the area of invasion. This would end in disaster as he would become overwhelmed by the weight of the objective psyche. As Jung notes:

> It is through the 'affect' that the subject becomes involved and so comes to feel the whole weight of reality. The difference amounts roughly to that between a severe illness which one reads about in a textbook and the illness which one has. In psychology one possesses nothing unless one has experienced it in reality. Hence a purely intellectual insight is not enough, because one knows only the words and not the substance of the thing from inside.[8]

To get past Deth's persona, we need to identify the roles other than detective that he has ascribed to, or claims for, himself. His girlfriend Lena jokingly describes him as a 'dangerman' and even gives him a small toy robot as a Christmas present. While it is unwise to place too much stress on what is essentially a humorous remark, the role of dangerman seems to hint at his need for excitement and at his quest to destroy Whistler. At the same time, the gift may suggest a weakness, which is that at all costs Whistler must be destroyed. He is 'programmed' to destroy Whistler, and in this respect he comes close to being a robot himself. Nearly out of control, he is almost a trancer himself. The film is ambiguous on this point, but it is important to note that the scene falls between two trancer-orientated situations. Firstly, Deth fights with the 'trancer-like' punks in the discos; next he returns to the flat where he receives his dangerman robot, where he is taken back up the line, only to return to find Whistler on a television newscast. Wherever he goes, he is surrounded by danger, and the movement of the film seems to indicate and strengthen that atmosphere.

In the film, Jack describes himself in two other ways, firstly as an agent of death. While he is working out how he is going to trap Whistler he rings him

saying, 'Tell him it's Deth, he'll know'. The point at which this occurs is towards the end of the film, just before the final sequence where Whistler meets his demise. In some ways, it seems to suggest that Deth has accepted his shadow qualities; as a hero in the underworld, he brings with him death. This has been evident throughout the film as he destroys trancer after trancer, but by the end of the film he seems able to accept these qualities and to deal with this side of his psyche.

His second claim, that he is a fortune-teller, comes to fruition when he tells Hap Ashby what the future has in store for him. As Jack is from the future, it isn't really such a great trick to be able to predict that one of Hap Ashby's descendants will become leader in the 23rd century, although Hap is suitably impressed and disbeliving. But interestingly, he not only tells Ashby the future, he also gets involved in helping him to prepare for it. He does this by participating in Ashby's ritualised washing – which symbolically prepares him for his new role. This washing occurs just before the final sequence of the film, in which Jack Deth, in abandoning his raincoat, sheds his persona and destroys Whistler. In doing this, does he delve deeper inside himself and adopt some of the character of the wise old man? Whatever, his prurient nature is surrounded by an aurora of psychic prophecy, and his benign prophecies find their compensatory opposite in the evil, mind-controlling power of Whistler.

Near the start of the film, we learn that Deth used his wife as trancer bait. Something went wrong, and she was killed by the trancer. Following this is the scene in which Jack emerges from the waters surrounding the sunken city. It is almost as though his investigations into the past keep the memory of his wife alive. Much as he once used his wife as bait for a trancer, so her memory entices him into the past, and into the underworld. His feelings about the death of his wife remain ambiguous, as does the way she died; perhaps she became a trancer. It is also possible that Deth feels guilty about his actions and putting her at risk. On these issues the audience is free to conjecture, but what is certain is that the loss of his wife provides part of his motivation and hatred towards Whistler. Deth is also determined not to let Leena lose her life in the same way. This is why he is so reluctant to involve her in the plot to capture Whistler. The origin of the development of his shadow partly lies in the unresolved guilt that he feels about his wife's death. He discusses her death at length with Leena, implying that his hatred of Whistler stems from the loss of his wife. The irony is that understanding and coming to terms with his own dark side, which he hates, is also the key to his success in killing Whistler.

The Shadow

Having dealt with the figure of the hero as detective, the time is now right to examine its compensatory opposite – the shadow as criminal. The shadow, like the hero, also operates in terms of a collective psychology. Whistler and the underworld represent more than just a projection of Jack Deth's shadow; they embody a wider and more general aspect of the objective psyche. As Jung puts it:

> With the rise of consciousness since the Middle Ages he (the devil) has been considerably reduced in stature, but in his stead there are human beings to whom we gratefully surrender our shadows. With what pleasure, for instance, we read newspaper reports of crime! A *bona fides* criminal becomes a popular figure because he unburdens in no small degree the conscience of his fellow men, for now they know once more the evil is to be found.[9]

It is clearly Whistler who personifies evil. He embodies the dark side which Deth must embrace as he continues along the path of individuation. It should be remembered that there is a similarity between the power possessed by the hero, which is the power of the ego and consciousness, and that possessed by the shadow. *Trancers* describes this in terms of 'psychic powers', which in the terminology of analytical psychology we might refer to as numinosity. It is not so much that the shadow is evil, rather it is that it still has to be assimilated into consciousness, and because it is repressed, it forces the pace of individuation as it grows in strength. During this time, it can either aid or destroy the hero psyche.

> But just as there is a passion that strives for blind unrestricted life, so there is a passion that would like to sacrifice all life to the spirit because of its superior creative power. This passion turns the spirit into a malignant growth that senselessly destroys human life.[10]

In many ways, Whistler represents the antithesis of Deth. While Jack is constantly demonstrating his physical powers by destroying trancers, rescuing Leena and so on, Whistler is not physically impressive. While Whistler may be physically weak, he is the cool, calm, intellectual villain – very much in the vogue of the 'James Bond' despot.

Jack Deth is a physical, earth character. Whister, on the other hand, has an almost illusory quality that lacks Deth's physical presence: the first time the viewer encounters him is in a pre-recorded image at the council; we next see him in a shopping mall by a grotto of Father Christmas at the North Pole (naturally Santa Claus turns out to be a trancer); and next we see him in a sequence where time has been slowed down and then on television and so forth. The key point is that all these appearances of Whistler are illusory, and this serves to increase the shadow like qualities that he embodies. There is something about him that is immaterial. In this way, Whistler not only personifies the negative aspects of the shadow, but his 'phantom' appearances indicate that the shadow is fundamentally an image and metaphor.

The film is making the psychological point that to regard the shadow as an enemy is also an illusion, it is wrong. The archetype of the shadow is part of the psyche and must be accepted as such, and then integrated into consciousness. Whether Deth achieves this or not will be examined in the section on individuation. At this point, it is sufficient to stress the ambiguity

of this, and to remember that before Deth can come to terms with his anima, he must first assimilate his shadow.

The negative aspects of the shadow are embodied in the numerous victims of Whistler's power – the trancers. Taking over their minds, Whistler is able to contol their actions, even to speak through them. However, once Whistler has finished with a trancer, or after one has been killed, their bodies are destroyed; glowing red and then disappearing, they leave behind a black scorch mark. The film calls this process singeing. These events are characteristic of the shadow and of the underworld. The red outline and heat given off by the body as is combusts, represents a destruction in a type of all consuming 'hell fire'. The black scorch, in the shape of the body, indicates that these were indeed shadow figures that belonged to the underworld. Interestingly, both the red outline and black scorch are reminiscent of the convention in detective films in which a white chalk outline is drawn around the bodies of murder victims. At this point, *Trancers* neatly ties together both mythological references to the shadow, and internal filmic references. In so doing, it creates its own mythological underworld. In other words, the film is giving voice to a collective and unconscious processes which is concerned with individuation.

These shadow qualities are also found in one of the sub-themes of the film, namely that the hero is connected with incest. At the end of the movie it becomes clear that Deth, still in the body of Dethton, is to marry Leena. The result of this marriage, many generations later, will be Jack Deth. It follows from this that Deth has therefore fallen in love with one of his own ancestral mothers, or to use a term from analytical psychology, his *first parents*. There are two possible explanations for this and the narrative remains deliberately ambiguous on this point. Either Jack Deth remains in the 20th century and in a quasi-incestuous relationship becomes his own father, or, alternatively, he returns to Angel City and Philip Dethton returns to his own body and marries Leena. At first sight, it appears that Deth has no option but to stay in Los Angeles, because there is only one dose of the time travel drug. However, the final shot of the film shows one of MacNulty's ancestors coming out of the shadows, an ancestor that had previously sent Deth up the line. It is therefore quite possible that MacNulty has returned to bring Jack back to Angel City. Despite this ambiguity, it is clear that Deth intends to enter into the semi-incestuous relationship with Leena. This not only aligns him with the shadow (it is only necessary to remember the fate of Oedipus to realise this), but indentifies him as a clearly mythological figure. As Neumann has commented:

> Jung has demonstrated that the hero's incest implements his rebirth, that only as one twice-born is he the hero, and that conversely any one who has suffered the double birth must be regarded as a hero.[11]

And later,

> ...the hero's 'incest' is a regenerative incest. Victory over the mother, frequently taking the form of actual entry into her, ie, incest, brings

about a rebirth. The incest produces a transformation of personality which alone makes the hero a hero, that is, a higher and ideal representative of mankind.[12]

This hero incest theme is therefore vital to the narrative of *Trancers* and to the development of detective as hero. Additionally, it introduces the mythological concept of rebirth into the film. Just as the hero has to be reborn on his quest, so too all on the quest for individuation have to be reborn; this applies on the cultural, as well as the individual scale. For a culture to participate in its individuation, it must create its own heroes, or, as Jung might have said, live its own myth. Perhaps this is why the detective film has been so enduring.

The Contrasexual Archetype: Anima

In the history of mythology, the image of the anima has varied; some have been positive in nature, but mostly the image is one of women who try to drain and destroy the lives of men. As we have already mentioned, psychologically this shows the fear, or at least ambivalence, that men feel towards their own interior feminine qualities. The twin identities of the anima, as both helpful and destructive, embody the mixture of attraction and anxiety that men have to this side of their psyche. Erich Neumann comments on the shifting nature of anima images, noting:

> She has many forms, ranging from the innocent virgin who is overwhelmed by the heavenly messenger and the young girl who receives the god in an ecstasy of longing, to the sorrowful figure of Sophia, who gives birth to the divine son, the Logos, knowing that he is sent by God and that the hero's fate is suffering.[13]

In fact, Neumann has only elucidated the benign form of the anima, and it takes only a brief look at the history of mythology to see the other aspect. Alongside the *femme fatale* are the Greek Sirens, the German Lorelei, Lilith, Lamais, vampires, and the witches of the 17th century: all these figures show the destructive and magical dimension to the anima.[14]

In *Trancers*, both sets of anima qualities are embodied in the character of Leena. Importantly, she is a 'strong' character, who cannot be tranced. This strength is vital to Jack Deth because his wife was weak and died, or at least was tranced, when used as bait. Leena provides some stability through which to bolster up this previous weakness in Jack's life, although he still fears losing her to Whistler. This is evident in the scene before the final confrontation with Whistler, where Jack helps dress Leena's gunshot wound which she received in the previous chase. Jack describes his belief that it was his own fear of Whistler which put his wife at risk, and explains that he is reluctant to put Leena in danger. During this scene, Leena's face is shown reflected in a mirror and in so doing doubling her visual presence. It is psychologically right that an anima figure should appear as a reflection, as she has to guide and lure the hero past the shadow phase, deeper in to the unconscious. If she does succeed in seducing

135

the hero, he may have to survive without a guide. It is significant that the double image of Leena is caused by a reflection, as this too emphasises the illusory quality of the anima. While the animus is outwardly strong, just as Deth is outwardly strong, the anima assumes the opposite role and is apparently weak. Partly explaining why Deth and Leena fall in love, Jung notes that there is a strong attraction between these opposites:

> When animus and anima meet, the animus draws his sword of power and the anima ejects per poison of illusion and seduction. The outcome need not always be negative, since the two are equally likely to fall in love (a special instance of love at first sight).[15]

As a result of this attraction, Deth is obliged to trust Leena, although, as an anima projection, she does not always seems to be entirely worthy of this trust. For example, initially Leena says she will not help Jack, then she tells him that she will act as his guide around Los Angeles. After this, she steals his car and leaves him at risk from a trancer, and stuck, burning, inside a suntan parlour. Eventually, she does return to save him, and this, combined with their burgeoning romance, explains why Jack returns to save her from being shot by Whistler's policemen. From this point onwards in the film, Leena is entirely trustworthy and her more dubious skills, for example hot wiring motorbikes, are used to Jack's advantage. She acts as both provider and guide, bringing him food and presents, and showing him how to find his way around the city. As Jung observes, 'Anima and animus do not only occur in negative form. They may sometimes appear as a source of enlightenment as messengers, and as mystagogues',[16] while Hillman notes:

> The interpreter's role is to help the ego-shade adjust to his underworld milieu. The interpreter is a guiding Virgil, or a Teiresias, or a Charon; he is not a Hercules or an Orpheus. His work is in service of Hermes *Chthonios* or Hermes *Psychopompos*, corresponding to the one way direction downward. Hermes takes souls down: the hero standing behind the ego tries to bring them back up again.[17]

The anima, like Charon, remains in the underworld, moving between two banks and serving to take the hero deeper into the maze of the underworld, that is, deeper into the unconscious. She is at once his guide and yet also his undoing. Leena personifies all the aspects of the anima, being both a guide and a mother.

To conclude this section on archetype's image and archetypal patterns in *Trancers* is a summary of the key points so far. In *Trancers*, it is possible to discern two key archetypes – the hero and the shadow. It is also possible to discover the contrasexual archetype. These archetypes are not discrete but aggregates and should therefore be considered as a group. This view is further substantiated when it is noticed that the hero archetype has his inner shadow projected on to the criminal Whistler, and his anima projected onto the figure of Leena. This establishes an archetypal cluster that contains a series of regulating and compensatory oppositions necessary for the hero's individuation.

Notes

1 Samuels, A., *Jung and the Post Jungians*, (London, 1985): p199.

2 Derived from Newman, K. *Trancers*, Monthly Film Bulletin, February (1985).

3 C. W. 5: 299.

4 C. W. 9, I: 284.

5 Neumann, E., *The Origins and History of Consciousness*, (New York, 1954). This edition, (New York, 1973): p131.

6 Zola, L., *Analysis and Tragedy* in *Post-Jungians Today: Key Papers in Contemporary Analytical Psychology* Casement, A., (ed) (London, 1998) p46.

7 C. W. 7: 312.

8 C. W. 9, II: 61.

9 Jung, C. G., *The Integration of the Personality*, Trans. Dell, M. S. (New York, 1939). (Not in Collected Works): para 69p.

10 C. W. 8: 646.

11 Neumann: p148.

12 Neumann: p154.

13 Neumann: p137.

14 The darker and malevolent side of the anima is evident in many *film noirs*, one of the most notable of these is *Double Indemnity* (Wilder: 1944). In this film, the 'hero', Walter Neff, is dragged deeper and deeper into the underworld as he is persuaded by the *femme fatale* figure of Mrs. Diedrickson to help murder her husband. Through the attraction of the anima, he is drawn into a fatal confrontation with his own shadow, and, unable to cope with his feelings for the anima figure, his shadow drives him to kill her husband. After this, he describes himself as a living corpse, not unlike a trancer. ' I could not hear my own footsteps. It was the walk of the dead man'. Unable to cope, the only solution he can find to the problem is to kill the *femme fatale*, and he succeeds in this, but not before she has shot him. Just as she wounded him psychologically, so she now wounds him physically and this injury will result in his death, either in the hospital or later in the gas chambers of San Quentin prison. From a psychological perspective, *Double Indemnity* not only illustrates the dangerous aspects of the anima, but also shows how the shadow responds to the advance of the anima. The inner man and inner woman walking hand in hand.

15 C. W. 9,II: 30.

16 Jung, C. G., *Basel Seminar*, (Zurich, 1934): para 48f.

17 Hillman, J., *The Dream and the Underworld*, (New York, 1979): p108.

9

Archetype: Image and Mythologem

Fred Bigelow (Edmond O'Brian): *I want to report a murder.*

Policeman: *Sit down. Where was the murder committed?*

FB: *San Francisco, last night.*

P: *Who was murdered?*

FB: *I was.*

D.O.A. (Rudolph Mate: 1949)

This chapter focuses on exploring the main mythological motif in *Trancers* – the quest – and relates this to the film's secondary, or auxiliary, myth themes of life and death, height and depth, and body and spirit. In doing this, we will discover how the visual surface of *Trancers* rests on top of an intricate mythological framework, which gives the film a psychological structure and mythological unity.

We have already seen how the principles of opposition and compensation are important in *Trancers*: they are an integral part of the analytical procedure that help us to break down the film into its components. However, the danger in this approach is that as the film is deconstructed, the interrelationship between the various parts is forgotten. This is especially true when the principles of opposition and compensation are being observed. In the search for clarity of meaning, it becomes all too easy to lose sight of the complementary opposite of an image. Put another way, we forget that to properly understand an image, we need to look at its other half. As Jung notes:

> The tendency to separate the opposites as much as possible and to strive for singleness of meaning is absolutely necessary for clarity of consciousness, since discrimination is of its essence. But when the separation is carried so far that the complementary opposite is lost sight of, and the blackness of the whiteness, and the evil of the good,

the depth of the heights, and so on, is no longer seen, the result is one-sidedness, which is then compensated from the unconscious without our help.[1]

Creative activities that are viewed psychologically are bound to reveal what appear to be contradictions and oppositions, because this is how the unconscious communicates. When examining the oppositions in the mythological stratum of *Trancers*, we should view them as parts of a psychological, regulating and balancing system. It is important that as we analyse these images, we constantly refer to opposites and their synthesis. In the following quote, Jung is writing about the development of psychology as a discipline, but his point holds as a general psychological principle. 'Contradictory views are necessary for the evolution of any science; they must not be set up in opposition to each other, but should seek the earliest possible synthesis.'[2] The idea of synthesis suggests that the search for opposites should not be used solely as a tool to deconstruct and fragment the audio-visual surface of films. Instead, when we examine opposites in a film, we should make sure that the textual and psychological unity of the film is retained. Even though films are made of separate parts – lighting, camerawork, design, script, direction, acting, and so on – the viewer experiences the final product as a coherent whole. As we work through the analysis, it is important to be aware of how each of these different elements influence the film's final meaning. This is achieved not by retracing the steps of the production process, but by seeing the film as an event that has meaning and value as a whole text. This is where Jung's psychological notion of *enantiodromia* becomes useful.

Enantiodromia is a term that Jung borrowed, and subsequently redefined, from Heraclitus. It is built up from two Greeks words, *enantio* which means counter to, and *dromia* which means running. Jung understood this to be the 'regulative function of opposites', or as Heraclitus more prosaically puts it, 'The way up, the and way down are one and the same'.[3]

> Old Heraclitus, who was indeed a very great sage, discovered the most marvellous of all psychological laws: the regulative functions of opposites. He called it *enantiodromia*, a running contrariwise, by which he meant that sooner or later everything runs into its opposite... Thus the rational attitude of culture necessarily runs into its opposite, namely the irrational devastation of culture. We should never identify ourselves with reason, for man is not and never will be a creature of reason alone, a fact to be noted by all pedantic culture-mongers. The irrational cannot and must not be extirpated. The gods cannot and must not die.[4]

If everything really does run into its opposite, then this raises some important implications for film theory. Rather then regarding an opposition as a textual hole, that is a place at which the fabric of the narrative deconstructs itself, opposition becomes something that can be unifying and solidifying. For example, that Jack *Deth* is on a search for *life* strengthens his mythological and

narrative importance. Deth descends into the underworld to fight crime, but in *Trancers* this 'underworld' is set in Los Angeles 1985. The inner-underworld and outer-world of Los Angeles have become one, and through this cohesion the mythological elements of the narrative are bound into a diverse, yet unified structure. The result of this is that if analysis is properly conducted, then it is possible to discover a new, and deeper, mythological level. Within a carefully conducted film analysis, it should be possible to retain both Jung's demand that myth and symbols remain non-rational, and the analyst's need to know what is going on beneath the surface. Indeed, these aspects can themselves be regarded as part of an *enantiodromaic* system. As Hillman notes:

> So it is a mistake to treat Jung's opposites with logical tools, as if he were making logical moves. Because his oppositions are not logically exclusive contradictories, anima does not exclude animus, and we can be conscious and unconsciousness at the same time, and so on. That is why Jung so often rejects 'either/ or thinking' in preference to 'both'. His pairs are antagonistic and complementary at the same time, but never contradictories.[5]

The Hero's quest or adventure

So far our analysis of *Trancers* has been looking at the detective's quest as a linear search for truth, in which the detective follows a series of clues which, when they are correctly interpreted, enable him to solve the crime. We have also seen how this search acts as a metaphor for the detective's personal individuation. This firmly places the detective in a landscape that is both mythological and psychological; indeed one is a projection of the other. This linear approach to the quest motif is fine as far as it goes, but there are alternatives. For example, it is possible to imagine a cyclical model in which the stages of the quest are broken down into component parts. This provides a general approach, which shows the universally recurring elements in the quest motif.

The cycle starts with the call to adventure. Jack Deth's call is when he is summoned by the council to hunt Whistler. Interestingly, he first of all ignores the Council and only accepts their invitation when he discovers that, 'Whistler's alive!' This suggest that for Deth his own inner call, or vocation, is more important than the council's summons.

The first helper that Deth encounters is Ruby, one of the council's engineers. Her job is to look after Jack's body after she has sent his consciousness 'down the line' into the body of Philip Dethton in 1985. With Ruby's assistance, Deth crosses the threshold of time, goes down the line, and enters the underworld of Los Angeles. Here, now in the body of Dethton, he undergoes his first test, which is to find the ancestor of Chairman Spencer before he is killed by Whistler. He enlists the aid of Leena (Second Helper) in this quest. Unfortunately he is too late – Spencer's ancestor has turned into a trancer. The result of this is that the father figure of Spencer pays for Deth's mistake

(atonement). It's also at this point that Deth uses his 'long second' watch for the first time (when the button on the watch is pressed, one second is stretched to ten for the person wearing it). Rather then steal a magical elixir, as suggested by the model, he uses a 'magical' watch that has been 'stolen' from the future. He goes back to Chinatown to decide on his next move, where, against his will, he is brought back to Angel City (Return). Here it is necessary to insert an additional section, as Deth returns once more to Los Angeles and uses another identical 'magical' watch to help him rescue his anima-guide Leena.[6] The pattern of the hero quest in *Trancers* is almost identical to the mythological hero-quest pattern, and this gives it a strong mythological resonance. Now that the mythological context for the central quest motif has been established, we can move on to think about the auxiliary myth themes of *Trancers*, the first of which is height and depth. Before embarking on a discussion of the psychological and mythological importance of this, it is important to be clear about the role that this concept plays within *Trancers*.

The cosmology of the film locates the city of Los Angeles as 'down the line', whereas the future Angel City is 'up the line'. This simple state of affairs masks several important ideas. The first of these is that there is a physical tie between the two cities which binds together two separate time-scales in one geographical location. Running through the two cities, the line operates as a type of *axis mundi*. Metaphorically depicting his descent into the underworld to hunt for Whistler, Jack Deth descends from Angel City, down the line, into the world of Los Angeles. Deth is constantly on a downward journey: first, he goes down the line, and nearly all subsequent movements in Los Angeles take him deeper. For example, in the motor-bike chase sequence, while Leena remains on the surface, Deth is forced further into the underworld, and at the end of the film he glides down a wire to rescue Leena. Jack Deth is heroically descending not only into the depths underworld, but also into his own unconscious.

While Jung constantly stresses the importance of the unconscious, he is also keen to acknowledge its dangers, and these are dangers that Deth is only too aware of:

> For where is a height without depth, and how can there be light that throws no shadow? There is no good that is not opposed by evil... what is down below is not just an excuse for more pleasure, but something we fear because it demands to play its part in the life of the more conscious and more complete man.[7]

The linking of upper and underworlds is a common mythological theme. The Egyptians thought the sky was supported by the father whose vitality and phallus became the *axis mundi* on which the world turned. In the Polynesian creation myth, the world is shaped by the people who inhabit it, thereby linking heaven and the earth. In India, Mount Meru is believed to stand in the middle of the world, and in Palestine Mount Tabor is also supposed to stand at the world's centre, and bind together heaven and earth. (The word *Tabor* is derived from Tabbur, meaning navel or more correctly world navel – the

equivalent of the ancient Greek *Omphalos*.) While the underworld may be dangerous, we are nonetheless bound to it, and cannot escape. Indeed, each of us carries the underworld in our own psyche, and as these myths illustrate our *imago mundi* is constructed around the *axis mundi* which stands as a metaphorical representation of our ego centre. In archetypal terms, the underworld that Jack Deth enters is also our underworld.

While it is desirable for the clarity of this analysis to separate out the cosmology of *Trancers* into two parts, the upper Angel City and the lower Los Angeles, there is a sense in which these two places are synonymous. If the principle of *enantiodromia* is applied, then we can see that it is no longer enough to create a mythological dualism which separates time and place. The opposites of 'above and below' and 'inner and outer' run into each other. Angel City and Los Angeles become, effectively, the same place; put in psychological terms, the inner world of the unconscious is the same as the outer world of the senses. As Hillman notes:

> The simultaneity of the underworld with daily world is imaged by Hades coinciding indistinguishably with Zeus, or identical with Zeus *chthonios*. The brotherhood of Zeus and Hades says that only the perspectives differ. There is only one and the same universe, coexistent and synchronous, but the brother's view sees it from above and through the light, the other from below and into its darkness.[8]

Jack Deth can visit Los Angeles either as a diver exploring the sunken ruins of the last City, or he can go down the line and explore as a detective in 1984. For him, the two places are one; the city does not change but his perspective on Los Angeles does alter. This is evident in the motorbike chase sequence. Here, he has to leave Leena, who asks him, 'Do you know your way back to Chinatown?', to which he replies, 'Sure, I used to swim through here'. One of the psychological 'truths' that Jack Deth has to learn is that while in Los Angeles he is both an 'outsider' *and* an 'insider'. One of the hidden messages of the film is that to progress with individuation, it is necessary to go deep into the underworld, but this can only be achieved by expanding conscious awareness, as it is through the conscious that the unconscious communicates. As Hillman observes:

> Our familiar term *depth psychology* says quite directly: to study the soul, we must go deep, and when we go deep, soul becomes involved. The logos of the soul, *psychology*, implies the act of travelling the soul's labyrinth in which *we can never go deep enough*.[9]

In other words, to understand the psyche at the deepest level, for a real depth psychology, one must go into the underworld. One of the clearest examples of the underworld in *Trancers* is provided by its two different views about death. In one, death is final and absolute, but in the other, death becomes part of life; it is a renewing event that results in rebirth. This polarisation is an ancient one, as illustrated by the following observation by Plato. 'Death is one of two

things. Either it is annihilation, and the dead have no consciousness of anything; or, as we are told, it is really a change: a migration of the soul from one place to another.'[10] The idea that death is final belongs to Whistler. His use of a psychic power to invade the lives of weak people, leaves his victims with bodies that lack a sense of self-identity. As Deth puts it at the start of the film, they are dead, but not dead enough.

The interconnection of life and death is one in which the whole detective film genre is immersed. In the *film noir*, *Crossfire* (Dmytryk: 1947), not only is this theme evident, but the film also has a similar way of depicting and mythologising death. It opens with a sequence in which the viewer is shown the shadows of two men fighting. We soon learn that this is the murder, around which the rest of narrative will centre. In the terms of analytical psychology, the symbolic interpretation is clear. Here consciousness wrestles with, and destroys, the shadow – as in *Trancers*, the shadow is equated with death. At the end of *Crossfire*, the Detective shoots the murderer, Montgomery, and notes, 'He was dead for a long time, he just didn't know it'; an echo of this is heard in Jack Deth's line that trancers are, 'dead, but not dead enough'.

Jung is anxious to stress that part of life should be the preparation for death (clearly, Whistler's victims do not have this opportunity). Jung notes, 'like a projectile flying to its goal, life ends in death. Even its assent and its zenith are only steps and means to this goal'.[11] And, 'from the middle of life onward, only he remains vitally alive who is ready to *die with life*'.[12] Finally, Jung observes that, 'Death is psychologically as important as birth and, like it, is an integral part of life'.[13] This psychological perspective presents an apparent paradox, that death does not *ipso facto* mean the end of life, it may actually signify the start of a new life. The idea that death can bring life is part of many religions and myths. Christianity has the sacrament of baptism in which the old self dies, so that a new person can be reborn. This new person is recreated, or reborn in Christ. As the apostle Paul writes in *Romans*:

> Do you not know that all of us who have been baptised into Christ Jesus were baptised into his death? Therefore we have been buried with him by baptism into death, so that, just as Christ was raised from the dead by the glory of the Father, so we too might walk in newness of life.[14]

The theologian Luther picks up this insight, commenting that, 'Christ's resurrection is our resurrection'.[15] What he means is that because a saviour (hero) has undergone a trail, humanity does not have to undergo it. In other words, heroes descend into the underworld on behalf of humanity, and the end result of their act is salvation.

In a small way, Jack Deth has some of these archetypal qualities. He too is a *Heilbringer*, someone who brings salvation. However, like all heroes, Deth must pay the price for his role as saviour by sacrificing himself. In the film, this occurs at the point when Deth has one container of the antidote to the time

drug, and he uses this to send Whistler up the line, to a body that has already been destroyed. In doing this, he makes the decision to stay in Los Angeles. In symbolic terms, his sacrifice is to leave behind the world of consciousness and to live in the underworld.

Like many myths, the myth of the self-sacrificing hero is actually quite common. It is clearly part of the Hindu Vedic creation myth of the *Cosmic Sacrifice*. Here the god Purusha, the supreme being, is both the cosmos and man. This means that his primordial sacrifice *is* the very act of creation. Purusha's self-immolation becomes the prototype that is repeated in all Vedic sacrifices.

> When they divided Purusha, in how many different portions did they arrange him? What became of his mouth, what of his two arms? What were his two thighs and his two feet called? His mouth became the brahman; his two arms were made into the rajanya; his two thighs the vaishyas; from his two feet the shudra was born. From the navel was the atmosphere created, from the head the heaven issued forth; from two feet was born the earth and the quarters (the cardinal directions) from the ear. Thus did they fashion the worlds.[16]

This myth aptly illustrates how death can be creative, and how it can result in new life. Of course, this only makes any sense when it is thought about in psychological and mythological terms; from any other perspective, death is final. This symbolic death is the type of death that Jack Deth embodies; it is not a destructive death, but a creative one. In psychological terms, it is not so much that Whistler has been killed, it is more that he has been 'transcended' and the shadow can now be assimilated.

Having explored the way that *Trancers* unites the apparently disparate themes of life and death, we can examine another example of *enantiodromia* in the film – namely, the relationship between body and spirit. Here, it is important to be clear about how we are using the term 'spirit'. First, there is the sense in which spirit refers to a person's consciousness, and this is what *Trancers* deals with. Associated with this is a second meaning in which spirit refers to the eternal self, or the soul, as the spiritual perfection of mankind. Of course these distinctions are not hard and fast as, in mythology, perfection of the bodily spirit may result in a higher level of spiritual perfection. Blake hints at this when he writes, 'Man has no Body distinct from his soul; for that Body is a portion of Soul discerned by the five senses, the chief inlets of soul in this age'.[17] The dualism of body and spirit is also part of Christianity, as in the familiar words of Jesus, ' Stay awake and pray that you may not come into the time of trial; the spirit indeed is willing, but the flesh is weak'.[18] This dualistic approach is adopted, and subsequently developed, by the apostle Paul, who believed that while the body may be perishable, the spirit was eternal.

> But if Christ is in you, though the body is dead because of sin, the Spirit is life because of righteousness. If the Spirit of him who raised

Jesus from the dead dwells in you, he who raised Christ from the dead will give life to your mortal bodies also through his Spirit that dwells in you.[19]

What Paul writes is typical of the hero sacrifice myth; through the hero's death and rebirth (resurrection), all believers may experience their own rebirth. In the terms of analytical psychology, this supports the mythological insight that a hero's individuation aids the whole culture in its individuation process.

The separation of body and spirit in *Trancers* is an all together less sophisticated and cruder form of dualism, but nonetheless it retains some resonance of these ideas. For example, while a body remains intact, its consciousness is sent variously up and down the line. Philip Dethton's body is inhabited by the mind of Jack Deth, with no apparent ill effects to either party. (There is a gap in the film's information at this point because the viewer never gets to know how Dethton feels about being taken out of his body, and Deth is certainly annoyed at the way in which his consciousness is moved around against his will.) However, real problems occur when an evil force inhabits the body: namely, the mind control of Whistler. Here, what happens is not a straightforward exchanging of bodies and spirits. Instead there is sort of attack, as Whistler attempts to take control of an individual, but this can only succeed on the weak 'squids', as Deth calls them. This is a mythological example of a psychological truth; that the shadow can possess those whose consciousness is under-developed.

Trancers are curious creatures who, as Jack notes, are half-dead. In many ways someone who has been tranced is similar to a Zombie. In folklore, these are people who have a spell cast on them and are made to work for someone else against their will; for example, someone may approach a witch-doctor to make a zombie who will kill. Trancers look like the traditional zombies of the cinema. They are clearly human in shape, and yet they have grotesquely swollen bodies and skin that is an unpleasant shade of jaundiced yellow. Interestingly, these physiological characteristics are not the only qualities that are shared by trancers. Everyone who gets tranced also wears some sort of uniform, be it that of a waitress, policeman, Santa Claus, or even a suntan. Using a psychological terminology, we might say that all these characters exhibit an excessive identification with the persona. The two tranced cops in the warehouse suggest this when they respond to Jack Deth by saying, 'The Lieutenant (Whistler) is the finest man on the force. I've pledged my life to him'. The trancers in the film are not really characters at all, but instead are more like functionaries. By identifying with the persona, they have made themselves susceptible to Whistler power; all that Whistler has to do is take the logical step, and exploit this weakness. What puts Deth at risk is that he seems to place a similar reliance on his persona.

Strangely, it is Deth who appears to activate the trancers. For example, a waitress is serving someone until he arrives, when she turns into a trancer and tries to kill him. The important thing is that it is impossible to tell who is, or is not, a trancer, until they meet Deth: it is almost as though he is a chemical,

rather than a secret agent. He seems to represent a catalyst which activates the latent trancer, although he seems unaware of the effect that he has. This gives Deth an odd closeness and affinity to the trancers. Like him, they hold onto their personas, but like Whistler they also represent the shadow. In some ways they form a midpoint between Deth and Whistler; on the outside they carry their persona and, like Jack, are physically strong; yet on the inside they hide the invisible shadow Whistler, and here they are weak.

Importantly, there is more than one set of trancers in the film. At the night-club, where Jack goes to dance with Leena, he encounters a group of punks who he describes as being, 'Like a bunch of trancers'. To him, they are trancer-like because they do not seem to have any control over their bodies. Like the trancers controlled by Whistler, Jack 'activates' the trancer-punks and ends up in a fight with them. It is Deth who triggers their violent and destructive behaviour. In contrast to the tranced characters in the film, Hap and Leena are able to resist Whistler. Both are strong characters who have a clear sense of purpose; they are also free from the persona identification that left the other characters at risk. Their respective strength stems from their missions: one of Hap's descendants will become a leader in the 23rd century; and Leena must guide and protect Deth. It is her devotion that gives her the strength to resist Whistler's attempt to overpower her. This causes Jack to comment, 'The girl won't trance, Whistler. She's too strong'. One interpretation of this would be that the film is saying that it is important to have a sense of purpose, and to be in control of yourself. *Trancers* seems to make heroes out of those with a singleness of purpose, a quality that Jack Deth exhibits in abundance.

To finish this chapter, here is a summary of the key points. Opposites tend to run into each other, as in death and life, which result in rebirth – this tendency is called *enantiodromia*. The central myth of *Trancers* is the hero detective's quest. The physical outward quest is a metaphor of his inner quest for individuation. The secondary, or auxiliary, myth themes of height and depth, life and death, and body and spirit are united by the central myth theme. Finally, the hero's individuation indicates a cultural quest for individuation, which it both reflects and aids.

Notes

1 C. W. 14: 470.

2 C. W. 18: 1774.

3 Heraclitus, *Heraclitus: Greek Text with a short Commentary,* Trans. Marrovitch, M., (Los Andes University Press, 1967): Fragment 30.

4 C. W. 7: 111.

5 Hillman, J., *The Dream and the Underworld,* (New York, 1979): p75-76.

6 It is interesting to note that Empire Entertainment, the umbrella organisation for all director Charles Band's activities, is planning to produce a sequel to *Trancers* called *The Return of Jack Deth*. From the quest model that has been created, certain predictions about the general plot structures of the film can be tempted. First, Jack Deth must be re-called across the threshold into the twenty-third century. Here, once again, his help will be required to maintain the civilisation of Angel City. To assist him in this quest he will be provided with certain magical items and will enlist the aid of at least one helper. In terms

of the individuation process, it would be expected that Deth will no longer be combating his shadow nor maybe even his anima, and the appearance of a 'wise old man' figure is anticipated. Of course, this is pure conjecture and just represents a development of the individuation process and one more circuit of the quest cycle. However, it would seem a vindication of this type of psychological model if the film does conform to these expectations.

7 C. W. 10: 271.

8 Hillman, (1979): p30.

9 Hillman, (1979): p25.

10 Plato, *The Last Days of Socrates: The Aplogy*, Trans. Tredennick, (London, 1954): p41.

11 C. W. 8: 803.

12 C. W. 8: 800.

13 C. W. 13: 68.

14 The Bible, *Romans*, New Revised Standard Version, (London, 1995): 6: 3-4.

15 Luther, M. , *Commentaries on I Corinthians* 15, (St Louis, 1973): 28: p202.

16 Rig Veda, *Hymns of the Rig Veda IV, In The Hindu Tradition: Readings in Oriental Thought*, ed Embree, A. T., (New York, 1972) p25-26.

17 Blake, W., 'The Marriage of Heaven and Hell. The Augment.' *The Complete Writings of William Blake*, editor Keynes, G., (London, 1966): Plate 4, Lines 10-12.

18 The Bible, *Matthew*, 26: 41.

19 The Bible, *Romans,* 8: 10-11.

10

Symbolism: Mythology and Mythologem

Al Ramsen (Benny Wilkes): *Never slug a guy while wearing a good watch. Take it off first and put it in your pocket.*

City Across the River (Maxwell Shane: 1949)

This chapter will examine a number of the key symbols that occur in *Trancers*. However, before we start on the analysis, it is important to remind ourselves that any symbol has the potential to contain a wide range of meanings; ultimately, the meaning of a symbol is ambiguous and polysemic. Nonetheless, the unfolding analysis will show how the symbols in *Trancers* form part of a cohesive mythological structure. Helping to narrow-down the possible interpretations for each symbol, we will use what we already know about the mythology of *Trancers*, and the psychology of its characters. In doing so, we will be guided by the way the film uses the imagery of the underworld, and by the myth of detection. Following the now familiar principles of opposition and balance, we will examine various, and apparently contradictory, readings of the symbols. Hillman has commented on the ambiguity of dream images, and his remarks seem equally applicable to films; they suggest that this approach is along the right lines.

> The ambiguity of dreams lies in their multiplicity of meanings, their inner polytheism, the fact that they have in each scene, figure, image 'an inherent tension of opposites', as Jung would say. The tension is more than that, however, it is the tension of multiple likenesses, endless possibilities, for the dream is soul itself, and soul, said Heractilitus, is endless.[1]

One of the less obvious, but nonetheless important, symbols in *Trancers* is the role that is played by time. Importantly, the perception of time is something that it is culturally dependent, and different cultures have devised different systems for its measurement. The Western system records time using an even cyclical method, in which the perception of time is of an even-flowing current;

as Thomas comments, however, this is a fairly recent development in Western thought:

> But, essentially, these beliefs about the unevenness of time were the natural product of a society which was fundamentally agrarian in character, and relatively primitive in its technology...These changes (in technology) meant that the Newtonian conception of time as continuously flowing and equable in quality was not just intellectually valid; it had also become socially acceptable.[2]

For Jung, this Newtonian concept of time was neither intellectually valid nor socially acceptable, and the concept of the objective psyche places archetypes outside time; they are independent universal patterns that govern past developments, and also prepare for future ones. As Jung observes:

> Anything psychic is Janus faced – it looks both backwards and forwards. Because it is evolving, it is also preparing the future. Were this not so, intentions, aims, plans, calculations, predictions and premonitions would be psychological impossibilities.[3]

Or more simply, ' Everything psychic is pregnant with the future'.[4] Jung's view of time is not rooted in a materialistic perception, rather he adopts a mythological approach in which time is at once present, future, and past. It is closer to the view in Blake's *Auguries of Innocence*, in which he wrote:

> To see a world in a grain of sand
> And heaven in a wild flower
> Hold infinity in the palm of your hand
> And eternity in an hour.[5]

In *Trancers*, time is essentially treated in a mythological and psychological manner. Here, the hero-incest theme, in which Jack Deth enters into a quasi-incestuous relationship with Lena, one of his distant female ancestors, is important. For Deth, the manipulation of time gives him a way to escape from the present; he can travel up and down the line, or stretch time, using his 'long-second' watch – of which more later. In the following quote, Jung describes the physical relationship between daughter and mother, but because Deth attempts to create his own ancestral heritage, and children, his remarks apply equally well to the situation in *Trancers*:

> The psyche pre-existent to consciousness (eg, in the child) participates in the maternal psyche on the one hand, while on the other it reaches across to the daughter psyche... This participation and intermingling give rise to that peculiar uncertainty as regards *time*: a woman lives earlier as a mother, later as a daughter. The conscious experience of these ties produces the feeling that her life is spread out over generations – the first step towards the immediate experience and conviction of being outside time, which brings with it a feeling of *immortality*.[6]

This suggests that the incest theme, as it is represented in *Trancers*, is an extension of a normal psychology, and that depiction of time in the film is mythological and psychological. Put another way, the treatment of time in *Trancers* is different to our normal materialist conception of time, in which it is thought of as something that is constant and linear. Instead, it symbolises the psychological reality that time is subjective; time is dependant on who you are, and what you are doing. While this view of time may not fit neatly with a Newtonian view of the world, it does go hand-in-glove with Einstein's theories of relativity.

> As part of his Special Theory, Einstein stated that the velocity of light is always constant relative to the observer, whatever his motion might be. Time is not absolute but relative to the position of the observer. This idea, in the Special Theory, was expressed in two forms; first, in the time-dilation effect; secondly, in its stress on the fact that two observers at different distances from an event will see it at different times…It (the time-dilation effect) asserts that two observers, moving at a large velocity (near that of light) relative to one another will see the other in slow motion, as if everything to do with him were running 'behind time'.[7]

From this, we can make the more general point that time in films is always closer to Einstein's view of the universe than to Newton's understanding of chronology. Very few feature films are shot in 'real-time', in which a minute of screen time equates exactly with a minute of time in the off-screen world. Where they are, a film that lasts for an hour appears, subjectively, longer. Instead films manipulate time; they compress and expand it. As Priestley puts it, '…film and television screens also offer some means of escape from relentless chronology, from the ticking away of youth and health and high spirits toward senility and extinction'.[8] There is a curious way in which myth and psychology are closer to science than might be immediately obvious.

Trancers has two further time themes. First, time in the Angel City and Los Angeles are not synchronised. Put another way, time and dates in the two locations do not correspond exactly, so when Deth leaves Angel City for the first time in July, he arrives in Los Angeles on Christmas Eve. There is another indication of non-linear time in the scene where Deth attempts to have sex with Leena. Here, he is taken out of his ancestor's borrowed body for five minutes, but when he returns, he discovers, to his chagrin, that more time than that has passed in Los Angeles. While the two worlds are connected, by what is almost an *axis universalis*, time in the upper-world and time in the underworld are moving at different speeds.

One of the inventive devices used by the film is Jack Deth's long-second watch; when activated, one second is stretched to ten for the person who is wearing it. This gadget is useful to him on two occasions: first, when Whistler shoots at Leena and Deth as they are coming out of a suntan parlour; and secondly, at the end of the film where Whistler throws Leena from the top of a building. On

both occasions Jack uses the long second, and is able to move Leena out of the bullet's path, and to catch her as she falls.[9] The film depicts the long second in two slow motion sequences, and these give the viewer the same view of the event as Jack. It is also evokes Priestley's description of the time-dilation effect, in which two fast moving observers see each other in slow motion.

The reasons for these apparent discrepancies in time-scale become clear when they are seen in relation to mythological representations of sacred and profane time. For Western people, it is no longer possible to rely just on the linear Newtonian concept of time because, as we have seen, the discoveries of Einstein and quantum physics have altered our perception of the universe. This has created a new mythology or, more accurately, an old psychological and mythological view of the world has been rediscovered. The scientist Heisenberg, who postulated 'The Uncertainty Principle', comments:

> Atoms are not Things. The electrons which form an atom's shell are no longer things in the sense of classical physics, things which could be unambiguously described by concepts like location, velocity, energy, size. When we get down to the atomic level, the objective world in space and time no longer exists, and the mathematical symbols of theoretical physics refer merely to possibilities, not facts.[10]

What is important here is that even in the field of theoretical physics, time and space no longer remain fixed, measurable quantities. This is also the case in the world of *Trancers*, where not only do time scales differ, but the actual experience of them also changes. From a different perspective, Eliade makes a similar distinction between 'magico-religious' and 'profane' time. He notes:

> The difficulty is not simply that magico-religious time and profane time are different in nature; it is rather more the fact that the actual experience of time as such is not always the same for primitive peoples as for modern Western man.[11]

This is certainly the case in *Trancers;* for Jack Deth in particular, his experience of time is different from everyone else's. It is as though, as a hero, he has numinous and magical qualities that carry with them their own time scale; in using devices such as the long-second, Deth makes incisions into profane time. These insertions of magical, or sacred, time are thematically linked together, and almost form another duration, with its own continuity. In mythological terms, Deth brings his own sacred time, which is independent of time in the underworld.

The way in which *Trancers* uses time creates a mythological association for the hero which evokes the theme of incest; this forms part of the hero's quest mythology, and reinforces his magical and numinous powers. While there appear to be contradictions in the way in which time is represented, in fact, the representation of time in *Trancers* reflects images of sacred and profane time. What occurs in the film is, in part, a re-working of the religious and magical aspects of the hero myth.

The transformation of an everyday image into a symbol also applies to the way *Trancers* depicts water, and there are three important points where water occurs. The first of these is when Jack Deth is summoned by the Council, and emerges from the ocean, where he has been exploring the sunken ruins of Los Angeles. Secondly, water is used to wash Hap Ashby – a symbolic cleansing that prepares him for his role as the father of a future leader in the 23rd century. Finally, at the very end of the film, just before Whistler is sent up the line, he is immersed in a fountain. The symbolism of water is complicated and includes: uterine symbolism; baptism; wisdom; the unconscious; life-force; lustration; etcetera. Rather than try to account for all the possible symbolic uses of water in *Trancers*, we will once more let the underworld perspective dominate the analysis; this will focus our attention on how water is connected to death. Keeping in mind the principle of *enantiodromia*, we will also examine how water symbolises life and, more specifically, rebirth.

Heraclitus draws attention to the association of water with death, noting, 'To soul, it is death to become water…'[12] and in another translation, 'It is delight, or rather death, to souls to become wet…'[13] If Heraclitus' observation is seen in conjunction with the alchemical advice to, 'perform no operation until all has become water', then it becomes clearer that individuation only starts when we are prepared to leave the old-self behind. Jack Deth's underwater investigations of the city suggest this type of activity. It is almost as though the contagious nature of the underworld gradually infects him, until he has no option but to go down the line to the sunken city. Hap Ashby is in a similar situation, although he is not as associated with the symbolism of lustration. Instead, in preparing for the death of his old tramp persona, and the creation of his new role as a respectable father, he undergoes a symbolic initiation. As the founder of a lineage whose psyche is to live on in the child that is destined to become one of the leaders of the future, he needs to 'delight' in washing away the old persona. These moments in *Trancers* illustrate a cycle where, in an *uroboric* movement, life and death are renewed by water. In the third example, Whistler is prepared for his death by Jack, who immerses him in water; it is only a few minutes after this that Whistler is sent up the line, to a body that has already been destroyed. The film is ambiguous about Whistler's future. Does the destruction of Whistler's body mean that he simply ceases to exist? Or maybe washing Whistler in a fountain, and in the presence of a statue of the Buddha, suggests a mythological rebirth? At this point, it is more helpful to look towards Jack Deth than Whistler. In immersing Whistler, Jack symbolically enacts his desire to 'wash away' his own shadow. This sequence seems to foretell the demise of Whistler, occurring, as it does, shortly after Jack has removed his persona-raincoat, and after he has made a commitment to Leena by using his long-second watch to rescue her. In symbolic terms, he has made a commitment to move past the shadow phase, through to a relationship with the anima.

Thus an *uroboric* movement, or flow, is revealed, as individuation demands a movement, like a flow of water. As Heraclitus puts it, 'To soul it is death to become water; to water, it is death to become earth. From earth comes water,

and from water, soul'.[14] To remain in a fixed, static relationship to earth is in a symbolic sense death; it results in stagnation of what should be soul making. Jack Deth knows this, and that is why he spends time in Angel City, swimming through the sunken ruins, immersing himself in water which, in this case, has quite literally come from the earth.

Food also comes from the earth, but it appears only three times in *Trancers*. On at least two of these occasions it has a symbolic function: the food suggests the mythological and psychological processes of the film; it not only unifies opposites but also provides the *tertium non datur*.[15] The first time we encounter food is at the start of the film. Here, Deth asks a waitress, who later turns out to be a trancer, for some coffee, to which she replies, 'What the real stuff? That's gonna cost you mister!' Deth also requests real milk and not a soya substitute. Before reflecting on this, it is useful to look at the second occurrence of food in the film, as this helps to provide a context. This time Deth's food is provided by Leena, who brings it to the apartment where they are staying. The food is Chinese (appropriate as they are in Chinatown) and is charged to Philip Dethton's account. Deth comments, 'We'll call it my inheritance' and expresses surprise at having real beef to eat, 'From cows?' At first there is an almost sacrificial atmosphere to the meal, characterised by long silences and eating small quantities of food; for someone who has not eaten all day, Deth takes remarkably little interest. The quasi-religious ambience continues, until Leena pretends to have found a message from Whistler inside a fortune cookie. Pointing us in how to interpret this, the analytical psychologist Hillman has the following comment to make on the association between food and the underworld:

> Such foods and such meals may then be understood as referring to Hades, 'the hospitable,' the hidden host at life's banquet. Then these ritual communions may open the way into an easier fellowship with one's 'dead persons'. These are usually experienced as family influences from the past, as the unlived life, the unfulfilled expectations of the ancestors that one carries unwittingly.[16]

In the first food sequence, Deth is fed by a shadow projection. Psychologically unable to cope with the situation, he is forced to singe the trancer. At the second meal, Deth is fed by one of his ancestors who, at the same time, is the recipient of his anima projections. The symbolic act of eating seems to suggest that the psyche needs feeding. Jung has briefly referred to this idea, and suggested that going to the cinema can provide the psyche with nourishment.

> ... eating the images means to assimilate, to integrate them. What you first see on the screen interests you, you watch it, and it enters your being, you are it. It is a process of psychological assimilation. Looking at the screen the spectator says to the actor: '*hodie tibi, cras mihi!*' (Today for you, tomorrow for me.)[17]

If Deth is to succeed on his quest, then he must receive nourishment, but this nourishment is not so much actual, as symbolic; he never drinks the coffee

and only eats a small portion of the beef. Intriguingly, both of the sequences precede dramatic events. In one, Deth discovers in the trancer a shadow projection, and in the other he is forcibly sent up the line. The idea that the psyche needs feeding, which is to say that the psyche needs inner food, just as the body needs outer food, is a common mythological motif. For example, there is the widespread practice of leaving food and cooking utensils in the graves of the dead. It also occurs in the annual Greek ceremony (*Anthest eria*) in which the souls that have returned from the underworld, to their former living place, are fed. Indeed, on Halloween as a 'treat' we give food to masked children in the hope that in return these *puer* like shades will not 'trick' us. All these examples indicate the psychological truth that if individuation is to proceed, if a psychologically healthy life is to be led, then the body needs the food of inner-images. As Hillman puts it, 'we are shown that the body draws upon the soul for its nourishment. The life of the body needs the soul staff of images'.[18]

In the mythological offering of food, the meat, or coffee or whatever might be offered is natural or 'real', but what nourishes is not literal – it is sacrificial and metaphorical. Eating becomes a moment in which change occurs, a transubstantive moment, in which the property of the outer natural world alters to become the property of the inner underworld. The food symbols in *Trancers* indicate this change, and over and above the opposites of nourishment and starvation, carry a *tertium* of sacrifice and inner growth. These symbols are a way of feeding death, of feeding the hero, and of communing with our ancestors. For Deth, this ancestor is Leena, but for the viewer of the film the ancestor is the hero archetype.

The colour symbolism reinforces this underworld perspective: blue and red are used throughout the film to light nearly every scene, and so dominate the lighting scheme of *Trancers*. In trying to assess the symbolic function of these colours, it would have been a help to us if their use fell neatly into organised patterns; however, as is often the way of symbols, they do not. This means that we can only make general comments about their symbolic role.

Perhaps the most obvious point to be made about blue and red is that they exist at different ends of the spectrum; in fact, they can be regarded as opposite colours. As signs in everyday life, they are often used in this way: blue may indicate cold, as in cold water, while red indicates the opposite. This duality continues into their symbolic life, where blue is associated with sky, while red stands for the ground or earth. In *Trancers*, blue comes to symbolise the upper daylight world of Angel city, while red stands for the underworld of Los Angeles – the city of lost angels. Chevalier has commented:

> In the combat between heaven and earth, the colours blue and white
> join forces against red and green, as Christian iconography often
> shows, especially so in its representations of Saint George's struggle
> with the dragon...[19]

If Chevalier is correct, then the symbolic battle between heaven and earth, depicted as the diurnal and the nocturnal, can be seen in the symbolic lighting scheme of *Trancers*. This fits well with our previous observations, where we saw how the cosmology of *Trancers* can be divided into two sections: the upper-world of Angel City, and the underworld of Los Angeles. These two worlds are connected by an *axis mundi*, a view which is reinforced by a symbolic interpretation of the film's lighting. The opposites of red and blue emphasise the division of these two worlds, but by using these colours together, the film also suggests their simultaneity.

So far we have seen how blue can symbolise the upper regions, or sky. However, in a twist of symbolic logic, blue can also symbolise not only the outer world, but also the inner-life. Among many possible interpretations of the symbol blue, Vries lists the following: '1. Heaven and heavenly gods... eternity, immensity: time and space; 3. Harmony, co-operation, spirituality... this is in contrast to the symbolism of the colour red which is associated with 1. Fire, lighting, heat...2. Active, creativeness, masculine (earthy), 3. Blood, war'.[20] From this, we can see that blue represents the spiritual while red stands for the earthy. But blue also symbolises the feminine (blue is the colour of the Virgin Mary), while red is masculine. If these opposites are applied to *Trancers*, then we can see that Leena is associated with the spirit, and hence the air and sky, but in true symbolic fashion she is located in the underworld. On the other hand, Deth, who is on an inner quest, comes from the upper-world of Angel City. Again, this fits neatly with the principle of *enantiodromia*, in which the oppositions of blue and red, of earth and spirit, 'run into' each other. This is shown by the way the film lights both the upper and the underworlds with the same blue and red scheme; the film shows, in the mythology of its lighting, the psychological insight that the inner and outer worlds are one. This is just another way of saying that the detective's outer search for truth, is also an inner search for individuation.

There are two names in *Trancers* that benefit from being treated symbolically: these are Deth, and Whistler. Before examining the specific symbolism of these names, it is important to stress the more general archetypal significance of names. As Hillman comments:

> It is as if archetypal material chooses its own descriptive term as one aspect of its self expression. This would mean that 'naming' is not a nominalistic activity, but realistic indeed, because the name takes us into its reality.[21]

The reality behind the names in *Trancers* is reasonably clear, especially now that we have established the mythological mode of interpretation. With its aural connotation, the name Whistler leads Leena to call him, 'Piper'. Much as the Siren sang their songs in an attempt to lure weak-minded seamen to their death, so too Whistler plays a psychological tune. The aim of his 'music' is much the same as the sirens; he too wants to control the minds of his victims, before eventually destroying them. The symbolism of the name Deth is more

obvious. His name holds both the promise of death, and the hope of new life; as a hero he is concerned with both destruction and renewal or, to use a mythological language, with rebirth and life. Some scholars regard even the very term *Hero* as *chthonian*, as it suggests the power of the lower world: Farnell notes the, 'common use of the word in later Greek for a deceased person'.[22] It would appear that in the world of mythology, to be a hero involves destruction. The symbolic use of names fits neatly into the pattern we have already established for *Trancers*. Names describe the psychological nature of their owners – in this case, death and seduction. Names also go beyond this, and point to a deeper mythological and psychological function; Whistler's name implies the potentially destructive qualities of the shadow, while Deth's suggests heroic and life renewing qualities.

To summarise, it is clear that the symbols examined in the film form part of a mythological and symbolic structure that is not readily apparent to the casual viewer. This structure supports the central myth theme, and its auxiliary themes, and at the same time it resonates with a number of other themes in the film. So far, the analysis has discovered that beneath the surface of the film there is a united, mythological, and symbolic structure that is psychological in its operation. The ideational perspective of the underworld provides a framework for the interpretation of symbols, and this is part of the film's mythology and also of a wider cultural mythology. The role of time in *Trancers* exemplifies this, in that it is non-linear, and provides a point of contact with the modern insights of 'The New Physics' and, curiously, with ancient myths. The images of water in the film are concerned with death and the underworld, and help to establish the circular, *uroboric* pattern of life, death and rebirth that is typical of the individuation process. The feeding of the body stands as a metaphor for the feeding of the psyche; outer food symbolises inner nourishment. This duality extends to the colour symbolism of the film, in which the unification of opposites is suggested by the lighting scheme. Finally, names identify the most clearly archetypal characters, and this indicates how to interpret their archetypal roles.

Notes

1 Hillman, J., *The Dream and the Underworld*, (New York, 1979): p126.
2 Thomas, K., *Religion and the Decline of Magic*, (London, 1971). This edition, (London, 1984): p744-745.
3 C. W. 6: 718.
4 C. W. 14: 53.
5 Blake, W., *Auguries of Innocence*, lines 1-4, 1803.
6 C. W. 9,I: 316.
7 Priestley, J. B., *Man and Time* (London, 1964) This edition (New York, Laurel, 1968): p62-63
8 Priestley (1968) p89.
9 With reference to the first of these two occasions, it is interesting to note that Robbe-Grillet wrote a detective novel, *The Erasers*, which takes place in the moment between the firing of the murderer's gun and the bullet's arrival in its victim. The detective's entire investigation takes place in this moment; perhaps some reference is being made to this novel.

10 Heisenberg, W., *Der teil und das Granze*, (Munchen, 1969): p63-64.

11 Eliade, M., *Patterns in Comparative Religion*, (New York, 1958): p388.

12 Heraclitus, Frg. 36. Translated Marcovitch.

13 Heraclitus, Frg. 77. Translated Freeman.

14 Heraclitus, Frg. 36. Translated, Marcovitch, M.

15 The third not logically given.

16 Hillman, 1979: p172.

17 Jung, C. G., *Seminars on Dream Analysis*, eidted McGuire, W., (London, 1984): p12.

18 Hillman, 1979: p174.

19 Chevalier, J., and Cheerbrant, A., *Dictionnaires des Symboles*, (France, 1969). This edition, (France, 1973-74), Vol.I: p211. (This quote translated by Chitnis, B., Strawberry Hill College.).

20 Vries, A *Dictionary of Symbols and Imagery*, (Amsterdam, 1974). This edition, (Amsterdam, 1984): p54.

21 Hillman, (1979): p25.

22 Farnell, L.R., *Greek Hero Cults and Ideas of Immortality*, (Oxford, 1921). P15-16.

11

Mythological Amplification

Edie Johnson (Linda Darnell): *I used to live in a sewer. Now I live in a swamp.*
I've come up in the world.

No Way Out (Joseph Mankiewicz: 1950)

This chapter focuses on uncovering the mythological parallels to the central and auxiliary myth themes. It will show that what may appear, *prima facie*, to be a series of dispirit mythological motifs, can more helpfully be regarded in terms of a theme and variations. It will uncover the central motif, which *Trancers* never directly states, and in so doing make another descent into the underworld. To help understand the psychological meaning that images hold for us, Jung devised a technique known as 'mythological amplification', and we will borrow this to help us understand the images of *Trancers*. He described the therapeutic value of the process as follows:

> When a patient begins to feel the inescapable nature of his Inner development, he may be easily overcome by a panic fear that he is slipping helplessly. More than once I have had to reach for a book on my shelves, bring down an old alchemist, and show my patient his terrifying fantasy in the form in which it appeared four hundred years ago. This has a calming affect, because the patient sees that he is not alone in a strange world which nobody understands, but is part of the great streams of human history, which has experienced countless times the very things that he regards as pathological proof of his craziness.[1]

There are two central images in *Trancers* that will provide the basis for amplification. These are the myth of Atlantis and the myth of the labyrinth.

From the perspective adopted by this chapter, there are some similarities between the myth themes in *Trancers* and the myth of Atlantis. One of the first hints we have of this is in the names of the two cities – Lost Angels, and the Lost City of Atlantis. This mythological association is reinforced when we discover that the city of Lost Angels sank as a result of 'The Great Quake'. This evokes the contemporary fear (which partly stems from the San Francisco

159

earthquake of 1906) that eventually the San Andreas fault will open up, and that the western sea-board of the United States will fall into the Pacific: and this gives the ancient myth a modern relevance. Interestingly, when we refer to Plato's description of Atlantis, in the dialogue *Timaeus,* we discover that Atlantis also sank as the result of an earthquake.

> But at a later time there occurred portentous earthquakes and floods, and one grievous day and night befell them, when the whole body of your warriors was swallowed up by the earth, and the island of Atlantis in a like manner was swallowed by the sea and vanished.[2]

Emphasising the importance of this image, the establishing shot for the location, where we first see the sunken city, is long, especially for a film that has a running time of only 76 minutes. This reinforces the mythological association, and it seems clear that the cities of Atlantis and Lost Angels belong to the same tradition, with one myth developing the other.

Jack Deth has to descend into the 'watery' city because, as a place of crime, it provides a suitable home for the shadow but, to use the words of the film, it is also a 'thriving metropolis'. Psychologically, the city is alive; it is a living place that can change both Deth and Whistler. The ancient city is where Deth will fulfil his duties as hero: exploring his own psyche, he will also save Angel City, and, by saving the ancestors of the leaders of the Council, he will secure the city's future.

The mythological form of Angel City suggests that it might also be seen from a psychological perspective. In Jung's discussion on the symbolism of the archetype of the Self, he established the convention that it can be represented by circular shapes. (The mandala – Sanskrit for circle – is one example of this symbolism.) For Jung, the spontaneous liberation of mandala images indicates an attempt by the psyche to heal itself. In the transition from the abstract image of the circle, to a symbol of wholeness, it is important to remember that the shadow of death is implied by the mandala; after all, we have already seen that wholeness should not be confused with perfection. Deth's lack of perfection is shown partly in his reluctance to acknowledge his shadow, but also in his relationship to his anima. It was this aspect of his personality that put his wife's life at risk, and which threatens to do the same to Leena. He needs to accept that the image of the city contains within it the shadow figure of Whistler and the underworld of crime. He needs to understand that the city is a mythological place, and metaphorical image, where he can achieve his goals, and in so doing discover his anima qualities.

The image of the city succinctly expresses these contradictory qualities. It is an embodiment of hope and wholeness, yet at the same time it is a place of crime, which means that it also belongs to the underworld. In this way, the city symbolically becomes a type of container for psychological change. Interestingly, the plan of the city of Atlantis forms a mandala-like pattern. In

mythological terms, it is appropriate that Poseidon, who is the brother of Hades, the god of the underworld, has a temple at the very centre of Atlantis, and it should also be no surprise to find Jack Deth drawn towards the underworld city of Lost Angels. It is well known that the classical Greek civilisation regarded the circle as a 'perfect' shape. They thought that the universe was constructed from a series of seven crystal spheres, each of which contained an essential element. Eliade observes that the shape of cities reflects the cosmology of their culture, which explains why in ancient Greek society we encounter circular city shapes, as in the city of Atlantis.

> Cities too have their divine prototypes. All the Babylonian cities had their archetypes in the constellations: Sippora in Cancer, Nineveh in Ursa Major, Assur in Arcturus, etc...not only does a model precede terrestrial architecture, but the model is also situated in the ideal (celestial) region of eternity.[3]

The mandala, and labyrinth-like construction of cities, is not confined to the ancient world. It can also been seen in modern cities such as Paris, where ten roads meet at *L'Étolie*, and in Palmanova in Italy which has star shaped fortifications.[4] What is significant is that the plans of such modern cities are like their ancient and mythological counterparts; they are projections of an inner landscape.

Individuation, viewed from the naturalistic perspective of growth, implies a strengthening of the psyche. In just the same way that the labyrinthine walls of the city of Atlantis were defences, so too the mandala is defensive. However, Jung warns against the defensive use of mandalas, and against, '... artificial repetition or a deliberate imitation of such images'.[5] But by its nature, the circle is a defensive shape, and its protective quality seemingly keeps at bay the underworld that it seeks to represent. Hillman notes that:

> As the Tibetan mandala is a meditative mode that protects the soul from capture by demons, so the Self as an all-embracing wholeness keeps the demonic nature of psychic events from getting through to the soul.[6]

The association of the circle with death also occurs in Western symbolism. It can be seen in ancient circular burial barrows, and later in circular Christian graveyards.[7] This image is also reflected in the circular wreaths of flowers that are laid at the grave-side, and in the Celtic mythology of the underworld.[8]

Further investigation into the nature and origin of cities shows that the original purpose of city walls was not defensive, and given the labyrinthine construction of the cities in *Trancers* this is important. Instead city walls separated out a special space, a space which was distinct from the chaos which pervaded the rest of the universe. This is relevant to the portrayal of the city in detective films; the origin of cities puts the detective firmly inside the magical mandala-like protective circle of death. Eliade notes:

The same is the case with city walls; long before they were military erections, they were magical defence, for they marked out from the midst of a 'chaotic' space, people with demons and phantoms... an enclosure, a place that was organised, made cosmic, in other words, provided with a 'centre'.[9]

So we can see that the figure of the detective in *Trancers*, and in detective films generally, is firmly at the centre of a cosmological mandala. But rather than acting as a defensive circle, the city in *Trancers* lets Deth in.

Often the centre of the city, as it appears in detective films, is Chinatown. While in *Trancers* it is by no means the most dominant location, it still provides the narrative centre. It is mentioned near the start of the film, when Deth is searching for the old Chinese theatre, and at its end where Chinatown provides the backdrop for the final confrontation between Deth and Whistler. The main significance of Chinatown is that it is foreign to the city that surrounds it. It is a special place that somehow is set aside from its environment; one of the reasons that it is important to the detective genre is that it is the opposite to the city in which it is situated. Interestingly, Deth does not go to Chinatown of his own accord, but is instead directed there by Leena - his anima and guide. She has the use of a friend's flat and thinks that it will be a safe place to be, 'no one will think of looking for us here', she comments. It is almost as though she recognises the protective qualities of Chinatown. Up to a point, her intuition is right and the only trancers they encounter there are the disco trancer-punks. At the end of the film, which is also set in Chinatown, Whistler's attempt to trance Leena fails. This is partly due to Leena's own strength, but the location may have had its role to play. The Chinatown in *Trancers*' Angel City is submerged, and this suggests its affinity with the unconscious, and we have already seen that water can be a symbol for the objective psyche.[10] Near the beginning of the film there is a shot of Deth coming out of the sea, in which he remarks that he is close to finding the old Chinatown theatre. At the end of the film this is going to provide the setting for the final confrontation with Whistler. One of the forms of Chinese Theatre is the shadow play; it is a home for illusions and this further suggests that we are right to interpret Whistler as Deth's shadow.

While Chinatown clearly remains part of the underworld, it is nevertheless different from the everyday world of crime in which it is situated; the distinction between Eastern and Western cultures underscores this separation. Chinatown represents the philosophy of the East, it is a place of inward searching or introspection, and as such it balances the Western extraverted nature of the city. But Chinatown is as much an attitude of mind as it is a place, and this enables the detective to be at his most intuitive and magical. It is a place where frequently the detective encounters the criminal, because in Chinatown the combat between ego-consciousness (the extraverted attitude) and the shadow (the inner, introverted attitude) takes place. To enter this realm is to enter an area of transformation, both cultural and psychological; in many ways it is the apotheosis of the city.

These characteristics of Chinatown – illusion, magic, and intuition – are not limited to *Trancers* and in fact typify the representation of Chinatown in the detective genre. For example, in *Big Trouble in Little China* (John Carpenter: 1986) they are evident in excess. The hero of the film, Jack Burton, has to rescue the heroine from inside a warehouse. The problem is that the warehouse is situated in Chinatown, which is also the home of the evil spirit, Lo Pan. Like Whistler in *Trancers*, Lo Pan can assume a bodily form, but only that of an old man, and has magical powers that can only be used when he is a spirit, ghost, or shadow. In order to rescue the stranded heroin, Burton enlists the aid of a Chinese sorcerer who goes with him into the underground labyrinth of the warehouse. With the help of magic potions, martial arts and Chinese black magic, Lo Pan is eventually destroyed. The significant point is that magic and illusion are alive in Chinatown; it is a place where, with the right help, the hero can do battle with a world of spirits and shadows.[11]

The Labyrinth

In *Trancers* we find two types of labyrinth: one is vertical, the other, horizontal. The horizontal labyrinth is the city and, in particular, Chinatown. From personal experience, we know that being in a modern city with which we are unfamiliar is not unlike being in a maze, and without the aid of a map or guide, confusion and frustration ensue. This is also true for Jack Deth, and when he arrives in Los Angeles one of the first things he has to do is gain the trust of Leena; without her help, he would be lost. The vertical labyrinth, by contrast, has two forms. First, there is the labyrinth through time. This is the time-line that links the diurnal nature of the upperworld with the nocturnal underworld of Los Angeles. Through the maze of time travel and bodily uncertainty, Jack Deth proceeds on his quest, at one moment sure of his direction, at the next finding himself in a dead-end and suddenly recalled to Angel City. It is through these corridors that Whistler has retreated, in an attempt to hide in the underworld. This image is vividly paralleled in Francis Thompson's 'The Hound of Heaven', in which the writer tries to hide himself from a pursuing God:

> I fled him, down the nights and down the days;
> I fled him down the arches of the years
> I fled him down the labyrinthine ways
> Of my own mind, and in the midst of tears
> I hid from him, and under running laughter.[12]

The second type of vertical labyrinth is the labyrinth that is formed by buildings. It is the convention in detective films for the detective to pursue the criminal through a building, often an office block or an old house: in the case of *Trancers* it is a disused warehouse. Just like the city as a whole, Deth finds the warehouse disorientating and is unable to find his way around. At one point he is attacked and cornered by a trancer, and has to rely on Leena to save him. Almost immediately, the floor gives way and they fall down into the imagistic

centre of the maze and discover the object of their search, Hap Ashby. Despite being confusing, the warehouse contains the prize that Deth needs, the ancestor of Margaret Ash, who is now the only surviving leader in the 23rd century city. The labyrinth in *Trancers*, like its mythological ancestors, stubbornly defends its prize.[13] In *Trancers*, Deth has to cope with the complexities of a four dimensional maze: not just width and length, but also depth and time, all conspiring to make his quest more testing.

It is impossible to be certain why labyrinths were originally made; it does seem as though they were defences whose purpose was to conceal the way to the centre. As Eliade notes:

> Without being overhasty in deciding the original meaning and function of labyrinths, there is no doubt that they include the notion of defending a 'centre'. Not everyone might try to enter a labyrinth to return unharmed from one; to enter in was equivalent to an initiation. The 'centre' might be a variety of things. The labyrinth could be defending a city, a tomb or a sanctuary but, in every case, it was defending some magico-religious space that must be made safe...[14]

This means that the labyrinth is an image of protection against the outside world, and that it is a sacred space which is worth defending. However, the protection it offers is not just against physical attack from hostile neighbours; it also offers a safeguard from psychological attack, from the negative sides of the unconscious, from demons and spirits. As Eliade notes:

> Religiously, it (the labyrinth) barred the way to the city for spirits from without, from the demons of the desert, for death. The 'centre' here includes the whole of the city which is made, as we have seen, to reproduce the universe itself.[15]

This myth is strongly paralleled by a Melanesian death myth, which alludes to the role of the anima in the underworld. It suggests that the anima (Leena in *Trancers*) can help those who wish to die to their conscious selves, and to enter the unconscious.[16]

> A myth of the Melanesian island of Malekula in the New Hebrides, describes the dangers of the way of the land of the Dead. It is told that when the soul has been carried on a wind across the waters of death and is approaching the entrance of underworld, it perceives a female guardian sitting before the entrance, drawing a labyrinth design across the path, of which she erases half as the soul approaches. The voyager must restore the design perfectly if he is to pass through it to the land of the dead. Those who fail, the threshold guardian eats. One may understand how very important it must have been, then, to learn the secret of the labyrinth before death...[17]

Perhaps, with all this talk of protection against sprits and demons, we should remind ourselves that we are talking symbolically and psychologically. The

suggestion is not that there are real, physical and bodily demons, which are waiting to attack us. Instead, we are trying to use this underworld imagery, which we find in detective films and *Trancers* in particular, in a metaphorical manner. The assumption is that it will help us to reflect on the psychological nature of the film, to understand the psychology of its characters, and to reflect on the appeal of this and similar films. In doing this, we are discovering that one of the reasons we enjoy films lies in the way that they use images that have a psychological relevance for us. Yet, at a conscious level, we are not aware of the meaning of this imagery, and so do not readily understand what it means. Put another way, images in film can have an unconscious archetypal dimension. For example, the idea that labyrinths offer protection is fine: it is almost common sense. But the labyrinth contains another less obvious imagery; it is also an image of the individuation process. Here, the meandering pathways take on a different meaning and represent the processes of assimilation, repression, suppression, etcetera, which we examined in the previous chapter. From this perspective, the sacred space at its centre is the, as yet, unconstellated archetype of the Self.

Within the framework of analytical psychology, analysis, whether by oneself or with the help of an analyst, is regarded as a way of assisting the individuation process. From the Jungian perspective, the analytic process is a mirror image of the individuation process; it too is a labyrinth. In the following quote, Carotenuto brings together many of the themes that we have been exploring: the incest themes of the hero; the labyrinth as an image of individuation; and the labyrinth as a way to achieve 'deep' awareness. The labyrinth is a good metaphor for individuation, as it encapsulates both the drive to become introspective and how, at the same time, this can be frustrating and difficult. Thus Jack Deth finds in the labyrinth-like city of Los Angeles a projection of his own unconscious. It is only by entering the maze that he can complete his search, even though the labyrinth will hinder as much as it helps. To go deep in analysis always involves accepting a frustrating situation; it also means taking on a heroic quest.

> When an analysis begins, the archetypal motif behind the myth of Oedipus, that is, of consciousness, is generally constellated; the same myth underlies the myth of Theseus, who penetrates the labyrinth. This means that anyone who undertakes an analysis, even or especially if he has been driven to his knees by suffering and necessity and is initially unaware of what awaits him, chooses the path of deep awareness, which is in itself already a heroic act in that it requires one to achieve a relative view of consciousness and of the rational attitude predominant in our historical period. A withdrawal of energy from the outside world is also necessary, and for this a certain price must always be paid.[18]

So far, this discussion of the labyrinth has assumed that the form of a maze is always the same; the labyrinth puts you in a state of isolation, and this is the

type of labyrinth that is ostensibly found in *Trancers*. Indeed, this type of maze dominates the landscape of the modern, and post-modernist world. As Diehl notes:

> With its intricate paths, blind ways, claustrophobic interior spaces, and perplexing design, the labyrinth both creates and symbolises the post-modern experience. It traps, isolated, alienates and confuses. It throws the viewer into the subjective experience of the Self.[19]

However this type of maze, which suggests an image of an alienated psyche, is a fairly recent development. There is a second, earlier type of labyrinth, in which all you have to do is follow the path to arrive at its centre. The striking difference is that, unlike the post-modern maze, the subject is guaranteed success – the centre of the maze *will* be reached. Thus the maze on the floor of the cathedral in Chartres was 'walked' by pilgrims on their knees, as a symbolic pilgrimage to the Holy Land. At the centre of this, and other medieval cathedral mazes, is the city of Jerusalem. The journey through the maze symbolises the inner journey, and the trust that pilgrims place in God to support them on their spiritual search.

> Like the post-modern mazes, these medieval mazes were apparently experiential. The experience of following the paths of the church maze, however, would not have been the modern one of fear, panic and impotence, but instead a spiritual experience, one of meaningful action and, upon reaching the centre, deep fulfilment.[20]

This explains the apparently contradictory imagery that we find associated with labyrinths. In contemporary culture, we think of the maze in its modern form, but the older version also has an archetypal dimension, in which the maze symbolises an inner search. In *Trancers*, the labyrinths are a source of alienation and also of growth; in other words, they are both modern and medieval. Entering, and solving the labyrinth, allows the hero to participate in individuation. It is a place of challenge and comfort, defending the sacred space of the Self, and yet trapping the demons and shadow figures of the underworld in its paths. Once again, we find Jack Deth in the curious world of *enantiodromia*, where the labyrinth is a defence, but also a gateway to the psyche – to the archetype of the Self. The concepts of: sacrifice (*axis mundi; imago mundi*) height and depth, rebirth, the underworld and its associated imagery, especially water and death, all find expression in the film's myth themes. This makes the image of the labyrinth the mythologem for *Trancers*: the point at which the themes of the film meet.

To summarise, we have seen how the myth of Atlantis parallels the myth of 'Angel City'. From a mythological perspective, the plan of a city is a map of the universe in which it is created: the form of a city is a projection of its unconscious, psychological cosmology. The city of Los Angeles, in *Trancers*, is represented as a labyrinth and, as a result of this, Deth requires the assistance of Leena to find his way through its pathways. The imagistic centre of this city

is Chinatown. In terms of analytical psychology, the labyrinth can give protection, but unwittingly it can also entrap the very objects it aims to exclude – the Cretian labyrinth contains the Minotaur, while in *Trancers* Whistler is trapped in Angel City. The labyrinth is an image of the underworld, and as such it helps to provide an underworld perspective on the other themes in *Trancers*, which are expressed in the central theme of the maze.

Notes

1 CW 13: 325

2 Plato, *Timaeus*. Translated, Bury, Rev. R. G., (London, 1929). This edition, (London, 1966): p256:D

3 Eliade, M., *The Myth of the Eternal Return*, (New York, 1954): p7

4 c.f. Jung, C. G., (ed) *Man and his Symbols* (London, 1964) this edition (London 1978) p271

5 C. W. 9,I: 718

6 Hillman, J., *The Dream and the Underworld*, (New York, 1979): p160

7 C.f. Allcroft, A. C., The Circle and the Cross, Vol. I, (London, 1927).

8 C. f. Reimschneider, M., *Rad und Ring als Symbole der unterwiet*, (Stuttgart, 1962): 3:p46-63.

9 Elide, M., *Patterns in Comparative Religion*, (New York, 1958): p371

10 As we know, it is Deth's quest to go into the underground, or underwater, in search of his shadow. It is therefore mythologically appropriate that two of the places where he comes across trancers are also underground. First there are the trancer-punks, who are in the night-club under the flat that he and Leena are staying in, and secondly there are the trancer-drunks, which he accidentally discovers when he falls through a weak roof in a warehouse.

11 The idea that monsters live in underground labyrinths is typical of trancer, or zombie, movies. For example, in *C. H. U. D.* (Douglas Cheek: 1984), the creatures of the title (Cannibalistic Humanoid Underground Dwellers) live in the city sewers. These sewers run underneath the city in a complex and disorientating labyrinth of interconnecting drains, allowing the C. H. U. D.s freedom of movement. Their similarity to trancers can be seen in one of the remarks made by a character who escapes from being eaten by one of the creatures. He accuses the police detective of being almost as evil as the C. H. U. Ds by saying, ' You go by the name of alive, and you are dead'. These creatures, like trancers, are the property of the underworld.

12 Thompson, F., *The Hound of Heaven*, Lines1-5, (London, 1913)

13 This is like the labyrinth examined in the analysis of *Sleuth*, c. f. Chapter Six, *The Symbolic Search*. The remarks about the relationship between the labyrinth and narrative structure are also applicable to *Trancers*. (That the viewers of the film are in a type of labyrinth, increases their identification with the detective, as both have labyrinths to explore.)

14 Elide, M., *Patterns in Comparative Religion*, (New York, 1958): p381

15 Ibid: p381

16 The association of the anima with the image of the labyrinth can also be found in the Greek myth of *Aeneaus*, c. f. Ovid, *Metamorphoses*, Book VII, Lines 162-167.

17 Ibid: p68-69

18 Carotenuto, A., *The Vertical Labyrinth-Individuation in Jungian Psychology*, Translated, Sheply, T., (Canada, 1981): p45

19 Diehl, H., 'Into the Maze of Self: Protestant transformation of the image of the labyrinth.' *The Journal of Medieval and Renaissance Studies*, Vol.16. No. 2 (Fall 1986): p281

20 Diehl: p284

12

The Individuation of Jack Deth

Walter Neff: *And yet, Keyes, as I was walking down the street to the drugstore, suddenly it came over me that everything would go wrong. It sounds crazy but it's true, so help me. I couldn't hear my own footsteps. It was the walk of a dead man.*

Double Indemnity (Billy Wilder: 1944)

This chapter focuses on the process of individuation as depicted in *Trancers*, and explores two themes. Firstly, it examines the general images of individuation in the film and secondly it looks at the images that are particularly associated with the individuation of Jack Deth. Previous chapters have explored how the concept of *enantiodromia* is central to the process of individuation, and that part of the work of individuation involves transforming an image into its *enantiodromic* equivalent. As we know, *enantiodromia* describes the principal way in which opposites behave, and represents the field of transformations which embraces all the oppositional functions. But Jung identifies three other processes which seem to organise the behaviour of opposites, namely: self-regulation (the regulation of a pair by its opposites), conjunction (the union of opposites), and *coincidentia oppositorum* (the identity of opposites).

> In this sense…conjunction and…the identity of opposites means the simultaneous perception by the perspectives of life and death, the natural and psychic. Conjunction, then, is a peculiar union of inner viewpoints. Through this union, identity of opposites becomes apparent. We see the hidden connection between what had hitherto been opposites.[1]

What follows is a table of some of the oppositions in *Trancers*. These oppositions are presented within the transformative context of *enantiodromia*. It is during the individuation process that the archetypes are constellated, and then assimilated, into the functioning of ego-consciousness.

	Self-Regulation	Conjunction	Coincidentia
Hero	Shadow (Whistler)		
Anima	Animus-Hero (Deth)		
Height/Depth	Up and Down the Line	Angel City and Los Angeles	
Inner/Outer			Labyrinth
Wet/Dry			Atlantis and Los Angeles
Consciousness	The Underworld, (Los Angeles)		
Life/Death		The Hero's Sacrifice	Rebirth
Labyrinth		Death and Rebirth	
Quest		Return	
Body/Spirit			Trancers

A table indicating some of the oppositions in *Trancers* as they relate to process of individuation

The table demonstrates that the main themes in *Trancers* can be viewed as parts of an oppositional system. Presenting these opposites in their different forms helps to show that what at first sight might appear to be non-oppositional themes, are in fact based on opposition – for example, the labyrinth. In some ways, the relationship of the different types of opposites is similar to the connection that exists between the archetypal pattern and the image of the archetype. In this context it is the labyrinth that forms the image, and the pattern comes from the oppositional theme(s) on which it is based. By their nature, the myth themes in *Trancers* are built up from opposites, but nonetheless they flow in the same direction – towards individuation. The reason for this state of affairs is straightforward. Individuation requires that we make conscious latent, and unconscious, oppositions. As the process progresses, we come to realise that in reality these 'opposites' are not in opposition to each other at all, but are in fact related and run into each other (this is why the process of *enantiodromia* provides the over-arching framework for individuation). When we recast this process in terms of the opposites in *Trancers*, then we can see how the opposites in the film are psychological projections of Jack Deth's inner, but as yet unconscious individuation.

Significantly it is the culture that reincarnates the archetypal pattern of the hero as detective. This means that his individuation is not just personal, because it also has a cultural dimension. In other words, it is not an accident that the image of the hero changes over time. Different cultures have their specific psychological needs. Consequently their heroes, and their villains for that matter, will look and behave differently. This demonstrates the psychological processes of balance and compensation at work, in which an archetype is activated and subsequently moulded into a culturally appropriate image. That the detective has proved such an enduring figure in the 20th and early 21st centuries suggests that we have a need for someone to solve our psychological problems for us. In this respect, the figure of the detective is, in many ways, a surrogate therapist. He embodies a cultural fantasy in which the psyche achieves balance and stability – after all, it is an attractive idea that we don't have to address our own problems and that they can be solved by someone else (maybe this is why Jung enjoyed reading detective fiction).[2] As with all archetypal fantasies, there is some truth in this hope. Analysis, and to a lesser extent watching films, can effect a psychological change, but they are only a partial solution. In the end, individuation must remain the responsibility of the individual.

In keeping with these observations, and staying in step with the underworld perspective, it is important to remind ourselves that the end of any individuation, be it personal or cultural, is death. As Jaffe has commented, 'The psychological path of individuation is ultimately a preparation for death'.[3] While in a literal sense death may be inevitable, the underworld perspective adopted in the analysis of *Trancers* has also shown that, from the perspectives of psychology and mythology, a consequence of symbolic death is rebirth. Put another way, death involves dying to the old self, and as a result of this act we gain a greater self-awareness and move forward with individuation. In terms of *Trancers*, this means that before Deth's anima can be assimilated into ego-consciousness: he must 'die' to his shadow-side. It is with this psychological quest in mind that he enters the labyrinthine world of the unconscious. This image provides us with one of the central oppositions in the film; while Deth is on the ideational search for new life, or the rebirth implied by individuation, he must also accept the death foretold by his name. Once again there is a mythological and psychological association between the process of individuation and death, and labyrinths are often associated with this type of imagery. As Joseph Campbell notes:

> ...the labyrinth, maze, and spiral were associated in ancient Crete and Babylon with the internal organs of the human anatomy as well as with the underworld, the one being the microcosm of the other. 'The object of the tomb-builder would have been to make the tomb as much like the body of the mother as he was able,...since to enter the next world, 'the spirit would have to be re-born'.[4]

Again the themes of death and life, of re-birth and individuation, are interwoven into the image of the maze. Entering the labyrinth of

individuation, Deth follows its paths as best he can. Accepting his destiny, he does not attempt to dam the unconscious, and, like the lost city of Atlantis, he eventually submerges himself, as ultimately he knows that he has no option but to trust the archetypes. As a diver relies on water to bring him eventually to the surface, so too Deth relies on the objective psyche to eventually relinquish its hold and to return him to consciousness. Until this happens, there is no option but to battle with the forces of the objective psyche. The result is that the unconscious becomes both a place of trust, and of combat. We saw in the previous chapter how this situation is mirrored by the experiences of medieval pilgrims who followed the paths of the cathedral labyrinth, and in so doing traced their individuation:

> Though the pilgrim would not be able to see the whole design at once, he could act with the faith that a comprehensive design existed, and that the path led to heaven and God, the symbolic centre of the maze.[5]

We have already discovered that this type of certainty no longer exists in the post-modern maze, and how it is a 'heroic' task to explore the depths of the objective psyche. Nonetheless, it is an inevitable process; everyone is called to individuation, personally and culturally, for the individual is a microcosm of the culture. As Edinger puts it, 'The hero is a figure lying midway between the ego and Self. It can perhaps best be described as a personification of the urge to individuation'.[6] Individuation is about realising the collective qualities that each individual shares with humanity, and so it is true to say that the ontogenesis of the individuation process is also phylogenetic; which is to say that as we experience individuation, we draw on the psychological development of humankind. As Jung puts it, 'Individuation does not shut one out from the world, but gathers the world to oneself'.[7] Naturally what we gather includes both the positive and negative aspects of being human. As Jung observes, there is no escaping from the shadow. 'There are many spirits, both light and dark. We should, therefore, be prepared to accept the view that the spirit is not absolute, but something relative that needs completing and pursuing through life.'[8]

As we know, the individuation of Jack Deth has reached the point where he must assimilate his shadow and accept his anima, and what we find in *Trancers* is the symbolic transformation of these two archetypes. The figure of Whistler is clearly visible, which means that Deth has not repressed, nor suppressed, his shadow. The symbolic assimilation of the shadow in *Trancers* is suggested by the death of Whistler, although there is a sense in which he is not really dead at all. Although the body of Whistler has been destroyed, his consciousness is still alive. *Trancers* does not explain where Whistler's consciousness goes but in psychological terms the answer is clear as it becomes part of Deth and is assimilated and integrated into his psyche. This fits well with the following observation from Hillman:

> The ideas of wholeness and creative growth cover the old *hubris* of the hero and the path of integration in his old heroic journey in which he

meets all the freaks of nature that are also divine forms of the imagination. As he proceeds from figure to figure, station to station, they disappear. Where have they gone when they are overcome and integrated, but into his own personality, divinising man into the apotheosis of a gigantic freak himself.[9]

In fact, the hero is no more freakish now than he was before; he has gained no new deformity or horror. All that happened is that material that was latent and unconscious has now been made conscious. Put another way, the process of assimilation has transcended the shadow.

Of course it is actually a matter of debate as to whether Deth has assimilated his shadow or not; however, the filmic evidence does seem to point in this direction. For example, at the end of the film Deth discards his raincoat (a symbol of his persona) before going on to fight his shadow, and this indicates a movement into the depths of his psyche. This happens after he has spoken with Leena, and indicated his love and commitment to her. As Leena is an anima figure, this again points towards an inner movement. However, the final confrontation between Whistler and Deth remains ambiguous. While Whistler is speaking to Deth, there is a close-up of Whistler's face that clearly shows Whistler's hypnotic staring eyes. Is he trying to turn Deth into a trancer, and does he succeed? It seems unlikely that Whistler is successful as Deth quickly sends Whistler's consciousness back to Angel City, but perhaps this is what Whistler wants. The important point is that we do not know. The ambiguous quality of this scene is heightened by the final shot of the film, in which the *puer* figure of MacNulty's ancestor mysteriously steps out of the shadow of the building.[10] Perhaps MacNulty has returned to singe a tranced Deth, or maybe he is just there to take him back to Angel City.

Psychologically, the ambiguity is appropriate. Individuation is a different experience for each of us. Even though there are some general principles that we can use to understand the framework of individuation, ultimately the experience of the process will differ from individual to individual. This must be the case, otherwise individuation would involve just conforming to a process in which we were enslaved by our own psyche. In reality, the opposite is true: ambiguity, nuance, personal history and collective responsibility – all influence the trajectory of our personal search for self-awareness. As Jung stressed, individuation is a metaphor and this is one of the reasons why cinema is such an apt psychological vehicle. The cinema is a place where we know that what we see and experience is not real – it is based on a fantasy: it gives us an insight into our individual and cultural psychology that is, in its form and substance, metaphorical.

This is why in *Trancers* it is appropriate that the viewer is left in the dark, and is uncertain about exactly what is going on. The puzzle over Jack Deth's individuation lets us contemplate our own situation. While wanting to preserve this ambiguity, on balance the weight of evidence still rests with the completion of the shadow phase. The discarding of the raincoat, sending

Whistler down the line, and his desire to stay with Leena: all point towards the assimilation of the shadow. In this assimilation there exists an aggregate of archetypes which gather around the shadow. Here, in the film's final sequence, the inter-related archetypes achieve a balance and stasis between the outer-man, or persona, and the inner-man, or shadow.

That Deth has identified and passed through the persona phase is characterised by his ease in 'playing roles', and the way that he can now adopt the appropriate persona for the situation. At one moment he is a police detective, then a lover, next a tramp, and finally, a saviour. All these persona-identities serve the same purpose and assist Deth in the pursuit of his shadow. Edinger puts it in the following way, 'This theme of reciprocal movement, in which the ego seeks the guidance of the unconscious while the conscious seeks the attention of the ego, is characteristic of the process of individuation'.[11] Throughout the film, Leena is the 'unconscious' figure who Deth has to rely on to guide him to his shadow, and once this has been achieved, she also provides the motivation for its assimilation – which means that Deth must stay in Los Angeles with her. But there is a curious sense in which Leena offers more than just romance; she is also his mother, a substitute wife, and is also young enough to be his daughter. This returns us to the symbolic incest theme, which, as we now realise, is integral to the hero's individuation. Jung makes the following observation which he derives from alchemy:

> The Queen of Sheba, Wisdom, the royal art, and the 'daughter of the philosophers' are all so interfused that the underlying psychologem clearly emerges: the art is queen of the alchemist's heart, she is at once his mother, his daughter, and his beloved, and in his art and its allegories the drama of his own soul, his individuation process, is played out.[12]

Using more straightforward psychological language, Hauke expresses the same idea:

> In this (individuation), past, present and future are mixed up so that there is no one-way traffic but there are flows in both directions at all times. We need to know the past in ourselves to fully live in the present and guide the future, or else we are dragged there unconsciously by events themselves with little regard for human need.[13]

That Deth has not yet assimilated his anima is evident from the incomplete symbolism of the incest motif, and from the dualism of body and spirit that runs throughout *Trancers*. It is worth noting that the *conjunction* depicted by the overt symbolism above the bed of Leena and Jack Deth (where, made out of neon, an arrow pierces a circle) is not physically realised, and hence psychologically the anima remains distinct from ego-consciousness. The symbol is also seen reflected in the television screen on which Whistler appears; the image suggests that the 'illusion' of the anima, and its assimilation, lies beyond the shadow figure of Whistler.

If Jack Deth could move towards a conscious realisation of his anima, this would, *ipso facto*, remove, or transcend, the body-spirit dualism which permeates *Trancers*. The only way for Deth to assimilate his anima and move onto the next stage is for him to die to ego-consciousness. As we have constantly stressed, it is only through entering the underworld – through dying – that life can be achieved. Deth knows this, and this is why, while his body remains suspended, almost sleeping, his ego-consciousness descends into the objective psyche. He goes to die in the labyrinth of the underworld and as Heraclitus comments, 'When we are alive our souls are dead and buried in us, but when we die, our souls come to life and live again'.[14] Or in a different translation which stresses the dream-like qualities of the descent:

> Man in the night kindles a light for himself,
> though this vision is extinguished;
> though alive he touches the dead, while sleeping;
> though awake, he touches the sleepers.[15]

This type of dualism can also be found within the Christian tradition. In the following quotation from Corinthians, the Apostle Paul draws together several of the mythological themes that have been discerned in *Trancers*. Paul believes that there are two bodies, the physical and the spiritual, of which the physical is the inferior. For those who have led the Christian life, the promise is that they will be raised from the dead in their spiritual bodies. This resurrection, in the spirit, is guaranteed by the Saviour, who has already undergone this process, and in so doing has made it possible for the rest of mankind. Here, Paul uses the mythological language of the Old Testament to describe how Jesus is linked to Adam; a psychological interpretation of this would be that Jesus is completing Adam's individuation (the name Adam means mankind).

> So it is with the resurrection of the dead. What is sown is perishable, what is raised is imperishable. It is sown in dishonour, it is raised in glory. It is sown in weakness, it is raised in power. It is sown a physical body, it is raised a spiritual body. If there is a physical body, there is also a spiritual body. Thus it is written, 'The first man, Adam, became a living being'; the last Adam became a life-giving spirit.[16]

If Jack Deth is to integrate his anima and move towards the constellation of the archetype of the Self, he must become a 'life-giving spirit'. To do this, he must establish a relationship with the Self that is characterised by a numinous language and experience. The Self represents what it is to be fully human, as Shorter puts it:

> 'Individuation appears, on the one hand, as the synthesis of a new unity which previously consisted of scattered particles, and on the other hand, as the revelation of something that existed before the ego and is in fact its father or creator as well as its totality.' When this happens, one's view of oneself as merely human and self-sufficient has

to be sacrificed. To take the risk of ascent knowingly will be with consciousness of one's own I/Thou relatedness.[17]

If Deth is to succeed in his individuation, then symbolically he must become a human sacrifice: sacrificing himself and his self-sufficiency in order to establish the existence of the Self. It is through the integration of the Self into ego-consciousness that one's own I/Thou relatedness is achieved; the hero becomes both human and spiritual.

To summarise, this chapter has explored the symbols, myths, and myth parallels to the central quest theme of *Trancers*. This process has been pursued within the framework of analytical psychology, and the film's mythological and symbolic themes have been revealed as unconscious projections of the objective psyche, and as images of the individuation process. The use of analytical psychology has shown that there is a complicated structure of myths and symbols which lie beneath the films' surface narrative and images. The film's mythological themes are an integral part of the individuation process and they not only reflect, but condition individuation. To understand the psychological significance of *Trancers*, and other detective films, it is essential to adopt, in part, the mythological perspective of the underworld; it is only via this perspective that ego-consciousness can move towards a greater understanding of its projections, and of other communications from the objective psyche.

Notes

1 Hillman, J., *The Dream and the Underworld*, (New York, 1979): p79.

2 c.f. Broome, V., *Jung Man and Myth* (London1985) p249.

3 Jaffe, A., 'Bilder und Symbole aus E.T.A. Hoffman's Marchen Der Golden Topf,' in: *Gertaltungen des Unbewussten*, Ed. Jung, C. G. (Zurich, 1950). Cited in Hillman (1979): p89.

4 Campbell, J., *The Masks of God: Primitive Mythology*, (USA, 1951). This edition, (London, 1984): p69.

5 Diehl, H., 'Into the Maze of Self: Prrotestant Transformation of the Image of the Labyrinth'. *The Journal of Medieval and Renaissance Studies*, Vol. 16: No.2 (Falls, 1986): p284.

6 Edinger, E., *The Bible and the Psyche: Individuation Symbolism in the Old Testament*, (Canada, 1986): p45.

7 C. W. 8: 432.

8 C. W. 8: 645.

9 Hillman, 1979: p99.

10 The *puer* is that element in the psyche which remains undeveloped and essentially a child, c. f. C. W.I, 9: 259-305.

11 Edinger, 1986: p79.

12 C. W. 14: 543.

13 Hauke, C., *Jung and the Postmodern: The Interpretation of Realties* (Routledge, London: 2000) p108.

14 Heraclitus, translated Cornford, *Greek Religious Thought*, (London, 1923): p81.

15 Heraclitus, Fragment 26. Translated Marcovitch.

16 *The Bible, New Revised Standard Version*, I Corinthians, 15: 42-45.

17 Shorter, B., *An Image Darkly Forming: Women and Initiation*, (London, 1987): p127, (Citing Jung, C. W., C. W. 11: 400).

Glossary

AFFECT. This is associated with emotions and feelings. The AFFECT is so strong that, unlike feelings, it can only be repressed with difficulty. Can cause obvious psychomotor disruptions.

AMPLIFICATION. The rational associations brought to an image by the analyst – normally within the analytical context.

ANIMA/ANIMUS. The 'feminine dimension of man's unconscious and vice versa. ANIMA and ANIMUS may appear as personified figures, but it is more accurate to think of them as representing archetypal patterns. Modern Analytical Psychology tends not to like these and other psychological characteristics to gender, but regards them as alternative modems of behaviour, perception and evaluation. They may also be regarded as forming a bridge between the EGO and the OBJECTIVE PSYCHE.

ARCHETYPE. An innate structuring potential which is inherent in the OBJECTIVE PSYCHE. N. B. It is the pattern which is inherited and structures the development of the PSYCHE, and not the image it assumes. It is the ARCHETYPES which govern the INDIVIDUATION PROCESS.

ASSOCIATION. The connection of ideas or perceptions because of similarity, coexistence or opposition.

COLLECTIVE UNCOSCIOUS cf OBJECTIVE PSYCHE.

COMPENSATION. This involves the balancing and regulating of the PSYCHE. Jung regarded the compensatory activity of the unconscious as balancing any 'defects' in consciousness.

COMPLEX. A collection of interrelated ideas and feelings which have an effect on conscious behaviour and experience. The concept of complex is central in the development of ANALYTICAL PSYCHOLOGY.

CONTRASEXUAL ARCHETYPES. The ANIMA and ANIMUS.

ECTOPSYCHIC SYSTEM. The outer functions of the PSYCHE: sensation, thinking, feeling, intuition cf TYPOLOGY.

EGO. The centre of consciousness. The EGO both contain personal identity and responds to the OBJECTIVE PSYCHE by moving the PSYCHE towards INDIVIDUATION and the SELF.

ENANTIODROMIA. The tendency of opposites to 'run into' each other, so that cycles such as life, death, rebirth are established.

EXTRAVERT. An attitude of personality those energies are primarily directed towards the external world of people and events, rather than the inner world of ideas and feelings.

HERO. An archetypal pattern which correlated with the SELF. Jung describes it as, 'a quasi-human being who symbolises the ideas, forms and forces which mould or grip the soul'. C. W. 5: 295

IDENTIFICATION. An unconscious PROJECTION of parts of the personality onto a place or person, thereby justifying the projecting person's behaviour patterns.

INDIVIDUATION. The life process governed by the archetypal patterns, in which a person becomes totally himself, and this involves integration of the conscious and unconscious parts of the PSYCHE.

INTROVERT. An attitude of personality in which he or she is more concerned with their own inner world. Ideas and feelings tend to be of more importance than places and events.

MANA PERSONALITY. A personality who gives to an individual, or group, or feelings that their conscious state can be heightened. The HERO is a forerunner of this figure. Guru figures such as Casteneda's Don Juan are MANA PERSONALITIES.

MANDALA. A magic circle, often divided into four. As a symbol of psychological unity it represents a phase in the development of the INDIVIDUATION PROCESS. This is may be the completion of any of its stages and the MANDALA marks the point at which the transition occurs.

MYTHOLOGEM. The central or unifying theme of a myth.

MYTHOLOGY. The language or images that a myth assumes. For example the Arthurian MYTHOLOGY and the detective MYTHOLOGY share the same MYTHOLOGEM: that of the quest.

NUMINOSUM. 'The NUMINOSUM is either a quality belonging to a visible object or the influence of an invisible presence that causes a peculiar alternation of consciousness'. C. W. 11: 6. Jung also regarded experience of the NUMINOSUM as part of all religious experience.

OBJECTIVE PSYCHE. A term used by Jung to indicate that the PSYCHE is an objective source of insight and knowledge. It also indicates that some of the PSYCHE is objective, as opposed to subjective and personal, in nature.

ONTOGENY. The development of an individual through the course of its life cycle.

PERSONA. Literally a mask. This mask is worn by the individual and is the way in which he or she approaches the world. As an ARCHETYPE it has the function of mediating between the EGO and the exterior world.

PHILOGENY. The development of the species.

PRIMORDIAL IMAGE. A term that Jung originally used in place of ARCHETYPE.

PROJECTION. Difficult, or positive, emotions or parts of the personality are transferred onto another person or place. It is also a way in which the contents of the OBJECTIVE PSYCHE are made available to ego-consciousness. However to be of real use to ego-consciousness those projections must be dissolved, that is recognised. PROJECTION most frequently happens with the ARCHETYPES of SHADOW, ANIMA and ANIMUS.

PSYCHE. The 'totality of all psychic processes, conscious as well as unconscious'. C. W. 6: 797. Symbolised by the MANDALA, square, circle, etc.

PSYCHOSIS. A state in which something 'unknown' takes possession of the PSYCHE. This is an invasion by the objective PSYCHE in which it takes control of ego-consciousness.

SELF. The SELF is the central unifying principle of the PSYCHE, and is the archetype of man's fullest potential and unity of personality.

SHADOW. The apparently negative or inferior parts of the PSYCHE. In fact these are just parts of the PSYCHE which have not been developed and integrated with ego-consciousness.

SPONTANEOUS IMAGE CREATION. A creation of the unconscious, often a dream but may also include paintings, poems, films, etc.

SYMBOL. A NUMINOUS representation produced by and of the OBJECTIVE PSYCHE, which seeks to unify and overcome opposition.

TRANSCENDENT FUNCTION. This function mediates between opposites of the PSYCHE and uses the SYMBOL to transcend the contradiction inherent in such opposition.

TYPE. cc TYPOGRAPHY.

TYPOGRAPHY. This is a personality system developed by Jung to show different modes of psychological functioning in terms of personality types. There are two key categories, or attitudes INTROVERT and EXTRAVERT, which combine with the four functions, sensation, thinking, feeling and intuition, to determine an individual's personality TYPE.

UROBOROS. A universal motif, often associated with Gnosticism, of a serpent curled into a circle and eating its own tail. A SYMBOL of death and rebirth.

Bibliography

Psychology, and Bibliographical Books on C G Jung

Adler, G. *Studies in Analytical Psychology*, (London, 1948). This edition, (London, 1966).

Alister, I. and Hauke, C. (editors) *Contemporary Jungian Analysis: Post-Jungian Perspectives from the Society of Analytical Psychology* (London, 1998).

Auger, J. A. *Images of Endings. Journal of Analytical Psychology*, Vol. 31: 1 (1986).

Barker, C. M. *Healing in Depth*, (London, 1972).

Barnaby, K., and D'Acierno, P. (Editors), *C. G. Jung and the Humanities: Towards a Hermeneutics of Culture*, (London, 1990).

Beck, J. S. and Molish, H. B. *Rorschach's Test*, (New York, 1945).

Beebe, J. *The Father's Anima*, in: *The Father: Contemporary Jungian Perspectives*. Edited, Samuel's. A. (London, 1985).

Benderson, A, 'An Archetypal Reading of *Juliet of the Spirits'*, *Quarterly Review of Film Studies*, Vol. 4, Number 2.

Bertine, E. *Jung's Contribution to our Time*, (New York, 1967).

Bishop, P. (Editor), *Jung in Contexts: A Reader*, (London, 1999).

Bowlby, J. *Child Care and the Growth of Love*, (London, 1953).

Broome, V. *Jung, Man and Myth*, (London, 1980).

Brooke, R., (Editor) *Pathways into the Jungian World: Phenomenology and Analytical Psychology*, (London, 2000).

Cassement, A. (Editor) *Post-Jungians Today: Key Papers in Contemporary Analytical Psychology*, (London, 1998).

Christopher, E. and McFarland Solomon, H. (Editors) *Jungian Thought in the Modern World*, (London, 2000).

Carotenuto, A. *The Vertical Labyrinth*, (Toronto, 1985).

Cohen, E, D. *C. G. Jung and the Scientific Attitude*, (New York, 1975).

Cox, D. *Teach Yourself Analytical Psychology*, (London, 1973).

Dourley, J. P. *The Psyche as Sacrament*, (Toronto, 1981).

Dry, A. *The Psychology of C. G. Jung: A Critical Interpretation*, (London, 1961).

Dyer, D. *Cross-Currents of Jungian Thought: An Annotated Bibliography*, (London, 1991).

Edinger, E. F. *The Creation of Consciousness*, (Toronto, 1981).

Edinger, E. F. *The Bible and the Psyche: Individuation and Symbolism in the Old Testament*, (Toronto, 1986).

Erickson, E. *Childhood and Society*, (London, 1951).

Evans, C. *Psychology: A Dictionary of Mind, Brain and Behaviour*, (London, 1978).

Evans, R. I. *Jung on Elementary Psychology*, (London, 1979).

Fordham, F. *An Introduction to Jung's Psychology*, (London, 1953).

Fordham, M. *Children as Individuals*, (London, 1970).

Fordham, M. *New Developments in Analytical Psychology*, (London, 1975).

Fordham, M. *The Self and Autism*, (London, 1976).

Freud, S. *The Psychopathology of Everyday Life*, First English Translation, (London, 1914). This edition, translated Tyson, A., (London, 1975).

Friedenberg, E. Z. *Laing*, (London, 1973).

Fromm, E. *To Have or to Be?*, (London, 1979).

Fuller, P. *Art and Psychoanalysis*, (London, 1980).

Glover, E. *Freud or Jung*, (London, 1950).

Goffman, E. *The Presentation of the Self in Everyday Life*, (London, 1969).

Goldbrunner, J. *Individuation*, (London, 1955).

Goodbread, J. H. *The Dreambody Toolkit*, (London, 1987).

Gordon, R. 'Losing and Finding: The Location of Archetypal Experience', *Journal of Analytical Psychology*, Vol. 32: 2 (1985).

Graesbeck, G. The 'Archetypal of the Wounded Healer', *Journal of Analytical Psychology*, Vol. 70: 2 (1975).

Grant, W. H., Thompson, M., and Clarke, T. E. *From Image to Likeness: A Jungian Path in the Gospel Journey*, (New York, 1983).

Gray, R. *Archetypal Explorations: An Integrative Approach to Human Behavior*, (London, 1996).

Greenfield, B., 'The Archetypal Masculine', in: *The Father Contemporary Jungian Perspectives*, Editor, Samuel, A., (London, 1985).

Hadfield, J. A. *Dreams and Nightmares*, (London, 1954).

Hall, J. A. *Jungian Dream Interpretation*, (Toronto, 1983).

Hall, J. A. *The Jungian Experience: Analysis and Individuation*, (Toronto, 1983).

Hannan, B. *Jung his Life and Work*, (London, 1976).

Harding, M. E., *Psychic Energy: Its Source and Transformation*, (Princeton, 1963). This edition, (Princeton, 1973).

Hauke, C., *Jung and the Postmodern: The Interpretation of Realities*, (London, 2000).

Hillman, J. *Re-Visioning Psychology*, (New York, 1975). This edition, (New York, 1977).

Hillman, J. *The Dream and the Underworld*, (New York, 1979).

Hillman, J. *Anima: An Anatomy of a Personified Notion* (Woodstock, 1985).

Hobson, R. 'The Archetypes of the Collective Unconscious', in: *Analytical Psychology a Modern Science*, Editor, Fordham, M., et al., (London, 1973).

Homes, P. *Jung in Context*, (Chicago, 1979).

Horney, K. *New Ways in Psychoanalysis*, (London, 1939).

Humphery, N. *Consciousness Regained*, (Oxford, 1983).

Jacobi, J. *The Psychology of C. G. Jung*, (London, 1969).

Jaffe, A. Bilder und Symbole aus ETA Heffman's *'Marchen der Goldener Topf'*, in: *Gestaltungen des Unbewussten*, Editor, Jung, C. G., (Zurich, 1950).

Jaffe, A. *The Myth of Meaning in the Work of C. G. Jung*, (Zurich, 1983).

Jaspers, K. *General Psychology*, translated, Hoenig, J., and Hamilton, M. W. (Mamchester, 1963). This edition, (London,1974).

Jung, C. G. *Collected Works of C. G. Jung*, Edited, Read, H., Fordham, M., Adler, G., translated by Hull, R., (London).

Vol. 1. *Psychiatric Studies*, (1957, 1970)
2. *Experimental Researches*, (1973)
3. *The Psychogenesis of Mental Disease*, (1960)
4. *Freud and Psychoanalysis*, (1961)
5. *Symbols of Transformation*, (1956, 1967)
6. *Psychological Types*, (1921)
7. *Two Essays on Analytical Psychology*, (1953, 1966)
8. *The Structure and Dynamics of the Psyche*, (1960, 1969)
9.I. *The Archetypes and the Collective Unconscious*, (1959)
9.II *Aion*, (1951)
9. *Civilisation in Transition*, (1964)

10. *Psychology and Religion: West and East*, (1958, 1969)
11. *Psychology and Alchemy*, (1944)
12. *Alchemical Studies*, (1967)
13. *Mysterium Coniunctionis*, (1963, 1970)
14. *The Spirit in Man, Art and Literature*, (1966)
15. *The Practice of Psychotherapy*, (1954, 1966)
16. *The Development of Personality*, (1954)
17. *The Symbolic Life*, (1977)
18. *Bibliography of C. G. Jung's Writings*
19. *General Index to the Collected Works*
 Supplementary Vol. A. *The Zofingia Lectures*, edited McGuire, W., (London, 1983).
 Seminar Papers, Vol. 1. *Dream Analysis*, edited McGuire, W., (London, 1984).

Jung, C. G. *Modern Man in Search of a Soul*, translated by Dell, W. S. and Baynes, C. F. (London, 1985).

Jung, C. G. *Basel Seminar*, (Zurich, 1934).

Jung, C. G. *Memories, Dreams, Reflections*, (London, 1963).

Jung, C. G. (editor), *Man and his Symbols*, (London, 1964).

Jung, C. G. *Letters*, (Princeton, 1973).

Jung, C. G. and Freud, S. *The Freud/Jung Letters*, (London, 1974). This edition, (London,1979).

Jung, C. G. *C. G. Jung Speaking: Interviews and Encounters*, editor, McGuire, W. and Hull, R. F. C. (London, 1978).

Jung, E. and von Franz, M. L. *The Grail Legend*, (London, 1971).

Keutzer, L. *Archetypes, Synchronicity and the Theory of Formative Causation*, Journal of Analytical Psychology, Vol. 27: 3, (1982).

Laing, R. D. *The Divided Self*, (Tavistock, 1960).

Lambert, K. 'Analytical Psychology and Development in Western Consciousness', *Journal of Analytical Psychology*, vol. 22: 1, (1977).

Lee, S. M., and Herbert, M. (editor), *Freud and Psychology*, (London, 1970).

Maidenbaum, J. 'The Scarlet Letter: a Contemplation of Symbol', *Psychological Perspectives*, Vol. 15: 2, (1984).

Marcuse, H. *One Dimensional Man*, (London, 1964).

Martin, P. W. *Experiment in Depth*, (London, 1955).

Mattoom, A. *Jungian Psychology in Perspective*, (New York, 1981).

Mindell, A. *The Dreambody in Relationship*, (London, 1987).

Molly, T. (editor), *In the Wake of Jung*, (London, 1983). This edition, (London, 1974).

Moreno, A. *Jung, Gods and Modern Man*, (USA, 1970). This edition, (London, 1974).

Nuemann, E. *The Origins and History of Consciousness*, (Germany, 1949). This edition, (New York, 1973).

Neumann, E. *Amor and Psyche: The Psychic Development of the Feminine*, (Princeton, 1956).

O'Neil, T. R. *The Individunted Hobbit*, (London, 1979).

Oswald, I. *Sleep*, (London, 1966).

Perera, S. B. *The Scapegoat Complex: Towards Mythology of Shadow and Guilt*, (Toronto, 1986).

Piaget, J. *A Child's Conception of the World*, (London, 1923). This edition, (London, 1973).

Prochasha, H. 'ARAS and Amplification', *Journal of Analytical Psychology*, Vol. 29: 2, (1984).

Progoff, I. *Jung's Psychology and its Social Meaning*, (London, 1953).

Rieff, P. *The Triumph of the Therapeutic*, (London, 1966).

Rycroft, C. 'A Detective Story, Psychoanalytic Observations', *Psychoanalytic Quarterly*, Vol. 26, (1957).

Samuel, A. (editor), *The Father: Contemporary Jungian Perspectives*, (London, 1985).

Samuels, A. *Jung and the Post Jungians*, (London, 1985).

Samuels, A. Shorter, B. and Plaut, A. *A Critical Dictionary of Jungian Analysis*, (London, 1986).

Samuels, A. *The Political Psyche* (London, 1983).

Sanford, J. *The Invisible Partners*, (New York, 1980).

Schneider, M. D. *The Theory and Practice of Movie Psychiatry*, The American Journal of Psychiatry, Vol. 144, No. 8, (1987).

Serrano, M. *Jung and Hermann Hesse: A Record of Two Friendships*, (London, 1971).

Shorter, B. *An Image Darkly Forming: Women and Initiation*, (London, 1987).

Singer, J. *Boundaries of the Soul: The Practice of Jung's Psychology*, (New York, 1972).

Singer, J. *Androgeny: Towards a New Theory of Sexuality*, (London, 1977).

Skinner, B. F. *About Behaviourism*, (New York, 1974).

Skinner, B. F. *Beyond Freedom and Dignity*, (New York, 1975).

Skinner, B. F. *Reflections on Behaviourism and Society*, (New Jersey, 1978).

Skogemann, P. 'Chuang Tzu and the Butterfly Dream', *Journal of Analytical Psychology*, Vol. 31: 1, (1986).

Snider, C., 'C. G. Jung's Analytical Psychology and Literacy Criticism', *Psychocultural Review*, Vol. 11, (1977).

Spinks, S. *Psychology and Religion*, (London, 1963).

Stafford, B. 'An Analysis on Non-Symbolic Experience: The Mystic in Everyman', *Imagination Cognition and Personality*, Vol. 4: 2, (1984-85).

Steele, S. R. *Freud and Jung: Conflicts of Interpretation*, (London, 1982).

Stein, L. 'Introducing not Self', *Journal of Analytical Psychology*, Vol. 12: 2, (1967).

Stern, P. *C. G. Jung: The Haunted Prophet*, (New York, 1976).

Storr, A. *Jung*, (London, 1973).

Strachan, E., and Strachan, G. *Freeing the Feminine*, (Dunbar, 1985).

Szasz, T. S. *The Myth of Mental Illness*, (New York, 1961).

Tyrell, G. *The Personality of Man*, (London, 1946).

Ulanov, A. and Ulanvo, B. *The Witch and the Clown: Two Archetypes of Human Sexuality*, (Illinios, 1987).

Van der Post, L. *Jung and the Story of our Time*, (Germany, 1976).

Von Franz, M. L. *C. G. Jung: His Myth in our Time*, (Germany, 1972). This edition, (London, 1975).

White, V. *God and the Unconscious*, (London, 1952).

White, V. *Soul and Psyche*, (London, 1960).

Whitmont, E. C. *The Symbolic Quest: Basic Concepts in Analytical Psychology*, (Princeton University, Princeton, 1978).

Wickes, F. *The Inner World of Choice*, (New Jersey, 1976).

Winnicott, D. W. *The Child, the Family and the Outside World*, (London, 1964).

Young-Eisendrath, P. (Editor) *The Cambridge Companion to Jung*, (Cambridge, 1997).

Film Theory and History

Andrew, D. *Concepts in Film Theory*, (Oxford, 1984).

Armour, R. A. *Fritz Lang*, (Boston, 1978).

Arnheim, R. *Film as Art*, (London, 1958).

Bauer, S., Bolter, L., and Hunt, W. 'The Detective Film as Myth', in, *American Imago a Psychoanalytical Journal for Culture*, (1978).

Baxter, J. *Hollywood in the Thirties*, (New York, 1968).

Brodwell, D. *Narration in the Fiction Film*, (London, 1985).

Bordwell, D. and Thompson, K., *Film Art*, (New York, 1986).

Branson, C. *Howard Hawks a Jungian Study*, (Los Angeles, 1987).

Bukatman, S. *Blade Runner* (London, 1999).

Carpenter, E. C. *Oh What a Blow that Phantom Gave Us*, (London, 1976).

Carrabino, V. (Editor), *The Power of Myth in Film: Selected Papers from the Second Annual Florida State University Conference in Literature and Film*, (Tallahassee, 1980).

Carrol, J. M. *Toward a Structural Psychology of the Cinema*, (New York, 1980).

Caughie, J. (Editor), *Theories of Authorship: A Reader*, (London, 1981).

Channan, M. *The Dream that Kicks*, (London, 1980).

Clarens, G. *Crime Movies*, (London, 1980.

Clifton, N. R. *The Figure in Film*, (London, 1983).

Davis, B. *The Thriller*, (London, 1973).

Davis, P. and Neve, B. (Editors), *Cinema, Politics and Society in America*, (Manchester, 1981).

Eberwien, P. T. *Film and the Dream Screen*, (Princeton, 1984).

Everson, W. *The Detective in Film*, (New Jersey, 1972).

Fell, J. L. *Film and the Narrative Tradition*, (Oklahoma, 1974).

Finch, C. and RosenkranTZ, L., *Gone Hollywood*, (London, 1979).

Friedricksen, D. 'Jung, Sign, Symbol, Film', in, *Quarterly Review of Film Studies*, Vol. 4:2, (1979).

Friedricksen, D. 'Jung, Sign, Symbol, Film, Part Two', in, *Quarterly Review of the Film Studies*, Vol. 5:4, (1980).

Gabbard, G. and Gabbard, K. 'Countertransference in the Movies', *Psychoanalytic Review*, Vol. 72: 1, (1985).

Gabree, J. *Gangsters: from Little Caesar to the Godfather*, (New York, 1973).

Gauntlett, D. *Moving Experiences: Understanding Television's Influences and Effects*, (London, 1995).

Geothals, G. T. *The TV Ritual: Workshop at the Video Altar*, (Boston, 1981).

Gordon, A. 'Return of the Jedi: the End of the Myth', in, *Film Criticism*, Vol. 8: 2, (1984).

Gow, G. *Hollywood in the Fifties*, (New York, 1971).

Grant, B. K, *Film Genre: Theory and Criticism*, (Methuen, 1977).

GregorY, C. Knight 'Without Meaning?,' in, *Sight and Sound*, Summer, (1973).

Hardy, P. 'They Lived by Night', in, *The Movie*, Vol. 4: 30, (1982).

Hardy, P. *The Encyclopedia of Science Fictions Movies*, (London, 1984).

Hayles, N. and Kindskopf, K. 'The Shadow of Violence', in, *Journal of Popular Film and Television*, Vol. 8: 2, (1980-1984).

Heath, S. *Questions of Cinema*, (London, 1981).

Henderson, B. *A Critique of Film Theory*, (New York, 1980).

Highan, C. and Greenberg, J. *Hollywood in the Forties*, (New York, 1968).

Hill, G. *Illuminating Shadows: The Mythic Power of Film*, (London, 1992).

Hocker Rushing, J., and Frentz, T. S. *Projecting the Shadow: The Cyborg in American Film*, (Chicago, 1995).

Huss, R. *The Mindscapes of Art*, (London, 1986).

Iaccino, J, F. *Jungian Reflections within the Cinema: A Psychological Analysis of Sci-Fi and Fantasy Archetypes*, (Connecticut, 1998).

Jarvie, I. C. *Towards a Sociology of the Cinema*, (London, 1970).

Jarvie, I. C. *Philosophy of the Film*, (New York, 1987).

Jenkins, S. (Editor), *Fritz Lang*, (London, 1981).

Kaminsky, S. M. *American Film Genres*, (New York, 1974).

Karpf, S. L. *The Gangster Film, 1930-1940*, (New York, 1973).

Kawin, B. F. *Mindscreen: Bergman, Godard and First-person Film*, (Princeton, 1978).

Kenevan, P. B. *Paths of Individuation in Literature and Film: A Jungian Approach* (Oxford, 1999).

Kinnard, R. and Vitone, R. J. *The Americans Films of Michael Curtiz*, (London, 1986).

Krutnik, F. *In a Lonely Street: Film Noir, Genre and Masculinity* (London, 1991).

Mcarthur, G, *Underworld USA*, (London, 1972).

May, J. R. and Bird, M. (Editors), *Religion in Film*, (University of Tennessee, 1982).

Metz, C. *Film Language: A Semiotics of the Cinema*. Translated, Taylor, M., (New York, 1974).

Metz, C. *Psychoanalysis and Cinema: The Imaginary Signifier*, (London, 1982).

Meyers, R. *TV Detective*, (London, 1981).

Monaco, J. '*The Big Sleep*', in, *Sight and Sound*, Winter (1974-1975).

Monaco, P. *How to Read a Film*, (New York, 1981).

Monaco, P. *Cinema and Society*, (New York, 1976).

Monaco, P. 'Films as Myth and National Folk Law', in, *The Power of Myth in Film and Literature*, Editor, Carrabino, V., (Tallahassee, 1980).

Munsterberg, H. *The Film a Psychological Study: The Silent Photoplay in 1961*, (New York, 1970).

Neale, S. *Genre*, (London, 1980).

Newman, K. '*Trancers*', *Monthly Film Bulletin*, February (1985).

Offenbacher, E. 'Film as Transcendental Experience', in, *Communications*, Vol. 11:3, (1985).

Overby, D. 'In the Shadow', in, *The Movie*, Vol. 3: 30, (1982).

Petric, V. (Editor), *Film and Dreams: An Approach to Bergman*, (New York, 1981).

Place, J. 'Women in Film Noir', in: *Women in Film Noir*, Editor, Kaplan, E. A., (London, 1978).

Rosenweig, S. '*Casablanca*' *and other Major Films of Michael Curtiz*, (Ann Arbour, 1982).

Rosow, E. *Born to Loose: The Ganster film in America*, (Oxford, 1978).

Roth, L. 'Raiders of the Lost Archetype: The Quest and the Shadow', in, *Studies in the Humanities*, Vol. 10, June, (1983).

Rybark, D. 'Jedi and Jungian Forces', in *Psychological Perspectives*, Vol. 14: 2, Fall, (1983).

Sage, L. 'Kojak and Co', in, *Sight and Sound*, Summer, (1975).

Saris, A. *The Films of Joseph von Sternberg*, (New York, 1966).

Schatz, T. *Hollywood Genres*, (New York, 1981).

Shadoian, J. *Dreams and Dead Ends: the American Ganster/Crime Film*, (Cambridge, Mass., 1977).

Shichtman, M. B. 'Hollywood's New Western: The Grail Myth in Francis Ford Coppola's' *Apocalypse Now* and John Boorman's *Excalibur*, in, *Post Script Essays in Film and the Humanities*, Vol. 4: 1, (1984).

Silver, A. and Ward, E. (Editors), *Film Noir*, (London, 1989).

Silver, A. and Ursini, J. (Editors), *Film Noir a Reader* (New York, 1996).

Skeene, M. D. (Editor). *Crime, Detective, Espionage, Mystery, and Thriller Fiction and Film*, (London, 1980).

Slotkin, R. 'Prologue to a Study of Myth and Genre in American Movies', in *Prologue*, Vol. 9, (1984).

Solomon, S. J. *The Film Idea*, (New York, 1972).

Solomon, S. J. *Beyond Formula: American Film Genres*, (New York, 1976).

Thompson, D. 'Deadlier then the Male', in, *The Movie*, Vol. 3: 30, (1982).

Tudor, A. *The Theories of Film*, (London, 1974).

Tuska, J. *Dark Cinema: American Film Noir in Cultural Perspective*, (London, 1984).

Tyler, P. *Sex, Psyche, Etectera in the Film*, (New York, 1969).

Tyler, P. *The Magic and Myth of the Movies*, (London, 1971).

Williams, C. (Editor), *Realism and the Cinema*, (London, 1980).

Wilson, G. M. *Narration in Light*, (Baltimore, 1986).

Wolfenstein, M. and Leites, N. *Movies: A Psychological Study*, (Illusions, 1950)

Wollen, P. *Signs and Meaning in the Cinema*, (London, 1969).

Mythology, Anthology and Comparative Religion

Allcroft, A. H. *The Circle and the Cross*, (London, 1927).

Allegro, J. *The Last Gods*, (London, 1977). This edition, (London, 1978).

Ashe, G. *The Virgin*, (London, 1976).

Bhagavad-Gita, The, Translated, Mascaro, J. (Harmondsworth, 1967). This edition, (London, 1979).

Bell, R. E. *A Dictionary of Classical Mythology*, (California, 1982).

Bible The, New Revised Standard Version: Anglicized Edition, (Oxford, 1995).

Bouquet, A. C. *Comparative Religion*, (London, 1941). This edition, (London, 1962).

Briggs, K. *A Dictionary of Fairies*, (London, 1976).

Burtt, E. A. (Editor), *The Teachings of the Compassionate Buddha*, (New York, 1955). This edition, (New York, 1982).

Campbell, J. *The Hero with a Thousand Faces*, (London, 1949). This edition, (London, 1968).

Campbell, J. *Myths to Live By*, (London, 1973). This edition, (Glasgow, 1984).

Campbell, J. *Primitive Mythology*, (London, 1973). This edition, (London, 1984).

Campbell, J. *Oriental Mythology*, (London, 1973). This edition, (London, 1984).

Campbell, J. *Creative Mythology*, (London, 1970). This edition, (London, 1984).

Carrabino, V., (Editor), *The Power of Myth in Literature and Film*, (Florida, 1980).

Caussin, N. *De symbolica aegyptiorum sapienta polyhistor symbolicus electorum symbolorum et paraborum historicum stromata.* (Paris, 1681, and 1631).

Cavendush, R. (Editor). *Mythology: An Illustrated Encyclopaedia*, (London, 1980).

Charroux, R. *Lost Worlds: Scientific Secrets of the Ancients*, (London, 1973).

Chase, R. *Quest for Myth*, (New York, 1949).

Chetwynd, T. *Dictionary for Dreamers*, (London, 1974).

Chevalier, J. *A Dictionary of Symbols*, (London, 1982).

Chevalier, J., and Gheerbrent, A. *Dictionaries des Symboles*, (France, 1969). This edition, (France, 1973-1974).

Cohn, J. M. and Phipps, J. F. The *Common Experience*, (London, 1979).

Cooper, J. C. *An Illustrated Encyclopedia of Traditional Symbols*, (London, 1978).

Dhammapanda, Translated, Mascaro, J. (Harmondsworth, 1973).

Diehl, H. 'Into the Maze of Self: Protestant Transformations of the Images of the Labyrinth': *The Journal of Mediaeval and Renaissance Studies*, Vol. 16: 2, (1986).

Eggeling, J. *The Sacred Books of the East*, Translated, (Oxford, 1882).

Eliade, M. *The Myth of the Eternal Return*, Translated Task, W. R., (New York, 1954).

Eliade, M. *Birth and Rebirth*, (New York, 1958).

Eliade, M. *Patterns in Comparative Religion*, (New York, 1958).

Eliade, M. *Myths, Dreams and Mysteries*, (London, 1961).

Eliade, M. *From Primitives to Zen*, (London, 1967). This edition, (London, 183).

Eliade, M. *Occultism, Witchcraft and Cultural Fashions*, (Chicago, 1979).

Evans-Pritchard E. E. *Theories of Primitive Religion*, (Oxford, 1965).

Farnell, L. R. *Greek Hero Cults and Ideas of Immortality*, (Oxford, 1921).

Fergusson, J. *An Encyclopedia of Mysticism and the Mystery Religions*, (London, 1976).

Frankfort, H. W. *Before Philosophy*, (London, 1949).

Freedman, D. N. and Grant, M. R. *The Secret Sayings of Jesus*, (London, 1960).

Gilchrist, C. *Alchemy*, (London, 1984).

Gilgamesh, The Epic of, Translated, Sanders, N. K. (Harmondsworth, 1960). This edition, (London, 1978).

Graves, R. *The Greek Myths*, (London, 1955).

Graves, R. *The White Goddess*, (London, 1977).

Guenther, H. V. *Buddhist Philosophy in Theory and Practice*, (London, 1971).

Gulpilil, *Gulpilil's Stories of the Dreams Time*, completed by Rule, H., and Goodman, S., (Sydney, 1979).

Gyatso, T. *The Kalachakra Tontia: A Rite of Initiation*, Translated, Hopkins, J., (London, 1985).

Hansen, C. *Witchcraft at Salem*, (Sydney, 1970).

Hindu Scriptures Translated Zachner, R. C., (London, 1931). This edition, (London, 1982).

Hiriyanna, M. *Essentials of Indian Philosophy*, (London, 1949).

Holmyard, E. J. *Alchemy*, (London, 1957).

Hooke, S. H. *Middle Eastern Mythology*, (London, 1963).

Hope-Moncrief, A. R. *Classic Myth and Legend*, The Gresham Publishing Company. (No date Given).

Hughes, P. *Witchcraft*, (London, 1952).

James, W. *The Workshop of the Sky God*, (London, 1963).

Kirk, J. S. *Myth: Its Meaning and Function in Ancient and other Cultures*, (Los Angeles, 1970).

Laws of Manu The, in: *Sacred Books of the East*, Translated Buhler, G., (Oxford, 1886).

Leca, A. P. *The Cult of the Immortal*, (London, 1980).

Lempriere, J. *Lempriere's Classical Dictionary*, This edition, (London, 1984).

Lévi-Strauss. *Totemism*, Translated Needham, R., (London, 1963).

Lévi-Strauss, C. *Mythologiques: Le Cru et le Cuit*, (Paris, 1964).

Michell, J. *City of Revelation*, (London, 1972).

O'Brain, E. *Varieties of Mystical Experience*, (New York, 1965).

Ovid, *Metamorphoses*, Translated Innes M. M., (Harmondsworth, 1955). This edition, (London, 1984).

Pinsent, J. *Myths and Legends of Ancient Greece*, (London, 1969).

Radford, E., and Radford, M. A. *Encyclopedia of Superstitions*, (London, 1948).

Radice, B. (Editor), *Early Christian Writings*, (London, 1968).

Rig Veda, in: *Hymns of the Rig Veda*, IV, Translated Griffiths, R. T. H., (Benores, 1892).

Riemsh, M. *Rad und Ring als Symbole der Underweit*, (Studdgart, 1962).

Robinson, R. *Aboriginal Myths and Legends*, (Melbourne, 1966).

Ruysbroeck, J. *The Adornment of the Spiritual Marriage. The Book of Supreme Truth. The Sparkling Stone*, Translated Wynshenk, C. A., (London, 1916).

Seltman, C. *The Twelve Olympians*, (London, 1952).

Seznec, J. *The Survival of the Pagan Gods*, Translated sessions, B. F., (Princeton, 1953).

Shakespeare, W. *King Lear*, The Arden Shakespeare, (London, 1964).

Smart, N. *The Religious Experience of Mankind*, (New York, 1968).

Speiser, E. A. *Ancient Near Eastern Texts*, translated, (Princeton, 1950).

Stace, T. W. *The Teachings of the Mystics*, (New York, 1960).

Steiner, R. *Christianity and Occult Mysteries of Antiquity*, translated Frommer, E. A., Heff, G., and Kandler, R. (New York, 1964).

Theodore de Barry, W. *The Buddhist Tradition*, (New York, 1969). This edition, (New York, 1972).

Terea, N. *The Heart of Buddhist Meditation*, (London, 1962).

Thompson, F. *Poetical Works*, editor, Weynell, W., (London, 1913).

Tsu, L. *Tao te Ching*, translated Feng, G. F., and English, J., (London, 1973). This edition, (London, 1974).

Upanishads, Translated Mascaro, J. (Harmondsworth, 1965). This edition, (London, 1985).

Van Gennep, A. *The Rites of Passage*, translated by Vizedons, M. B. and Caffee, G. L. (London, 1960). This edition, (London, 1977).

Vires, A. *Dictionary of Symbols and Imagery*, (Amsterdam, 1974).

Virgil, *The Aeneid*, translated Jackson-Knight, W. F., (London, 1956).

Warner, M. *All Alone of her sex: The Myth and Cult Of Virgin Mary*, (London, 1976).

Warner, R. *Encyclopedia of World Mythology*, (London, 1970).

Wood, E. *Yoga*, (London, 1959).

Zaehner, R. C. *Hinduism*, (New York, 1962).

Zimmer, H. *Myths and Symbols in Indian Art and Civilisation*, edited Campbell, J. (Princeton, 1946). This edition (Princeton, 1963).

Cultural and Literary Criticism, Literature and Science

Adams, V., *Crime*, (Nederlands, 1978).

Andrews, A., *The Greeks*, (London, 1967).

Auden, W., *The Dyer's Hand*, (London, 1948).

Barthes, R., *Mythologies*, Translated Lavers , A., (London, 1973).

Barthes, R., *Image music Text*, Translated Heath, S., (London, 1977).

Bateson, G., *Steps to an Ecology of the Mind*, (London, 1973).

Bateson, G., *Mind and Nature*, (London, 1979).

Blake, W., *The Complete Writings of William Blake*, Editor, Keynes, G., (London, 1966).

Bronowski, J., and Mazlish, B., *The Western Intellectual Tradition*, (London, 1960).

Cairnes, D., *The Image of God in Man*, (London, 1973).

Capra, F., *The Turning Point*, (London, 1982). This edition, (London, 1984).

Carrell, A., *Man the Unknown*, (London, 1935).

Collins, *Encyclopaedia*, (London, 1979).

Corbishley, T., *The Spiritually of Teilhard de Chardin*, (London, 1971).

Cottrell, L., *Life Under the Pharaohs*, (London, 1954).

Eberling, G., *Lutheer*, (London, 1970).

Fontana, Dictionary of Modern Thought, (London, 1971). This edition, (London, 1983).

Gould, S. J., *Ontogeny and Phylogeny*, (London, 1977).

Grossvogel, D. I., *Mystery and its Fictions: From Oedipus to Agatha Christie*, (Baltimore, 1979).

Haining, P., *The Art of Mystery and Detective Stories*, (London, 1983).

Heisenberg, W., *Der Teil und der Ganze*, (Munchen, 1969).

Heraclitus, *Greek Religious Thought*, Tranaslated Cornford, (London, 1923).

Heraclintus, *Ancilla to the Pre-Socratic Philosophy*, translated Freeman, K., (Oxford, 1948).

Heraclintus, *Heraclintus: Greek Text with a short Commentary*, translated Marrovitch, M., (Los Angeles University Press, 1967).

Huxley, J., *Evolution*, (London, 1942).

Kant, I., *Critique of Pure Reason*, translated Smith, N. K., (London, 1979).

Kee, A., *The Way of Transcendence*, (London, 1972).

Keeting, H. R. F., (editor), *Crime Writers: Reflections on Crime Fiction*, (London, 1978).

Knight, S., *Form and Ideology in Crime Fiction*, (London, 1980).

Leibeniz, G., *Nouveaux Essais sur l'Entendement Humain*, translated and edited Remnan, P., and Bennett, J., (Cambridge, 1981).

Lello, S. R., *Revelations, Glimpses of Reality*, (London, 1985).

Lewis, C. S., *The Discarded Image*, (Cambridge, 1964).

Most, G ., and Stowe, W. W., *Poetics of Murder: Detective Fiction and Literary Theory*, (New York, 1983).

Palmer, J., *Thrillers: Genesis and Structure of a Popular Genre*, (London, 1978).

Plato, *Timeaus and Critias*, translated Bury, Rev. R. G., (London, 1966).

Robbe-Grillet, A., *The Erasser*, (London, 1964).

Robbe-Grillet, A., *Into the Labyrinth*, (London, 1978).

Rookmaster, H. R., *Modern Art and the Death of a Culture*, (London, 1970).

Sheldrake, R., *A New Science of Life*, (London, 1981). This edition, (London, 1984).

Sheldrake, R., *Need Biology be Godless?*, Centre space, Occasional Paper, Number 3, June (1984).

Sheldrake, R., *The Presence of the Past*, (London, 1988).

Smith, M., *The Theory of Evolution*, (London, 1958). This edition, (London, 1966).

Symons, J., *Bloody Murder*, (London, 1972).

Tertullian, *De Anima 55*, Ante-Nicence Christian Library, editor Roberts, A., and Donaldson, T., (Edinburg, 1870).

Thomas, K., *Religion and the Decline of Magic*, (London, 1971). This edition, (London, 1984).

Tillich, P., *The Dynamics of Faith*, (New York, 1956).

Todorov, T., *The Fantastic*, translated Howard, R., (London, 1973).

Todorov, T., *The Poetics of Prose*, translated Howard, R., (lOndon, 1977).

Walker, K., *The Diagnosis of Man*, (London, 1962).

Weber, M., *The Sociology of Religion* , (London, 1963).

Winks, R. W., (Editor), *Detective Fiction*, (New Jersey, 1980).

Filmography (in date order)

The Blue Angel	UFA, Paramount, 1930)
Director,	Joseph von Sternberg
Producer,	Erich Pommer
Screenplay,	Carl Zuckmayer, Karl Vollmoler and Robert Liebmann
Story,	Professor Unrat, by Heinrich Mann
Photography,	Gunter Rittan, Hans Schneeberger
Art Director,	Otto Hunte, Emile Hasler
Sound Engineer,	Fritz Thiery
Editors,	S. K. Winston (English Version), Walter Idee (German Version)
Music,	Friedrich Hollander
Principal Cast,	Emil Jannings (Professor Immanuel Rath), Marlene Dietrich (Lola Lola), Kurt Gerron (Kiepert), Rosa Valetti (Guste), Hans Alberts (Mazeppa), Reinhold Bernt (Clown).
Running Time,	109 mins.

King Kong	(RKO Radio Pictures, 1933)
Directors,	Merien C. Cooper and Ernst B. Shoodsack
Producer,	David O. Selznick
Editor,	Ted Cheesman
Photographer,	Eddie Linden
Screenplay,	James Creelman, Ruth Rose
Music,	Max Steiner
Key Actors,	Fay Wary, Robert Armstrong, Bruce Cabot, Frank
Reicher,	Sam Hardy, Nobele Johnson, Steve Clemento, James Flavin,
Running Time,	100 mins.

The Kennel Murder Case (Warner Brothers, 1933)
Director, Michael Curtiz
Producer, Robert Presnell

Screenplay, Robert N. Lee, Peter Milne
Photography, Willaim Reese
Art Director, Jack Okey
Editor, Harold McLarnin
Principal Cast, Willaim Powell (Philo Vance), Mary Astor (Hilda Lake),
 Euguene Pallette (Heath), Ralph Morgan (Raymode
 Wrede), Helen Vinson (Doris Delafield), Etienne
 Giradote (Daremund)
Running Time, 73 mins.

The Devil is a Woman (Paramount, 1935)
Director, Joseph von Sternberg
Screenplay, John Dos Passos, S. K. Winston
Photography, Joseph von Sternberg
Art Director, Hans Drier
Music, Ralph Rainger, Andres Setara
Editor, Sam Winston
Principal Cast, Marlene Dietrich (Concha Perez), Lional Atwill (Don
 Pascal), Cesar Romero (Antonio Galvan), Edward
 Everett Horton (Don Paquitto), Alison Skipworth
 (Senora Perez), Don Alvarado (Morenito), Morgan
 Wallance (Dr Mendez)
Running Time, 85 mins.

Double Indemnity (Paramount, 1944)
Director, Billy Wilder
Cinematographer, John Seitz
Art Director, Hans Dreir, Hal Pereira
Music Supervisor, Miklas Rozsa
Editor, Doane Harrison
Screenplay, Billy Wilder, Raymond Chandler. From the novel by
 James M. Caine
Principal Cast, Fred MacMurray (Walker Neff), Barbara Stanwyck
 (Mrs Diedrickson), Edward G Robinson (Mr Keys)
Running Time, 104 mins.

Murder My Sweet aka
Farewell My Lovely (RKO, 1944)
Director, Edward Dmytryk

Producer,	Adrain Scott
Screenplay,	John Paxton
Story,	*Farewell My Lovely* by Raymond Chandler

Director of Photography,	Harry J Wild
Music,	Roy Webb
Art Directors,	Albert S. D'Agostino, Carrol Clark
Editor,	Joseph Noreiga
Principal Cast,	Dick Powell (Philip Marlowe), Claire Trevor (Velma/Mrs Grayle), Anne Shirley (Anne), Otto Kruger (Amthor), Mike Mazurki (Moose Malloy), Miles Mander (Mrs Grayle), Douglas Wakton (Marrot), Don Douglas (It Randell), Rolfe Harolde (Dr Sonderborg), Ester Howard (Mrs Florian)

The Woman in the Window	(RKO, 1944)
Director,	Fritz Lang
Producer,	Nunally Johnson
Screenplay,	Nunally Johnson
Story,	*Once of Guard*, J. H. Wallis
Photography,	Milton Krasner
Special Effects,	Vernon Walker
Art Director,	Duncan Cranmer
Music,	Arthur Lang
Editor,	Marjorie Johnson
Principal Cast,	Edward G Robinson (Richard Wanley), Joan Bennet (Alice), Raymond Massey (District Attorney), Dan Duryea (Blackmailer), Edmond Breon (Dr Barkstone), Thomas E. Jackson (Inspector Jackson).
Running Time,	99 mins.

Crossfire	(RKO, 1947)
Director,	Edward Dmytryk
Producer,	Adrian Scott
Cinematopgaphy,	J. Roy Hunt
Art Director,	Albert S. D'Agostino, Alfred Herman
Music,	Roy Webb
Editor,	Harry Gerstad
Screenplay,	John Paxton
Story,	*The Brick Fox Hole*, Richard Brooks
Special Effects,	Russel A. Cully
Principal Cast,	Robert Young (Finlay), Robert Mitchum (Keeley), Robert Ryan (Montgomery), Gloria Graham (Ginny),

| | Richard Powers (The Detective), Sam Levene (Samuels), George Cooper (Mitchell) |
| Running Time, | 86 mins. |

The High Window aka
The Basher Dubloon
	(Twentieth Century Fox, 1947)
Director,	John Brahm
Producer,	Robert Bassler
Screenplay,	Dorothy Hannah
Story,	*The High Window*, Raymond Chandler
Director of photography,	Lloyd Ahern
Music,	David Buttloph
Art Directors,	James Basevi, Richard Irvine
Editor,	Harry Reynolds
Principal Cast,	George Montgomery (Philip Marlowe), Nancy Guild (Merle Davis), Conrad Janis (Leslie Murdoch), Roy Roberts (Lt. Breeze), Fritz Kortner (Vannier), Florence Bates (Mrs Murdoch), Marvine Miller (Blaire), Houseley Stevenson (Morningstar), Bob Adler (Sgt. Spangler)
Running Time,	72 mins.

Lady in the Lake
	(MGM, 1947)
Dircetor,	Robert Montgomery
Producer,	George Haight
Screenplay,	Steve Fisher
Story,	Raymond Chandler
Photography,	Paul C. Vogel
Special Effects,	A. Arnold Gillespie
Music,	David Snell
Art Director,	Cedric Gibbons, Preston Ames
Editor,	Gene Ruggiero
Principal Cast,	Robert Montgomery (Philip Marlowe), Lloyd Nolan (Lt. De Garmon), Audry Trotter (Adrienne Fromsett), Tom Tully (Capt. Kane), Leon Ames (Derance Knigsby), Jayne Meadows (Mildred Haveland), Morris Ankrum (Eugene Grayson)
Running Time	105 mins.

Detective Story
	(Paramount, 1951)
Director,	William Wyler
Producer,	William Wyler
Associate producers,	Robert Wyler, Lester Koenig

Cinematography,	Lee Garmes
Art Director,	Hal Pereira, Earl Hendrick
Editor,	Robert Swink
Screenplay,	Philip Yordan, Robert Wyler
Story,	Sidney Kingsley
Principal Cast,	Kirk Douglas, Eleanor Parker, Willaim Bendix, Cathy O'Donnell, Geroge MacCready, Horace McMahon, Gladys George, Joseph Wiseman, Lee Grant, Gerald Mohr, Frank Faylen.
Running Time,	103 mins.

Sleuth (Fox Rank, 1972)

Director,	Joseph L. Mankiewicz
Excutive Producer,	Edgar J. Sherick
Photography,	Oswald Morris
Screenplay,	Anthony Shaffer
Editor,	Richard Marden
Principal Cast,	Lawrence Olivier (Andrew Wyke), Micheal Caine (Milo Tindle), Alice Cawthorne (Inspector Doppler), Margo Channing (Marguerite), John Mathews (Det. Sgt. Tarrant), Teddy Martin (P. C. Higgs)
Running Time,	139 mins.

Equus (United Artists, 1976)

Director,	Sidney Lumet
Producer,	Elliot Kastner
Editor,	John Victor Smith
Design,	Tony Walton
Photographer,	Oswald Morris
Screenplay,	Peter Shaffer
Principal Cast,	Richard Burton (Martin Dysart), Peter Firth (Alan Strang), Colin Blakely (Frank Strang), Joan Plowright (Dora Strang), Harry Andrews (Harry Dalton), Eileen Atkins (Hester Solomon), Jenny Agutter (Jill Mason)
Running Time,	137 mins.

Star Wars (Twentieth Century Fox, 1977)

Director,	George Lucas
Produce,	Gary Kurtz
Photographer,	Gilbert Taylor
Screenplay,	George Lucas
Special Effects	

Supervisor,	John Dykstra, Industrial Light and Magic
Editors,	Paul Hirsh, Marcia Lucas, Richard
Music,	John Williams
Principal Cast,	Mark Hamill (Luke Skywalker), Harrison Ford (Hans Solo), Carrie Fisher (Princess Leia Orgma), Peter Cushing (Grand Moff Tarkin, Governor of Imperial Outland Regions), Alec Guiness (Ben [Obi Wan] Kenobi), Anthony Daniels C-3PO, Kenny Baker R2-D2, Peter Mayhew (Chewbacca), David Prowse (Lord Darth Vader)
Running Time,	121 mins.

Star Trek: The Motion Picture	(Paramount, 1979)
Director,	Robert Wise
Producer,	Gene Roddenberry
Editor,	Todd Ramsay
Photographer,	Richard H. Kline, Richard Yuricich
Screenplay,	Harold Livingstone
Special Effects	Douglas Trumbull
Principal Cast,	William Shatner (Admiral James T. Kirk), Leonard Nimoy (Mr Spock), De Forrest Kelley (Dr Leonard "Bones" McCoy), James Doohan (Engineering Officer Montgomery "Scotty" Scott), George Takei (Helmsman Sulu), Majel Barrett (Dr Christine Chapel), (Communications Officer Uhura)
Running Time,	132 mins.

Raging Bull	(United Artists, 1980)
Director,	Martin Scorsese
Producer,	Irwin Wrinkle, Robert Shartoff
Editor,	Thelma Schoonmaker
Photographer,	Micheal Chapman
Screenplay,	Paul Schraeder, Mardik Martin
Design,	Gene Rudolf
Principal Cast,	Robert De Niro (Jake La Motta), Cathy Moriarty (Vickie LA Motta), Joe Pesci (Joey La Motta), Frank Vincent (Salvy), Nicholas Colasanto (Tommy Como), Theresa Salandra (Lenore, Mario Gallo (Mario).
Running time,	129 mins.

Blade Runner	(Columbia, 1982)
Director,	Ridley Scott
Producer,	Micheal Deeley
Photographer,	Jordon Cronenweth
Screenplay,	Hampton Frencher, David Peoples
Story,	*Do Andriods Dream Electric Sheep?*, Phillip K. Dick
Special Effects	
Supervisors,	Douglas Trumbull, Richard Yuricich, David Dryer
Principal Designer,	Lawrence G. Paull
Music,	Vangelis
Editor,	Terry Rawlings
Principal Cast,	Harrison Ford (Rick Deckard), Rutger Hauer (Roy Batty), Sean Young (Rachel), Edward James Olmos (Gaf), M. Emmet Walsh (Capt. Bryant), Daryl Hannah (Pris), Williams Sanderson (J. F. Sabastian), Brian James (Leon), Joe Turkel (Dr Tryell), Joanna Cassidy (Zhora)
Running Time,	102 mins.

C. H. U. D.	(New World Pictures, Bonime Productions, 1984)
Director,	Douglas Cheek
Producer,	Andrew Bonime
Adaptation,	Parnell Hall
Director of Photography,	Peter Stein
Story,	Shepard Abbott
Editor,	Claire Simpson
Music,	Cooper Hughes
Design,	William Bilowit
Principal Cast,	Laurie Mattas (Flora Bosch), John Herd (George Cooper), Kim Greist (Laurin), Brenda Currin (Francine), Justin Hall (Justin), Chistopher Curry (Capt. Bosh), Cordis Hurd (Banderson), Eddie Jones (Chief O'Brian), Daniel Stern (The Reverend)
Running Time,	87 mins.

The Terminator	(Orion, 1984)
Director,	James Cameron
Executive Producer,	John Aly, Derek Gibson
Editor,	Mark Goldblatt
Art Director,	George Costello
Photographer,	Adam Greenberg
Screenplay,	James Cameron, Gale Anne Hurd
Special Effects,	Fantasy II Film Effects, (Production Supervisor, Leslie Huntley).
Principal Cast,	Arnold Schwarzeneggar (Terminator), Micheal Biehn

	(Kyle Reese), Linda Hamilton (Sara Conner), Paul Winfield (Traxler), Lance Henriksen (Vukovich), Rich Rossovich (Matt), Bess Motta (Ginger), Earl Boen (Silberman)
Running Time,	107 mins.

Tightrope	(Warner Brothers, 1984)
Director,	Richard Tuggle
Producer,	Clint Eastwood, Fritz Manes
Dir of Photography,	Bruce Surtees
Editor,	Joel Cox
Music,	Lennie Neihaus
Design,	Edward Carfagno
Written by,	Richard Tuggle
Principal Cast,	Clint Eastwood (Wes Bloch), Dan Hedaya (Detective Moligan), Jennifer Beck (Penny Bloch), Rebecca Perle (Becky Jacklin), Randi Brooks (Janie Cory), Margaret Howell (Judy Harper), Genevieve Bujold (Berly Thibodeaux), Alison Eastwood (Amanda Bloch), Marco St John (Leander Rolfe), Regina Richardson (Santa), Jamie Rose (Melanie Siber)
Running Time,	110 mins.

Trancers	(Lexyen productions. An Empire Pictures Presentation, 1984)
Director,	Charles Band
Executive Producer,	Peter Manoogian, Brad Arensman
Producer,	Charles Band
Cinematographyer,	Mac Ahlberg
Musical Superviser,	Richard Band
Music,	Mark Ryder, Phil Davies
Screenplay,	Danny Bilson, Paul De Moe
Special Effects,	John Buechler, Mechanical and Makeup Imgeries Jeff Staggs
Principal Cast,	Tim Thomerson (Jack Deth), Helen Hunt (Leena), Micheal Stefani (Martin Whistler), Art De Fleur (McNulty), Telma Hopkins (Engineer Raines), Richard Herd (Chairman Spencer), Anne Seymore (Chairman Ashe), Miguel Fernandes (Officer Loped), Biff Manard (Hap Ashby), Pete Schrum (Santa Claus), Barbera Perry (Mrs Santa Claus), Brad Logan (Bull), Minnie Lindsay ('Mom'), Richard Erdman (Drunken Wise Old Man), Wiley Harker (Dapper Old Man), Allyson Croft (Baby McNulty), Micheal McGardy (Chris Lavery), Edward

McLarty (Jerry the Punk), Don Ross (Security Guard), Micheal Heldebrandt (Boy with Santa), Kim Shepard (Newswoman), Steve 'o' Jenson, Nocky Beat, Tony Malone, Lantza Kranzt (The Buttheads)

Running Time, 76 mins.

2010 (MGM, UA, 1984)
Director, Peter Hyams
Producer, Peter Hyams
Editor, James Mitchell, Mia Goldman
Design, Albert Brenner
Photographer, Peter Hyams
Screenplay, Peter Hyams
Visual effects,
Supervisor, Richard Edlund, George Jensen.
Pricipal Cast, Roy Schneider (Dr Heywood Floyd), John Lithgow (Walter Curnow), Helen Mirren (Tanya Kirbuk), Bob Baluban (Dr R Chandra), Keir Dulla (David Bowman), Douglas Rain (HAL 9000).
Running Time, 116 mins.

Big Trouble in Little China (Twentieth Century Fox, 1986)
Director, John Carpenter
Producer, Larry J. Franco
Adaption, W. D. Richter
Director of photography, Dean Cundey
Written by, Gray Goldman, David Z. Weinstein
Executive Producers, Richard Edlund
Music, John Carpenter, Alan Howarth
Principal Cast, Kurt Russell (Jack Burton), Kim Cattrall (Gracie Law), Dennis Dun (Wang Chi), James Hong (Lo Pan), Vistor Wong (Egg Shen), Kate Burton (Margo)
Running Time, 97 mins.

Index

2010 (Peter Hymas) 23, 207

A Stolen Life (Curtis Burnhart) 63
Affect(s) 16, 25, 26, 27, 41
 97, 131, 177
Aggregate 68, 69, 111, 136, 174
Agutter, J 20, 203
Alchemy/Alchemical 153, 159, 174
 184, 192, 193
Alienation 18, 19, 30, 48, 166
Allcroft, A 167, 191
America(n) 14, 63, 77, 127
Amplification 6, 8, 40, 42, 112
 159, 177
Analysand 3, 42
Analysis 7, 9, 23, 28, 31, 33
 35-38, 41, 44, 62
Analyst 40, 43, 54, 62, 63, 73
 94, 120, 141, 165, 177
Analytical Model 71, 74, 100
Analytical Psychology i, v, 3, 4, 6-9
 13-15, 18, 19, 21, 23, 24
 29, 30-36, 38, 40, 43, 44
 47, 54, 55, 60, 62, 63
 70, 75, 77, 80, 83, 88
 89, 90-93, 98, 100
 103, 112, 116, 120
 121, 125, 130, 133
 134, 137, 144, 146
 165, 167, 176, 177
Ancestor 21, 49, 126, 129
 134, 141, 142, 150, 151
 154, 155, 160, 164, 173
Anima 34, 37, 42, 43, 54, 66
 67, 68, 78, 79, 85-88, 94
 98, 100, 104, 107, 108
 111-117, 121, 126, 133
 135, 136, 141, 142, 148
 153, 160, 162, 164, 167
 170, 171-175, 177
Animal 15, 21, 54, 85-88, 96

Animus 34, 42, 66, 67, 68, 104
 111-113, 117, 121
 136, 141, 170, 177, 179
Anthest eria 155
Apocalyptic 83
Archetypal v, 5-7, 29, 31-38, 40, 41
 43, 47, 55, 59, 60, 61-73, 75
Assimilation 98, 99, 110, 111, 114
 117, 119, 154, 165, 172
 173, 174
Atlantis 8, 159, 160, 161
 166, 170, 172
Audience (see viewer)
Axis mundi 142, 143, 156, 166

Babylonian 82, 85, 161
Balance (also see compensation) 17, 21
 31, 35, 36, 42, 63, 72
 100, 171, 173, 174
Band 125, 147, 206
Band, C 8
Baptism 82, 86, 87, 92, 144, 153
Bathing Beauty (George Sydney) 63
Beckwith, M 100
Behaviour 5, 6, 16, 17, 18, 20
 22, 26, 31, 34, 51, 61, 65
 66, 94, 112, 147, 169, 177, 178
Behaviourist Theories 13-17, 28, 89
Bennet, J 97, 101, 196
Berghölzli 23, 29
Beware My Lovely
(Harry Horner) 77
Bible 88, 98, 101, 122, 148, 176
Big Heat, The (Fritz Lang) 116
Big Trouble in Little China
(John Carpenter) 163
Binding 54, 55
Biology/biological 5, 15, 29, 34, 89
 103, 104, 111, 112
Birth 24, 31, 55, 88, 104, 135, 144
Blake, W 145, 148, 150, 157
Blindness 84
Blue 155, 156
Blue Angel, The
(Joseph von Sternberg) 115, 121, 199

Body/Bodily 8, 31, 36, 37, 86, 92
 94, 109, 126, 129, 130, 134
 139, 144-147,151, 153
 155, 157, 159, 160, 165
 171, 172, 174, 175
Bogart, H 59
Branson, C 54, 55, 100
Breath 86
Brooks, H 116
Broome, V 176, 181
Brothers Rico, The (Pil Karlson) 103
Buddha 84, 88, 153
Buddhist 32
Burnhart, C 63

C.H.U.D. (Douglas Cheek) 167
Caduceus 104
Caine, M 95
Cameron, J 16, 205
Carpenter, J 163
Carrabino, V 44
Cartesian 90
Charon 136
Cheek, D 167, 205
Chetwynd, T 85, 88, 96, 101
Chevalier, J 155, 156, 158
Chinatown 7, 81, 85, 110, 126
 142, 143, 154, 162, 163, 167
Christ 83, 87, 144, 146
Christian 20, 82, 86, 92, 120, 144
 145, 155, 161, 175
Christmas Holiday
(Richard Siodmark) 47
Chthonic/Chthonios 136, 143, 157
Cinema i, 2, 6, 7, 8, 9, 30, 40
 44, 110, 111, 154, 173
Circle/Circular 39, 42, 52, 53
 86, 105, 120, 157, 160
City/Cities 48, 52, 78, 79, 83
 85, 87, 97, 101, 109, 110
 115, 129, 153, 159, 160
 161, 162, 163, 164, 166
Classification 6, 65-69, 111
Clinical 3, 4, 9, 15, 62, 91
Cognitive 73, 89, 106
Coincidentia oppositorum 169, 170
Colli, G 96
Colli, G 100
Colour 8, 119, 155, 156, 157
Compensation/
Compensatory 35-41, 51, 63, 72, 78
 93, 94, 100, 106, 108, 132
 136, 139, 140, 171, 177
Complex 15, 18, 62, 100, 105
 106, 110, 129, 177

Coniunctio 98, 99, 184
Conjunction 8, 169, 170, 174
Consciousness 5, 6, 13-18, 24-27, 34-37
 41-43, 48-52, 55, 62, 64
 65, 66, 72, 73, 78, 79
 84, 90-116, 120-122
 126-128, 130, 133, 137
 139, 141, 144-146, 150
 162, 165, 169, 170-179
Contrasexual (see also, anima/animus) 8, 34
 42, 66, 67
 104, 108, 111, 112, 114
 135, 136, 177
Corinthians 148, 175, 176
Cosmic 74, 83, 91, 145, 162
Creation (see also recreation) 36, 68, 82, 84
 85, 86, 88, 142, 145
Crime 26, 48, 50, 54, 85, 97
 98, 99, 108, 110, 115, 127
 130, 133, 141, 160, 162
Criminal 6, 25, 47, 49, 50, 51
 52, 53, 55, 97, 98, 109, 110
 127, 131, 132, 133, 136, 162, 163
Crossfire (Edward Dmytryk) 144, 201
Cuchulainn 82
Culture(s) 4, 5, 9, 20, 29, 30
 34, 35, 36, 43, 60-69, 83
 107, 111-116, 121, 127
 135, 140, 146, 149, 161
 162, 166, 171, 172

D.O.A. (Rudolph Mate) 139
Darwin, C 60, 89
Daughter 150, 174
Davies, M 121
De Niro, R 19, 204
Death 8, 22, 30, 55, 80, 81, 82
 83, 84, 85, 86, 92, 95, 96
 104, 113, 115, 131, 132
 137, 139, 143-147, 153-157
 160, 161, 164, 166, 169
 170-172, 178, 179
Deconstruction 4, 112, 140
Definition 6
Depth psychology 143
Descartes, R 89
Descent 97, 127, 142, 159, 175
Detection 108, 128, 131, 149
Detective v, 6, 7, 8, 18, 25, 29, 30, 47
 48, 49, 50, 51, 52, 53, 55, 61
 77, 78, 85, 89, 95, 97, 103
 108-117, 119, 121, 122
 127-147, 156, 161, 162, 163
 165, 167, 171, 176
Detective Story (William Wyler) 130, 202

Devil is a Woman, The
(Joseph von Sternberg) 115, 121, 200
Diehl, H 166, 167, 176
Dietrich, M 115, 121, 199, 200
Differentiation 103, 104, 106, 107
Diksha 82
Dionysos 49
Director 70, 92
Dirty Harry (Don Siegel) 110
Diurnal 48, 51, 156, 163
Dmytryk, D 144, 200, 201
Double Indemnity (Billy Wilder) 101
 116, 137, 169
Double Indemnity (Bily Wilder) 200
Douglas, K 130
Dove 82, 86, 98
Dracula (Tod Browning) 63
Dream interpretation 38-41
Dreams 5, 23, 24, 36, 38, 39
 55, 64, 93, 99, 179
Dreams and films 7, 23, 31, 32, 54, 97, 98
 99, 149
Dragon 40
Dualism 89, 143, 145, 146, 174, 175
Durbin, D 47
DVD 2

Eastwood, C 25, 47, 206
Eating 86, 154, 155, 179
Edinger, E 99, 101, 172, 174, 176
Effects of film 6, 9, 171
Ego 5, 16, 42, 43, 66, 85
 91-101, 103-108
 110-117, 120, 128, 129
 133, 136, 143, 162, 169, 171
 172, 174, 175, 178
Einstein, A 8, 151, 152
Eliade, M 88, 152, 158, 161, 164, 167, 192
Emotion 3, 5, 21, 25-27, 40, 41
 49, 70, 78, 79, 84, 110, 114, 177, 179
Enantiodromia 8, 140-147, 153, 156
 166, 169, 170, 178
Equus (Sidney Lumet) 19, 203
Erasers, The 157
Eucharist 20, 92, 93
Eurydice 127
Evil 48, 50, 88, 109, 119
 127, 133, 140, 142
Evolution 60-62, 75, 140, 196
Extravert 13, 18-21, 108
 162, 178, 179

Fairy-tale 5, 9, 74
Fantasy 3, 5, 7, 20, 23, 24
 35, 44, 49, 66, 99, 106

 113, 159, 171, 173, 188
Farewell My Lovely (Dick Richards) 109
Farewell My Lovely (Edward Dmytryk) 200
Farnell, L 157, 158, 192
Father 48, 66, 71, 75, 79
 100, 113, 130, 134, 142
 144, 153, 175, 181, 185
Feeling 19-23, 27, 37, 78-81
 84, 113, 131, 132, 137, 150
 177, 178, 179
Female 32, 34, 66, 87, 96
 112, 120, 121, 150, 164
Female Jungle, The
(Bruno VeSota) 29
Feminine 34, 66, 78, 108, 112, 113
 114, 116, 119, 121, 135
 156, 177, 185, 186
Femme fatale 67, 98, 113, 114
 115, 116, 121, 135, 137
Film Analysis v, 11, 24, 40, 43, 47
 70, 71, 75, 88, 100, 125, 141
Film Noir 47, 63, 67, 75, 77, 97
 109, 114-116, 121
 122, 128, 137, 144, 189, 190
Firth, P 19, 203
Flying Down to Rio (Thornton Freeland) 63
Food 8, 136, 154, 155, 157
Ford, H 204
Fordham, F 20
Fordham, M 104, 121, 184
Form 3, 4, 6, 30, 34, 38, 59
 60-64, 69, 105, 112
Frankenstein (James Whale) 63
Franz, M 70, 74, 76, 113, 114, 184, 186
Freeland, T 63
Freud, S 5, 15, 16, 24, 35, 38, 90, 110, 182
Freudian 3-7, 15, 17, 23, 29, 38, 55, 59
Freund, K 63
Future 5, 7, 40, 87, 150, 174

Gauntlet, D 9, 188
Gender 34, 66, 111, 112, 117, 177
Gennep, A 44, 194
Genre 8, 76, 115, 119, 129
 144, 162, 163, 188, 189, 190, 196
Gilgamesh 82, 86, 192
God 19, 20, 32, 33, 52, 54
 59, 82, 85, 86, 96, 120
 121, 127, 135, 140, 142
 145, 156, 161, 163, 166
 172, 176, 185, 186
Goddess 85, 192
Gold Diggers of 1933, The
(Mervyn Le Roy) 63
Good 50, 113, 117, 119, 127, 140

Grahame, G 116
Grant, B 76, 188

Hades 49, 52, 54, 127, 143, 154, 155, 161
Haller, H 100
Hannah, B 44
Harmony 84, 93, 156
Harvey, S 63, 75
Hauke 174
Hauke, C 60, 61, 75, 111, 121
176, 181, 183
Hawks, H 55, 187
Hayworth, R 89
Hegel 72
Heisenberg, W 152, 157, 196
Heraclitus 49, 140, 147, 153
158, 175, 176, 196
Hercules 34, 136
Hermes 136
Hero 8, 25, 30, 31, 40, 59, 61
71, 77, 78, 79, 80, 83, 87
110, 117, 125-128, 131-137
141-147, 150, 152, 155, 157
158, 160, 165, 166, 170-178
Hesse, H 100, 185
Hillman, J 3, 47, 49, 55, 98
101, 104, 105, 121, 122
136, 137, 141, 143, 147
148, 154-158, 161, 167, 172, 176, 183
Hindu 82, 100, 119, 120, 122
145, 148, 193, 194
Hinduism 119, 194
History 2, 31, 34, 64, 72, 73
116, 121, 135, 137, 159, 173, 185
Holistic 89, 90, 100
Hollwood 77
Hollywood 30, 33, 67, 77, 99
111, 128, 187, 188, 190
Horner, H 77
Horse 20
Humanistic 17
Humphrey, B 59
Humphrey, N 103, 121
Huston, J 125

Iconography 155
Ideational 7, 106, 157, 171
Identification 51, 98, 130, 146, 147, 167, 178
Identity 103, 112, 144, 169, 178
Illusion 50, 53, 64, 80, 81, 84
85, 87, 99, 101, 108
133, 136, 162, 163, 174
Imago Dei 32, 33
Imago mundi 143, 166
In a Lonely Place (Nicolas Ray) 59

Incest 134, 135, 150-152, 165, 174
Individual 4, 9, 15, 19, 21, 26-32
36-39, 40-43, 49, 60, 61
64, 65, 78, 103, 105-109
110, 112, 117, 119, 120
128, 135, 172, 178, 179
Individualism 42, 105
Inferior function 65
Introvert 13, 18-21, 90, 162, 178, 179
Intuition 21-23, 27, 32, 162, 163, 177, 179
Invasion 26, 27, 97, 131, 179
Jaffe, A 171, 176, 183
Jarvie, I 30, 44, 188
Jungian 1-9, 13, 15, 18, 21
23, 27, 28, 34, 38, 39, 41
43, 44, 54, 55, 59, 60, 64
70, 72, 75, 76, 88, 89, 90
91, 100, 103-108, 111, 112
121, 122, 137, 165, 167, 181-189
Kant, I 59, 75, 196
Kast, V 5, 9
Kaye, D 63
Kenevan, P 2, 9, 189
Kennel Murder Case, The
(Michael Curtiz) 108, 200
Kerenyi, C 94
Key Largo (John Huston) 125
King Kong (David O'Selznick) 22, 199
King Lear 83, 84, 88, 194
Kodl, J 29
Labyrinth 7, 8, 95-101, 104, 121
143, 159, 161, 163-167, 170-172
175, 176, 182, 192, 196
Lacan, J 35
Lacanian 3, 4
Laura (Otto Preminger) 101
Leibniz, C 28
Lévi-Strauss, C 44
Lighting (lit) 48, 82, 101, 109
115, 128, 140, 155-157
Lilith 135
Longissima via 104
Lorelei 113, 115, 135
Love me Tonight
(Robert Mamoulain) 63
Lucas, G 119, 203, 204
Lumet, S 19, 203
Magic/magical 30, 33, 37, 39, 40-44, 54
55, 92, 96, 101, 113, 116
117, 135, 142, 148, 152
157, 161-164, 178, 190, 196
Male (see also, masculine) 32, 34, 112
Mana-personality (see also, trickster) 119
Mandala 39, 42, 52, 94, 100
120, 121, 160-162, 178, 179

Mankiewicz, J — 7, 89, 95, 159, 203
Mankind — 29, 30, 32, 35, 41, 43
64, 82, 120, 122, 128, 135
145, 172, 175, 194
Manu — 82, 88, 193
Marxist — 4
Masculine — 34, 66, 112, 119, 121, 156, 183
Maslow, A — 17
Mechanistic — 89, 90
Media — 1, 2, 9, 42, 114
Mediaeval — 1, 192
Mediation — 42
Medusa — 88
Memory — 24, 27, 38, 91, 132
Metamorphoses — 167, 193
Metaphor — 3, 6, 7, 25, 29, 37, 54
64, 78, 80, 81, 105, 108, 110
112, 119, 127, 133, 141-143, 147
155, 157, 160, 165, 173
Miller, T — 9
Mise-en-scène — 70, 80, 109
Monaco, P — 30, 32, 36, 37, 40, 44, 189
Mother — 66, 100, 112, 134, 136
150, 171, 174
Mulvey, L — 4
Mummy, The (Karl Frend) — 63
Murder — 13, 25, 26, 34, 47, 48
50-54, 95, 97, 99, 101, 108
113, 128, 134, 137
139, 144, 196, 200
Myers, I — 21, 28
Myth — 8, 37, 47, 64, 73, 75
100, 121, 126, 151, 176, 178
Myth and film — 40, 44
Myth and labyrinth — 95, 159
Myth criticism — 4
Myth of initiation — 82
Myth of Manu — 82
Myth of Tyr — 54, 55
Myth, Biblical — 85
Myth/recurring — 29, 30
Mythic — 37, 39, 41, 77, 188
Mythologem — v, 31, 69, 71, 73-76
80-83, 86, 97, 119
125, 139, 166, 178
Mythology — 29, 40, 47, 53, 70-73
75, 76, 81-85, 88, 95, 96
100, 112, 125, 135, 145, 149
152, 156, 157, 161, 171
176, 178, 185, 191

Natural — 5, 7, 19, 36, 39, 42, 87, 103
110, 121, 150, 155, 169
Nature — 4, 14, 17, 24, 25, 30-33, 37-39
40, 41, 48, 67, 70, 77, 84

91-93, 104-107, 110
113-116, 127, 130-135,
152, 153, 157, 159,
161-165, 170, 173, 178, 195
Neugent, E — 63
Neumann, E — 103, 127, 134-137, 185
Neurosis — 27, 110
Newton, I — 8, 89, 151
Newtonian — 150-152
Night — 48, 53, 63, 83, 160, 175
Nimoy, L — 21, 204
Noah — 82, 86
Noll, R — 27
Non-rational — 22, 23, 90, 93, 141
Numinos (numinosity) — 32, 43, 109
117, 133

O'Brian, E — 139
O'Neil, T — 28, 185
Objective Psyche — v, 6, 29, 30-41, 50, 60
62-65, 69, 73, 78, 80, 84
89, 90-94, 96, 99, 100
103, 106, 117, 122, 131
132, 150, 162, 172, 175
176-179
Oedipal, Oedipus — 5, 15, 16, 38, 115
121, 134, 165, 195
Olivier — 95, 203
Omphalos — 121, 143
Opposites/Opposition — 4, 8, 15, 21, 32
35-37, 42-44, 48, 49
51, 55, 63, 68, 69, 72
74, 78, 84, 86, 89, 94
95, 98, 99, 100, 104-108
116-121, 126-128
132, 136, 139, 140, 141
143, 147, 149, 154, 155
156, 157, 169-173, 177-179
Orpheus — 127, 136
Other — 1, 2, 4, 7, 9, 14, 17, 21
22, 23, 29, 30, 32, 33
34, 38, 41, 42, 47, 48
52, 53, 59, 60, 66, 79
81, 83, 84, 86, 91, 93
94, 95, 98-101, 108
110, 111, 113, 117, 119
126-129, 131-135, 139
143-147, 150-152, 155-157
162, 166-170, 175-177, 189, 193
Owl — 85

Paradigm — 16, 89, 90
Paris — 44, 161, 191, 193
Participation Mystique — 92
Past — vii, 5, 17, 50, 122, 126

129, 131, 132, 135, 150
153, 154, 174, 196
Pathology/Pathological 19, 20, 27, 90
104, 159
Pattern v, 6, 20, 22, 29, 30-33
35, 47, 51, 55, 60-65, 68
69, 71-73, 75, 78, 80, 81
86, 91, 103, 106, 107, 119-121
125-128, 136, 142, 155
157, 158, 160, 167, 170
177, 178, 192
Persona 6, 25, 48, 49, 51, 53
65, 67, 106-108, 111
117, 126, 128-132, 147, 174
Personal vii, 1-6, 9, 13, 16, 21
24, 27, 29, 34, 35-42
49, 60-64, 74, 78, 83, 92, 93
108, 109, 112, 113, 120, 128
141, 163, 171, 173, 178
Personal Unconscious 29, 60, 92, 93, 109
Philemon 117
Photographs 2, 129
Photography 1, 2, 199-203, 205-207
Physics 31, 90, 152, 157
Plato 59, 144, 148, 160, 167, 196
Pneuma 86
Police 25, 48, 49, 52, 77
95, 97, 110, 126, 131, 167, 174
Political 3, 4, 29, 33, 36, 116, 185
Politics 4, 187
Post-Jungian 3, 7, 9, 34, 44, 88
90, 100, 103, 106, 112
122, 137, 181
Postmodern(ism) 60, 62, 75, 121
176, 183
Preminger, O 101
Priestley, J 151, 152, 157
Profane 152
Projection/Projected 2, 7, 25, 50, 51, 55
66, 67, 78, 79, 85, 92
96, 98, 101, 106-115, 121
127, 132, 136, 141
154, 155, 161, 165, 166
176, 178, 179, 188
Psyche 3-7, 13-18, 21-29, 30-55
60-65, 69, 70, 78, 79, 80
83, 84, 86, 92-99, 100-111
119, 120, 127, 131-135
143, 150, 153-155, 157
160, 161, 166, 171-173
176-179, 182, 186, 190
Psychoanalysis 3, 4, 7, 13, 89, 182
183, 189
Psychodynamic 13, 15, 16, 27
Psychologist 13, 22, 49, 70, 77, 90, 103

104, 126, 154
Psychopathic 104
Psychosis 63, 179
Psychotherapy viii, 120, 121, 184
Purusha 145

Quest 8, 78, 80, 81, 85, 87, 97
113, 128-131, 135, 139, 141
142, 147, 148, 152, 164, 167, 176, 189

Raging Bull (Martin Scorsese) 19, 204
Rain 83
Rational 2, 22, 27, 37, 79, 92, 93
106, 111, 140, 177
Ray, N 59
Reason 17, 38, 50, 54, 73, 90
91, 112, 140, 170
Rebirth 55, 80, 81, 86, 135
146, 147, 157, 171, 178
Red 134, 155, 156
Reductio ad absurdum 17
Reed, C 13
Reimschneider, M 167
Relativity 151
Replicants 7, 77-79, 80-86
Representation 17, 48, 87, 110, 116
127, 143, 152, 163, 179
Repressed/Repression 3-7, 15, 16, 24-29
38, 42, 48, 60, 104, 109
110, 116, 130, 133, 165, 172, 177
Richards, D 109
Rico, J 103
Rites of passage 34, 44, 194
Ritual 20, 54, 82, 86, 154
Robbe-Grillet, A 157, 196
Robinson, E.G 97, 101, 125, 200, 201
Romans 144, 148
Ruach 86
Rubik's cube 119
Ryan, R 77, 201

Sacrament 92, 144, 182
Sacrifice 145, 155, 166, 170, 176
Saint George 155
Samuels, A 3, 4, 9, 28, 44, 60, 61
72, 75, 76, 90, 100, 112-119
121-125, 137, 185
Scarlet Street 101
Scheider, R 23
Schwarzenegger, A 16
Scorsese, M 19, 28, 204
Screen 4
Search (see, quest)
Self 27, 68, 79, 81, 107, 119, 120
144, 161, 175, 179, 182

Self-actualisation 17, 18
Self-reflection 105
Self-regulation 72, 169, 170
Sensing 22, 23, 79
Sequel 147
Sex 20, 26, 49, 51-55, 66, 67, 151
Shadow 6, 8, 25, 26, 31, 42, 43, 48-55
65-68, 96-98, 104, 107-112
117, 126-128, 130, 132-137
144-148, 153, 160, 162-167
172-174, 179, 185-189
Shakespeare, W 83, 88, 194
Shorter, B 28, 75, 122, 175, 176, 185
Sidoli, M 121
Siegel, D 110
Sign 91, 92
Sirens 95, 115, 135
Skinner, B 14, 28, 89, 100, 185
Sleep my Love (Douglas Sirk) 116
Sleuth (Joseph Mankiewicz) 7, 89
95-101, 167, 203
Smart, N 122, 194
Smith, M 75, 196
Snake 39, 40, 85, 86, 100
Society 2, 4, 7, 28, 30, 41, 44
63, 83, 90, 91, 150, 161, 181-189
Son 87
Song of Songs (aka Song of Solomon) 97
98, 99, 101
Sophia (see, Sophos)
Sophos 113, 121
Soul 17, 28, 44, 49, 67
96, 98, 111, 143, 144
145, 149, 153, 155, 164, 186
Space 5, 23, 31, 91, 152
156, 161-166
Speiser, E 88, 194
Spirit 19, 26, 33, 35, 67, 86
87, 91, 117, 133,
145-147, 171-174, 184
Spiritual 20, 32, 33, 36, 50, 85
115, 119, 145, 156
166, 175, 193
Stanwyck 116, 200
Star Trek: The Motion Picture
(Robert Wise) 21, 204
Star Wars (George Lucas) 119, 203
Stein, L 68, 72
Steppenwolf 100, 101
Sternberg, J. von 115, 190, 199, 200
Stevens 121
Stormion 121
Subject/Subjectivity 15, 60
Suppression 49, 110, 165
Sydney 63

Tabula rasa 24
Tao 80, 81, 87, 88, 194
Teleology/Teleological 5, 68, 69
Terminator (James Cameron) 16, 17, 205
Thinking 3, 9, 14, 15, 21, 22, 27
40, 83, 92, 108, 141, 179
Third Man, The (Carol Reed) 13
This Gun for Hire (Frank Tuttle) 116
Thompson, F 163, 167, 194
Tierney, L 29
Tightrope v, 6, 25
(Richard Tuggle) 26, 47-53, 55, 66, 206
Timaeus 160, 167
Time 4, 8, 24, 25, 42, 84
116, 126, 134, 143, 145
149, 150-157, 163
Trancers (Charles Band) v, 8, 123-189
206
Transcend(ed) 37, 40, 84, 107
145, 173, 175, 179
Trevor, C 125, 201
Trickster 71, 117
Tuggle, R 6, 25, 47, 206
Tuttle, F 116
Tyler, P 33, 44, 99, 101, 190

Underworld 26, 48-55, 95-101
110, 115, 127, 131-183, 189
Unicorn 86, 87, 88
Up in Arms (Elliott Neugent) 63
Uroboric (see also, symbol)

Vampire(s) 51, 135
Vedic 145
VeSota, B 29
Viewer(s) 25, 50-54, 85, 87
95-98, 100, 128, 129, 133, 140
144, 146, 152, 155, 157, 166, 167, 173
Villian (see, criminal)
Vries, S 156, 158

Water 8, 32, 51, 81, 82
87, 153, 154, 162, 166, 172
Welles, O 13
Wenders, W 109
Whitmont, E 62, 73, 75, 76, 90
94, 100, 186
Wholeness 42, 43, 79, 94, 100
104, 120, 160, 161, 172
Wife 19, 26, 50, 53, 95
115, 130, 132, 135
Wilder, B 101, 116, 137, 169, 200
Winnicott, D.W 186
Wise old man/woman 40, 67, 71, 79, 81
94, 107, 117, 132, 148, 206

Witches	135	Wright, B	31, 38-40, 44
Wolf	54, 55, 100	Wyler, W	130, 202
Woman in the Window, The			
(Fritz Lang)	7, 89, 97, 99, 101	Zeus	143
Word association test	15	Ziggurat	85
World War I,II	63	Zoja, L	77, 88
Wound(ing)	99, 121, 135, 137, 182	Zombie	146